Studies in Rhetorics and Feminisms

Series Editors, Cheryl Glenn and Shirley Wilson Logan

GENDER AND RHETORICAL SPACE IN AMERICAN LIFE, 1866–1910

Gender and Rhetorical Space in American Life, 1866–1910

Nan Johnson

Southern Illinois University Press
Carbondale and Edwardsville

The following articles are reprinted here in a revised form:
"Reigning in the Court of Silence: Women and Rhetorical Space,"
Philosophy and Rhetoric 33.3 (2000): 241–42. Copyright 2000 by The
Pennsylvania State University. Reproduced by permission of the publisher.
"'Dear Millie': Nineteenth-Century Letter Writing and the Construction
of the American Woman," *Nineteenth-Century Prose* 27.2: 22–46.

Library of Congress Cataloging-in-Publication Data

Johnson, Nan, 1951–
 Gender and rhetorical space in American life, 1866–1910 / Nan
Johnson.
 p. cm. — (Studies in rhetorics and feminisms)
 Includes bibliographical references and index.
 1. Speeches, addresses, etc., American—Women authors—History and criticism.
2. Rhetoric—Social aspects—United States. 3. Feminism—United States—History.
4. Women orators—United States.
I. Title. II. Series.

PS407 .J64 2002
815.009'9287—dc21
ISBN 0-8093-2426-1 (pbk. : alk. paper) 2001032230

The paper used in this publication meets the minimum requirements of American
National Standard for Information Sciences—Permanence of Paper for Printed Library
Materials, ANSI Z39.48-1992. ⊚

This book is dedicated to my daughter, Isabel.

CONTENTS

FIGURES

ACKNOWLEDGMENTS

I have many people to thank for their support of this study. This was a project long in coming, and the personal and scholarly support of friends and colleagues was an indispensable resource. I would like to thank particularly Amy E. Shuman, who read all of this manuscript and gave me invaluable feedback. Additionally, I would like to thank the following colleagues and friends who encouraged this project in various ways: Greg Clark and Mike Halloran for their initial interest in my parlor focus on nineteenth-century rhetoric pedagogues; C. Jan Swearingen, Jane Donawerth, Lynette Hunter, and Susan Jarratt who provided critical input at key points; Jamie L. Carlacio, Win Horner, Wendy Dasler Johnson, Shirley Wilson Logan, Jacqueline Jones Royster, and Kathleen Welch who gave valuable support as the argument evolved; Marilyn Bronstein, Jim Fredal, Leigh Gilmore, and Elizabeth Renker who energetically supported me in my bouts of writing with energetic support; my friends in the Postmodern Studies reading group who provided instruction and challenges; and Cheryl Glenn who said to me at the Penn State Rhetoric Conference in the summer of 1999, "So, Nan, how about that book?" and who has stuck by the project ever since. I would also like to thank The Ohio State University and its Department of English for research funds and release time. A final word of appreciation goes to all my friends at The Ohio State Library Book Depository who so efficiently located all those "old books."

GENDER AND RHETORICAL SPACE IN AMERICAN LIFE,
1866–1910

INTRODUCTION

THE FEMINIST ANALYSIS OF RHETORIC AS A CULTURAL SITE

> The realization of the radical potential of women's history comes in the writing of histories that focus on women's experience and analyze the ways in which politics construct gender and gender constructs politics. Feminist history then becomes not the recounting of great deeds performed by women but the exposure of the silent and hidden operations that are nonetheless present and defining forces in the organization of most societies.
> —Joan Wallach Scott, *Gender and the Politics of History*

I assume in the following essays that a feminist reading of the history of rhetoric necessarily means that the complicated relationship between rhetorical practices and the inscription of cultural power must be addressed as we revisit or uncover rhetorical traditions and practices of the past. In the discussions that follow, I treat rhetorical theories and rhetorical practices as cultural sites where we can observe the interdependence of codes of rhetorical performance and the construction of conventional identities, particularly but not exclusively gender identities. Whenever we read a rhetorical theory or practice as a cultural site, we are locating a nexus where cultural capital and rhetorical performance have become one. From this critical point of view, the history of Anglo-American rhetoric can be read as a revealing narrative about how convention, rhetorical expectations, and the lines of cultural power converge.

To see how this narrative is formed and reformed in different historical eras requires first the acknowledgment of the institutional role that rhetorical pedagogies play in inscribing discursive practices that maintain rather than destabilize status-quo relationships of gender, race, and class. If rhetoric did not have this kind of institutional force, rhetorical power could not have

been held so long by so few. The boundaries around rhetorical space have been actively patrolled for as long as it has been undeniably clear that to speak well and write convincingly were the surest routes to political, economic, and cultural stature. I argue in this book that it is the particular obligation of feminist historians to recover the role of rhetoric in the disposition of power and in what has always been in American culture a highly gendered struggle over the control of public rhetorical space and its benefits. By re-reading the history of rhetoric as a drama about how convention is inscribed and redefined within rhetorical space, we better prepare ourselves to iden-tify where and how circles of rhetorical power are constructed in our own times and to better understand who is drawing those circles, who stands within them, and who remains outside.

In *Gender and Rhetorical Space in American Life: 1866–1910,* I argue that during the postbellum era, we see the rise of nonacademic pedagogies of rhetoric and popular constructions of rhetorical propriety that became im-plicated in a cultural program of gender politics that sought to control ne-gotiations about the boundaries of *rhetorical space* and as well as the debate about who was allowed to occupy it.[1] The specific purpose of the following chapters is to explore how nonacademic or *parlor* traditions of rhetoric and popular constructions of rhetorical performance after the Civil War helped to sustain the icon of the white, middle-class woman as queen of her do-mestic sphere by promoting a code of rhetorical behavior for women that required the performance of conventional femininity. The history of how gender identities and rhetorical behavior are linked in cultural attitudes in the postbellum period and the latter decades of the nineteenth century il-lustrates that cultural contestation about rhetorical practices often marks a historical moment when foundational values are in flux and a cultural prob-lem is being renegotiated. What emerges in the postbellum period and the late-nineteenth century as a solution to what many nineteenth-century authors define as *the woman question* (the debate over women's roles and rights) is the strategy of constraining the political power of women's discourse by redirecting women to rhetorical roles in the home and complicating their access to the public rhetorical spaces where the fate of the nation was de-bated. After the Civil War and extending into the turn of the century, rhe-torical pedagogies designed for a popular audience, such as elocution manu-als and letter-writing handbooks and other instructive commentaries about rhetorical behavior, represent cultural sites where the tension between ex-panding roles for women and equally intense desires to keep those roles stable manifests itself in open controversy about how to value women's words.

Scholarship on the role of women in the rhetorical life of nineteenth-

century America has made increasingly clear over the last several decades that the controversy over the value of women's words was well-established by the Civil War. We can now take as a scholarly point of departure the fact that at the start of the nineteenth century, the arts of rhetoric were the undisputed province of the male professional classes. Ministers learned to preach, lawyers learned to argue, politicians learned how to persuade the masses, and white, middle-class, young men acquired the rhetorical habits of speech and writing that marked their status as those who would surely make everything happen, and women learned little to nothing about any of it. More importantly, they were chastised or worse for trying. The highly gendered nature of nineteenth-century American attitudes toward access to rhetorical power has been documented by a body of feminist scholarship that has identified the determined women who overcame strong resistance to ascend to the platform or take pen in hand to champion reformist causes such as abolition, temperance, women's rights, medical care, education, and labor reform. In *Man Cannot Speak for Her: A Critical Study of Early Feminist Rhetoric* (1989), Karlyn Kohrs Campbell, among other scholars, has documented the rhetorical careers of nineteenth-century women reformers and stressed the obstacles that women such as Angelina Grimké, Lucretia Coffin Mott, Elizabeth Cady Stanton, and Sojourner Truth encountered under a cultural regime that dictated that it was a man's nature to inhabit the public rhetorical sphere and woman's nature not to. Lillian O'Connor made the same point in her earlier survey of antebellum women speakers, *Pioneer Women Orators: Rhetoric in the Antebellum Reform Movement* (1954), in which she describes the widespread resistance to women speakers who spoke to mixed audiences or sought formal education in the rhetorical arts (3–34).

Preceding both O'Connor and Campbell in the canonical recovery of nineteenth-century women speakers and the description of the obstacles they faced is the ground-breaking scholarship of Doris G. Yoakum, whose article "Women's Introduction to the American Platform" appeared in the often cited canon text *A History and Criticism of American Public Address* (1943).[2] Yoakum's treatment of antebellum women orators represents the first substantial attempt in twentieth-century historical scholarship to restore to the canon of American oratory a record of the achievements of influential nineteenth-century women speakers such as Frances Wright, Grimké, and Mott who overcame significant obstacles in their paths to the public platform. Yoakum is also the first historian of rhetoric to define how the *woman's sphere* issue contextualized the cultural climate in which nineteenth-century women speakers struggled for recognition:

3

A small minority of women, however, who possessed courage, ambition, and curiosity to investigate existing conditions (as have individual and representative women throughout history), continued to chafe under the legal, economic, and social restrictions imposed by a society formed and controlled by men. (154)

Yoakum's praise of the achievements of a "courageous" minority of women orators who "contributed a mighty advance step toward the breaking down of women's barriers" initiated a scholarly tradition that subsequently has made ever more clear the historical fact that rhetorical education and influence represented a gendered battleground in nineteenth-century American life (154).

Since the 1970s, scholarship analyzing the history of the rhetorical contributions of American women speakers and writers and the nature of the prejudice these women experienced has been able to draw increasingly upon the scholarship of feminist historians who have explored how American women's lives and achievements were affected by the domestic context that defined their identities and who have also examined the rhetorical history of early feminism. The typicality of the assumption among nineteenth-century rhetoric scholars that evaluating the achievements and status of women should be contextualized by the power of gender ideology in this period is exemplified in how customary it is for scholars to preface their explorations with exactly this observation. Susan Wells observes that the large canon of scientific writing by nineteenth-century women "complicates our understanding of the relations of gender, science, and writing, presenting the discourse of medicine a variety of gendered positions rather than a univocal performance of patriarchal power" (176). Jane Donawerth notes that Sigourney, like her contemporaries, the early female abolitionists, "coopts the social institution of women's gendered sphere by analyzing women's means to power through that sphere: teaching, conversation, reading aloud as part of parlor entertainment, and letter writing" ("Hannah More" 157). Feminist historians of rhetoric have benefited measurably from Aileen S. Kraditor's theory of the *cult of domesticity* explored in *Up From the Pedestal: Selected Writings in the History of American Feminism* (1968); from Barbara Welter's definition of the *cult of true womanhood* in *Dimity Convictions: The American Woman in the Nineteenth Century* (1976); and from Linda K. Kerber's study of the ideological force of *Republican motherhood* in *Women of the Republic: Intellect and Ideology in Revolutionary America* (1980).[3] Terms like cult of domesticity, cult of true womanhood, and Republican motherhood that describe the ideological climate of nineteenth-century America have provided historians of rhetoric with a heuristic, critical vocabulary as

well as greater historical insight into the kinds of constraints that women rhetoricians faced. Campbell's debt to this perspective is clear at several junctures in her work where she quotes Welter's definition of true womanhood, as she does in a discussion on early African-American feminists:

> Afro-American women, in addition to the special problems arising out of slavery, historically faced the same problem as all other women. Married, they were dead civilly; unmarried, they were dependents with few possibilities for self-support; regardless of marital and socio-economic status, they were oppressed by the cult of true womanhood, which declared that true women were pure, pious, domestic, and submissive. (434)

Campbell's influential, methodological commitment to reading the achievements and struggles of women orators in nineteenth-century America against the background of the cult of true womanhood and the domesticity problem (as Kraditor and others have defined it) has been widely reiterated in the last two decades by other historians of rhetoric who have founded new inquiries on the assumption that the climate of nineteenth-century rhetorical life can be accurately described only when the ideological impact of the *true womanhood–cult of domesticity* context is taken into consideration. In a recent article on the development of the *promiscuous audience* problem (the assumption that women should not address audiences of both men and women, which Yoakum is the first to identify as one the major battles in the rhetoric wars of the antebellum period), Susan Zaeske makes clear that studies of nineteenth-century rhetoric now assume as a point of scholarly predisposition the importance of the true-womanhood debate to the investigation of the rhetorical activities and status of nineteenth-century women:

> The emergence of women on the public platform is one of the major developments in the history of public address in the United States. Rhetorical scholars and historians alike have begun to identify central figures and major texts in an effort to accord woman orators their rightful place in the canon. An important part of their work has been to explore the barriers that confronted women who sought to speak in public during the nineteenth century. Of these barriers, as Karlyn Campbell has noted, none was more formidable than the charge that it was improper for women to speak from the public platform. "In nineteenth-century America," Campbell writes, "femininity and rhetorical action were seen as mutually exclusive. No 'true woman' could be a public persuader." Women who did give speeches "entered the public sphere and thereby lost their claim to purity and piety." (191)

Although Zaeske refers here to the fraught situation of women's participation in public speaking, recent studies that have focused on the involvement of nineteenth-century women in other rhetorical arts and in rhetorical education typically confirm the historical assumption that the cultural stress on nineteenth-century women to confine their words to the parlor was persistent and represented an obstacle that had to be circumvented or overcome.

Building upon what is now a well-established historical relationship between nineteenth-century discourses on gender and definitions of rhetorical performance, I hope to extend our understanding of the dilemma nineteenth-century women faced by tracing the reach of the ideology of true womanhood across rhetorical materials that have not yet been examined and by establishing that a highly conservative cultural agenda regarding public rhetorical space and gender roles was still the dominant cultural viewpoint as the nineteenth century ended. Postbellum pedagogical materials designed to educate Americans in rhetorical skills at home comprise a collective of discourses that persistently directed the American woman to the domestic sphere as her proper rhetorical space. These pedagogies appeared to urge the American woman to become an effective speaker and writer; however, the ultimately conservative agenda of the postbellum parlor-rhetoric tradition reinforced a general mistrust in white, middle-class culture of the presence of women in public rhetorical space that is just as observable after the Civil War as before. One of the major arguments that I make in this book is that the imposition of the cult of true womanhood on the rhetorical fortunes of white, middle-class, American women lasted far longer and was deployed by more avenues than we have realized.

My exploration of how resistance to women's participation in public rhetorical space was deployed between the end of the Civil War and the early twentieth century relies on a body of work that has extended our knowledge of how women rhetoricians achieved success and faced the challenges of their times. Prominent among recent scholarly projects on nineteenth-century American women that explore how they balanced their desire to do rhetorical work and the conservative expectations that both hampered and enabled their influence is the crucial perspective on the rhetorical contributions of African American women speakers and writers provided by the work of Shirley Wilson Logan in *"We Are Coming": The Persuasive Discourse of Nineteenth-Century Black Women* (1999) and Jacqueline Jones Royster in *Traces of a Stream: Literacy and Social Change among African American Women* (2000). Both Logan's and Royster's projects respond to the general inadequacy of twentieth-century canonical accounts of the rhetorical involvement of African American women in nineteenth-century life. Logan and

Royster concentrate mainly on restoring the names and contributions of African American women to the history of nineteenth-century rhetorical practices and on profiling the unique rhetorical traditions that these women employed in public lives devoted to the advancement of African Americans both before and after the Civil War. I would argue that *"We Are Coming"* and *Traces of a Stream* represent the most significant inscriptions of women into the history of American rhetoric since the publication of Yoakum's initial treatment of antebellum women speakers.[4]

As the result of the work of scholars such as Logan and Royster, more inclusive treatments of women's rhetorical contributions and activities now shape our understanding of the scenes in which nineteenth-century American women conversed, debated, and composed. That understanding has been deepened by the work of many other scholars who have filled in the historical picture of nineteenth-century women's rhetorical and literate pursuits. Several scholars have expanded our understanding of the challenges imposed on nineteenth-century women and the means by which women enhanced their access to rhetorical forums and education despite barriers to their doing so. Carol Mattingly, Bonnie J. Dow, and Mari Boor Tonn have provided analyses of the skilled rhetorical practices of the works of nineteenth-century women reformers such as Frances E. Willard and Mary Harris "Mother" Jones; Jane Donawerth and Susan Kates have expanded our understanding of the pedagogical contributions of women who taught rhetoric and wrote rhetoric textbooks in the latter decades of the nineteenth century; Anne Ruggles Gere and Susan Miller have each reminded us of the range of speaking and writing occasions available to nineteenth-century women despite their marginalization in the public sphere; Kathryn M. Conway, Joanne Wagner, and Sue Carter Simmons have collectively described the institutionalization of rhetorical training at nineteenth-century women's colleges despite opposition; Lisa M. Gring-Premble and A. Cheree Carlson have examined ways that antebellum women reformers forged a feminist consciousness through rhetorical strategies that both resisted and co-opted the constraints of woman's proper rhetorical sphere; and Robert J. Connors has provided the most detailed recovery yet of the public speaking career of Frances Wright, whom he describes as the "First Female Civic Rhetor in America"[5] (30).

The scholarship named here is by no means intended as a complete record of the many contributions that have shaped our current perception of nineteenth-century rhetoric and the place women have in its history. However, these brief examples represent what Cheryl Glenn has described as a project of *remapping* the history of rhetoric. The intellectual energy of the feminist

project of remapping the history of nineteenth-century rhetoric, which can trace its earliest scholarly roots to the work of Yoakum, O'Connor, and Campbell, has been further supported by historical accounts of the rhetorical role of women in previous eras. These accounts include writings such as Glenn's *Rhetoric Retold: Regendering the Tradition from Antiquity Through the Renaissance* (1997) and the revisionist essays included in editor Andrea A. Lunsford's *Reclaiming Rhetorica: Women in the Rhetorical Tradition* (1995) and in editor Molly Meijer Wertheimer's *Listening to Their Voices: The Rhetorical Activities of Historical Women* (1997). Standing directly in the line of significant canon revisionists, Glenn remaps the territory of classical, medieval, and renaissance rhetoric by recovering the silenced voices of women whose contributions to rhetorical theory and practice of earlier periods have been overlooked, such as Hortensia, Fulvia, Amasia Sentia, Julian of Norwich, Margery Kempe, Elizabeth Faulkland Cary, Catherine of Aragon, and Elizabeth I. Defining remapping as the goal of feminist historiography in rhetoric studies, Glenn presents her study as a scholarly answer to the problem, "So what if the traditional rhetorical map flattened the truth, leaving scarcely a ridge on the surface that could suggest all the disenfranchised rhetorics just off the main road?" (14–15).

The remapping orientation of *Reclaiming Rhetorica* takes its cue from a title that reflects the revisionist motives of recent projects that have attempted to rewrite the history of Western rhetorical practices. As Lunsford points out, "Taken together, the essays in *Reclaiming Rhetorica* suggest that the realm of rhetoric has been almost exclusively male not because women were not practicing rhetoric—the arts of language are after all at the source of human communication—but because the tradition has never recognized the forms, strategies, and goals used by many women as 'rhetorical'" ("On Reclaiming Rhetorica" 6). A number of the essays in *Reclaiming Rhetorica* offer new maps of the history of rhetoric, including C. Jan Swearingen's treatment of Diotima (as represented by Plato) as an example of "the public presence of women as teachers, religious celebrants, and orators in classical antiquity" (25); Susan Jarratt and Rory Ong's discussion of Aspasia as a teacher and practitioner of the Socratic method of public speaking in fifth-century BCE Athens (9–24); and Christine Mason Sutherland's depiction of Mary Astell's contribution to seventeenth-century rhetorical practice through a "mastery of the art of eloquence, and her bold invasion of the masculine stronghold of traditional rhetoric" (93). In her review of *Listening to Their Voices,* Phillippa M. Spoel highlights the "listening" dimension of the orientation of this collection of essays that addresses "the

neglected richness and diversity of women's contributions to rhetoric, as well as the extent of all that remains to be recovered and reinterpreted" (92).

Historical remapping projects presume that when the contributions of women to rhetorical history are recovered, we gain a more accurate sense of the roles women have played in rhetorical enterprises of the past and also a greater insight into what actually constitutes the range of women's rhetorical activities in any given historical period. With the recovery of the women missing from the map also comes the recovery of a range of rhetorical practices in which women were involved but that have been historically devalued or erased. In *Traces of a Stream,* Royster expresses an expansive insight into the diversity of rhetorical practices that efforts to remap the territory of the history of rhetoric can offer:

> Ultimately, then, within a context of inhospitable circumstances, nineteenth-century African American women used language and literacy as a tool to authorize, entitle, and empower themselves; as an enabler for their own actions; and as a resource for influencing and inspiring others. . . . [N]ineteenth-century African American women "read" and rewrote the world. They succeeded in developing a critical consciousness by which they envisioned their context, shaped their realities, and charted courses of action. They redefined their sphere of operation, imagining intersections for themselves among private, social, and public domains, and inventing ways to effect change using whatever platform was available to them. (234–35)

Although designed to define the particular parameters of African American women's rhetorical traditions, Royster's description of the rhetorical inventiveness of African American women also illustrates the kind of qualitative gain in historical insight into the range of what we can call *rhetorical* that feminist revisions of the rhetorical tradition have generated.

As the history of feminist studies of nineteenth-century rhetoric reveals, from Yoakum to Royster, 1943 to 2000, remapping the history of rhetoric is an on-going scholarly project that relies for its intellectual integrity on a willingness within the discipline to see the virtues of redrawing the map over and over again. The feminist project of remapping leads to engagement with two feminist historiographic questions: How might we define rhetorical practices differently if we take the eloquence of women in its many forms into consideration? and How might we define the rhetorical tradition differently when the roles of women in the history of rhetorical practices are taken into account? Remapping projects that have written forgotten women

into histories of rhetorical traditions have moved toward constructing a more complete account of how women's voices changed history and also have laid the foundation for a closer scrutiny of the relationship between rhetorical performance and how cultural power is distributed. My aim in the essays that follow is to build upon the insights of the remapping tradition in feminist histories of rhetoric to further complicate the crucial question "Where are the women missing from the map, and who were they?" with the equally essential question "Why are nineteenth-century women's rhetorical accomplishments (or women's contributions in any era) missing from the map of the history of rhetoric in the first place?" To proceed with this question means to assume that cultural power and rhetorical pedagogy are inevitably entangled issues and that the investigation of that entanglement requires that we view rhetorical theories and pedagogies as a cultural field or site where the disposition of power is constantly being renegotiated.

Joan Wallach Scott expresses a similar view of field in her definition of how the feminist historian must view political history: "Political history has, in a sense, been enacted on the field of gender. It is a field that seems fixed yet whose meaning is contested and in flux." To apply Scott's insight to the feminist study of the history and nature of rhetoric is to understand that any historical narrative we now have about the obstacles that women have overcome to participate in rhetorical activities must be contextualized by yet another historical narrative that accounts for how the articulation of rhetorical practices has been enacted on a politicized cultural field constituted by the links among ideologies about gender, race, or class and conventional principles of rhetorical performance. Regarding the history of rhetoric as a map *and* as a cultural field or site widens our historiographic grasp on rhetorical traditions and practices of the past by supplementing current understandings about neglected women rhetoricians and their activities with an account of the cultural dynamics that created the possibility of that neglect. As Scott points out, a feminist focus on the political arena as a "field of gender" does not yield exactly the same view of history as the kind of feminist focus that restores "missing" women to the historical record (48). To apply Scott's point to the history of rhetoric is to be aware that although it is historiographically crucial to ask the question "Who are the women missing from the map of rhetorical history?" it is equally valuable to complement that question with an inquiry into what cultural circumstances would have given license for the blatant erasure of women's rhetorical lives and to ask what those circumstances tell us about how exclusionary maps are drawn and why.

The idea of approaching the history of rhetoric as a cultural site where

ideological confrontations take place is not an unprecedented one although, as yet, this approach to the writing of feminist histories of rhetoric has preoccupied the field less than the enterprise of reclaiming women's voices and rhetorical achievements. Glenn draws our attention to the importance of considering rhetoric as a cultural practice when she observes that an understanding of gender studies has become an indispensable one to her notion of what it means to write history: "If we understand the particular and contextually specific ways gender and society (or culture) interanimate one another, we can more knowledgeably chart and account for those gendered limits and powers as we take a specific route along the borders of rhetorical history" (14). I agree that writing feminist histories of rhetoric confronts us with a matrix of interrelationships between gender and power, and I would go further to argue that contextualizing every silence in the historical record is a cultural narrative about the conditions that constrained or erased women's rhetorical achievements. The argument for the feminist analysis of the history of rhetoric as a cultural field asks that we consider what forces of cultural contestation can be detected behind the silences and blank spaces. Swearingen has recently observed that "the project of feminist historiography in rhetoric has begun to diversify and shift the question, despite formidable protests, from *whether* women should be added to the history of rhetoric to *how* and *on what grounds* they should be recuperated and examined in different periods" and points out that it is of "special value" to feminist historians of rhetoric to "amplify the methods we have for reconstructing the lives and experience of women in the ancient Near East" by posing questions about "social roles, identity, and status; the boundaries dividing public from private roles" ("Plato's Women" 35–36). Although Swearingen does not use the term *cultural field,* she points to the importance of a particular type of historiographic questioning that results from "shifting" the feminist historiographic question toward a consideration of cultural context as a viable form of historical evidence in the reappraisal of figures such as Diotima and Aspasia. Swearingen implies that an understanding of the rhetorical status of women in the ancient Near East requires not only the observation that women such as Aspasia appear to have been textually silenced, but also an exploration of why that occurred: "For what reasons, in a number of places and periods, did such public women's roles become suppressed or sequestered as they did in Athens with laws forbidding women to mourn in public? How do women's funeral songs resemble or not resemble the earliest epitaphia?" ("Plato's Women" 38).[6]

Historiographic questions like these presuppose that the rhetorical positioning of women within any historical period cannot be understood with-

out an inquiry into the cultural value of particular rhetorical practices and the degree to which the ideological authority of gender impinges on that position. The explanatory power of regarding rhetorical theories and practices as politicized cultural fields is foregrounded by Jody Enders in her recent analysis of the culturally authorized programs of violent suppression of women's rhetorical capacities in the fifteenth century and later). In "Cutting Off the Memory of Women," Enders points out how the development of and cultural dominion of misogynistic fears of women's intelligence and of their potential to shape social and political events through public speech "normalizes and naturalizes violence against women—all with God's permission" (48). Enders's willingness to read the decidedly horrific underside of the history of rhetoric for the high-stakes politicized drama that this case represents argues the point that male rhetorical power is rarely given up to women without institutionalized resistance. By pursuing the historical documentation of violent rhetorical oppression of medieval women, Enders implies that the rhetorical position of women in the late Middle Ages cannot be fully accounted for by recovering the literate practices of medieval women or by the recognition of exemplary women who came to historical attention despite cultural opposition. In her historiographic approach, Enders models, as does Swearingen, that the task of feminist histories of rhetoric implies not only identifying which women have been silenced or overlooked throughout the history of the tradition, but also pursuing just as dedicatedly information about why women were silenced and how programs of rhetorical silencing were deployed.

Within existing scholarship on the role of women in the history of nineteenth-century American rhetoric, a focus on the nature of rhetorical practices as a cultural site where convention is institutionalized has been represented by projects that depart from the assumption that cultural tensions about gender and power can be "read" in the constitution of rhetorical genres, performance, and theory. June Hadden Hobbs makes exactly this point in *"I Sing for I Cannot Be Silent": The Feminization of American Hymnody, 1870–1920* (1997) in which she characterizes hymnody as a rhetorical practice that empowered women as social agents and constrained them to silence in the public world of the church. Hobbs recognizes that the "ownership" of hymnody is contested on gendered grounds and that forces of social economy are at work in that struggle over control of this genre: "Hymns became part of an exchange through which women received control of private Christianity and men assume control of its public promotion and power" (35). Although Hobbs does not liken the composition of hymns to the conduct of rhetorical practices such as oratory or the writ-

ing of essays, she reads hymnody as an activity burdened with a gendered tension that imposes itself on the development and cultural function of American hymns. Hobbs's central point is to confirm the value of the ways that American women made use of the voice that hymnody gave them; however, her account of the contested ownership of hymn composition and performance makes it clear that this triumph is a qualified one.[7]

In her article "Rhetorical Power in the Victorian Parlor: *Godey's Ladies Book* and the Gendering of Nineteenth-Century Rhetoric," (1993), Nicole Tonkovich is more directly concerned with the political nature of conventional rhetorical practices in her analysis of the rhetorical career of Sarah J. Hale (long-standing editor of *Godey's Ladies Book,* journalist, and conduct author). Tonkovich argues that Hale paradoxically reinscribed the terms of gendered marginalization for herself and for the women she was attempting to instruct in acceptable rhetorical practices because Hale's authority as an author was based on her role as an interpreter of cultural conventions that sought to stabilize class and gender. Across Hale's polemics about language use, Tonkovich reads the playing out of American middle-class anxiety about protecting the status quo through language conventions. In her similar analysis of the construction of the literary reputation of Harriet Beecher Stowe, in "Writing in Circles: Harriet Beecher Stowe, the Semi-Colon Club, and the Construction of Women's Authorship," Tonkovich calls for "more textured studies" of nineteenth-century women's lives "to account for what one hundred and fifty years of racial and class prejudice has obscured" (169). Tonkovich's work on the cultural construction of nineteenth-century female authorship makes the point that gaining a clear view of the often contradictory rhetorical position of nineteenth-century American women requires recognizing from the start that rhetorical practices are ideological in construction. Like Hobbs's analysis and the works of Enders and Swearingen, Tonkovich demonstrates the value of shifting the question of feminist studies of rhetoric to account for the layers of ideological predisposition that always underlie the unstable rhetorical position of women in cultures in which the demonstration of rhetorical skill is equated with the desire for political power.

The historiographic approach that I take in this book, *Gender and Rhetorical Space,* presumes that a comprehensive insight into the role of women in nineteenth-century American rhetoric would account for not only who is missing from the map but also for what cultural interests contributed to the blotting of women's words from the record of nineteenth-century American history to such an extent that historiographic efforts to redress that neglect have engaged the attention of feminist scholars for decades. By pro-

ceeding with a historiographic focus on rhetoric as a revealing cultural site
where tensions and priorities are played out, I hope to add to our under-
standing of rhetoric as an institution of such remarkable force that profound
bargains about cultural power are constantly being struck in its name. I will
argue that the conservative and gendered agenda of the postbellum parlor-
rhetoric movement that promoted the importance of rhetorical training for
all American citizens yet subtly reserved instruction in oratory and argumen-
tation for white men is evidence that new maps alone cannot reveal the entire
story of the complex situation of the rhetorical status of women before and
after the Civil War. By posing questions about how gender and rhetorical
power were being negotiated in postbellum America, I explore why, at the
end of the nineteenth century, white, middle-class women were still being
constructed ideologically within the same confined rhetorical space as their
counterparts at the beginning of the century. The highly gendered nature
of parlor instruction in rhetorical skills such as elocution and letter writing
so successfully marketed to the postbellum middle class indicates that al-
though a few publicly acclaimed nineteenth-century women may have
gained temporary access to the powerful public rhetorical space of the po-
dium and pulpit, the majority of middle-class, white women were being
encouraged to see their rhetorical identities as a reflection of their roles as
wives and mothers. It is one of the central ambitions of this book to profile
the dilemma of these women who found themselves stranded in the parlor
with little hope of securing a voice in public affairs and to explore what it
means to our understanding of the connections between rhetoric and power
that a conservative agenda based on gender is an obvious part of the suc-
cessful promotion of rhetorical literacy throughout the nineteenth century.

From the postbellum decades to the early twentieth century, a variety of
popular publications including periodicals, rhetoric manuals, conduct
manuals, and biographies of famous Americans reinforced the generally held
opinion that the powerful speakers and writers who shaped the fabric of
American life ought to be distinguished, white men.[8] This popular construc-
tion of rhetorical power as properly residing only in the hands of white men
runs contrary to the historical fact of wide participation by white and Afri-
can American female orators and writers in the rhetorical life of the nation
and indicates that the tensions being played out on the nineteenth-century
field of rhetoric were more complex than we yet understand. How were
rhetorical practices and gender roles entwined in the public mind? What
cultural conversations sustained that fusion? What do those conversations
reveal about why the rhetorical careers and activities of nineteenth-century
women were omitted from the historical record?

The parlor-rhetoric movement of the postbellum era was an institutional agent that defined relatively separate and distinctly unequal rhetorical spheres for women and men. Parlor rhetorics represented prestige discourses in nineteenth-century American culture, and these pedagogies exerted an institutional power over public opinion already predisposed toward defining the home as the American woman's proper rhetorical sphere. Through the longevity of the parlor-rhetoric movement and the influence of other pedagogical dialogues that sponsored a conservative view of the domestic rhetorical domain of women, gendered theories of rhetorical performance exerted an ideological influence on public views of rhetorical roles well into the late nineteenth and early twentieth centuries. In chapter 1, "Parlor Rhetoric and the Performance of Gender," I explore the foundations of this influence by showing how elocution manuals and rhetoric *speakers* (anthologies of performance pieces to be read or acted out) reinscribed a highly conservative construction of the white, middle-class woman as a wife and mother who needed rhetorical skills only to perform those roles to greater effect. Elocution and speaker manuals complicated the ostensible promise of the parlor-rhetoric movement to provide equivalent rhetorical training for one and all by associating rhetorical performance for women primarily with parlor activities that centered on domestic themes or entertainment and by continuing in a long-standing pedagogical tradition that linked oratory and argumentation only to white men.

The mixed feelings that postbellum America had about women's public rhetorical activities are foregrounded throughout the postbellum period and the latter decades of the nineteenth century not only by parlor-rhetoric manuals but also by various types of conduct literature that reinforced the conservative message that women's words matter most in the home. The ideological role of postbellum conduct literature in the rhetorical repatriation of women to the parlor is profiled in chapter 2, "Reigning in the Court of Silence: Women and Rhetorical Space." In this chapter, I focus on a legion of conduct authors who overtly discouraged women from having strong voices, literally and culturally, and who reminded American readers that if happiness was to be preserved in American homes, women needed to reserve their rhetorical influence for their counseling and instructive roles as wives and mothers. In an era of uneasiness about shifting gender roles, the icon of the "quiet woman" ruling her domestic kingdom wisely and graciously seemed to compete with the tension of the woman question by returning the American woman to the parlor where she belonged. Contributing yet another layer of prescriptive confirmation to the cultural admonition that the proper rhetorical sphere of women was the home, letter-writing

guides published both before and after the Civil War reinforce a conservative image of women's rhetorical activities and sphere by insisting on an inseparable relationship between epistolary manners and conduct becoming a "lady." Chapter 3, "'Dear Millie': Letter Writing and Gender in Postbellum America," examines how letter-writing texts designed for the parlor learner conflate women's letter writing and the performance of conventional, gendered behavior so consistently that by the end of the nineteenth century, the epistolary world of women is still defined by domestic obligations rather than being shaped by the professional and political interests that would motivate men to write public letters.

Conservative constructions in letter-writing guides, conduct literature, and parlor-rhetoric texts that saw the home as the rhetorical space women were best suited to occupy contribute to a postbellum cultural conversation about rhetorical performance that promised the American woman persuasive impact through her normative roles. Chapter 4, "Noble Maids Have Come to Town," explores the close affinity between that promise and the ideological tone of nineteenth-century biographical and autobiographical portraits of prominent women rhetoricians such as Susan B. Anthony, Elizabeth Cady Stanton, Mary A. Livermore, and Frances E. Willard. In widely circulated and reviewed postbellum publications profiling the lives of notable American women, only a handful of women were recognized as influential public rhetoricians. Appearing most frequently in this category were well-known speakers Stanton, Livermore, Willard, and Anthony who were relentlessly portrayed in the biographical and autobiographical texts as models of the best of American womanhood. By characterizing prominent women speakers as noble women who were always modest and gentle in their speaking roles and essentially maternal in their characters, postbellum biographies of women orators co-opt the public-speaking podium as a domestic site and portray women rhetors as achieving their public influence only as a result of an inspired extension of their feminine domain. Postbellum biographical and autobiographical treatments of women rhetoricians represent further generic evidence of how inevitable it appeared to be in the cultural climate of the latter decades of the nineteenth century for women's rhetorical activities to be evaluated for signs of gender propriety.

Throughout the postbellum period and the latter decades of the nineteenth century, rhetorical practices remained a highly politicized cultural site where gender identity was defined in conventional terms that reaffirmed the domestic rhetorical influence of women and the public rhetorical power of white men. Access to public rhetorical space in American life was carefully guarded throughout the nineteenth century by a series of rationalizations

that defined rhetorical behavior as a site where desirable constructions of gender could be reinscribed and, thus, controlled. The final chapter of this book, "Noble Maids and Eloquent Mothers, Off the Map," advances the argument that at the turn of the century cultural attitudes toward women assuming public rhetorical roles had shifted very little from the conservative climate of the postbellum period. The continued cultural function of rhetorical practice as a site where gender identity and the politics of cultural power were negotiated takes on yet another guise in the form of canonical debates about whether to recognize the rhetorical careers of prominent women speakers in emerging histories of American public address. The instability of cultural regard for women's participation in public rhetorical space that is so clearly outlined in postbellum parlor-rhetoric manuals, conduct literature, and biographical and autobiographical constructions of prominent women speakers undermines the canonical claims of nineteenth-century women speakers to inclusion in formative histories of American public speaking. From the outset, these histories defined the history of American oratory as the story of great, white statesmen speaking well.

In the inconsistency of canonical recognition of women at the turn of the century and the eventual erasure of women from the historical record of American oratory by 1910, we see yet another enactment of the drama of affirmation and disavowal that frames how the rhetorical lives of American white, middle-class women were constructed by a collective of discourses that could not put to rest the debate about whether the words of women mattered. Canon authors who provide the first accounting of the history of the masterpieces of American oratory inscribed an ambivalent view of women's rhetorical roles that reflects the mixed desires of a white, middle-class culture that remained caught between praise of the iconic virtues of the idealized American woman and a desire to qualify her rhetorical influence in public affairs. A close scrutiny of how gender and rhetoric were positioned in the ideological life of postbellum America reveals that the cultural climate of American life after the Civil War exerted varied forms of pressure on the American woman to disassociate herself from the rhetorical space of public life and to perceive her persuasive powers to be the most forceful when she remained seated at her hearthside. The complicated cultural field that nineteenth-century rhetorical performance represents comes into sharper focus when we realize that the gender agenda of the parlor-rhetoric movement testifies to a deep ambivalence in postbellum America toward women's rights and their claims to rhetorical space that remained unresolved in American life even at the turn of the century.

The role of parlor rhetoric and its pedagogies in sustaining this ambiva-

lence reminds us that the cultural impact of rhetorical performance cannot be understood fully unless we recognize that rhetorical traditions are frequently compromised as agents of ideological change because of the nature of rhetoric as an institutional discipline. Because the cultural power of rhetoric depends on its function as a discipline that "disciplines" discursive possibilities, pedagogies and histories of rhetoric are always simultaneously empowering and disenfranchising. Only by stepping into the contradiction between "discipline" and "possibility" inherent in how rhetorical traditions play out their power can we become more clear in our own minds why even in the new millennium our day-to-day lives remain corrupted by rhetorical theologies that value some voices more than others.

1

Parlor Rhetoric and the Performance of Gender

> Between the Home set up in Eden, and the Home before us in Eternity, stand the Homes of Earth in a long succession. It is therefore important that our Homes should be brought up to the standard in harmony with their origin and destiny. Here are "Empire's primal Springs;" here are the Church and State in embryo; here all improvements and reforms must rise. For national and social disasters, for moral and financial evils, the cure begins in the Household.
> —Julia McNair Wright, *The Complete Home*

Offering readers of *The Complete Home: An Encyclopedia of Domestic Life and Affairs* (1879) a guide to a "happy, orderly, and beautiful" home (3), Julia McNair Wright captures in this celebration of the American home and its promise for salvation for the nation the deep cultural attachment to the domestic world and its potential to heal "disasters" that can be read across a variety of popular publications between 1868 and 1900.[1] In the tumultuous decades after the Civil War, Americans were weary and disheartened by the deaths of half a million, widespread destruction, and a pervasive sense that the rationality of American life had been compromised by a political, economic, and military struggle that had torn the heart out of what might have been imagined as a national community. Not unlike nearly a century later in the era immediately following World War II when America tried to lose a sense of horror and loss by courting a nostalgia for domesticity and progress that implied that God was still in His Heaven, and all could be right with the world once again, postbellum America sought to heal wounds that ran deep by reconceiving a foundation for American life that prized the eternal values of education, progress, expansion, and the stability of the family. In this era of suppressed desperation, cultural energy

moved in a myriad of ways to reinforce social values and habits of behavior that enshrined, among other icons, the American woman as a central player in a drama of recovery, and the American home as the single-best foundation on which the health of the nation could be rebuilt.[2]

Characterized as that necessary angel whose moral influence in the home would reflect upon the whole nation, the American woman was reinstructed as to her proper sphere of influence at every opportunity in the postbellum press and in a variety of culturally significant discourses that shaped public opinion. Influenced by this confluence of discourses, the public's view of the rhetorical role of women as public figures was mixed. The great cause of abolition that had propelled so many women to take to the lectern and to take pen in hand had passed, and the public rhetorical role of women was by no means secure. With the passing of abolition went American women's most prominent hold on the rhetorical climate of the nation, a nation that in the latter decades of the century was far from accepting the causes of temperance and female suffrage as equally righteous issues. The tension in the land over the woman question was still palpable and very much on the public's mind. In an era in which the American public sought the redrawing of a conservative social landscape, the persistent efforts of determined women to challenge traditional boundaries curtailing their lives were met with similarly determined efforts to reinscribe those boundaries and keep women within them. Nowhere is this conflicted energy more clear than in influential discourses about the principles of rhetorical performance: how to speak, to whom to speak, and what to speak about.

Between the end of the Civil War and the turn of the century, the controversy in American life about who women were and ought to be played itself out in popular self-improvement manuals of the day that offered condensed versions of academic and practical subjects including the principles of elocution, oratory, and composition. Encyclopedias, conduct manuals, and rhetoric handbooks collectively promised a complete home education in subjects ranging from math and English to bookkeeping and how to dry flowers. Rhetorical training was given top priority in this curriculum for the home learner. Letter writing, public speaking, and composition were typical entries in tables of contents not only of rhetoric manuals but also of encyclopedias and conduct books that focused on general information as well as the lessons of leading a happy and useful life. The reader interested in learning to speak and write effectively could find in the vast contents of encyclopedias such as *Treasures of Use and Beauty: An Epitome of the Choicest Gems of Wisdom, History, Reference, and Recreation* (1883) and *Collier's Cyclopedia of Commercial and Social Information and Treasury of*

Useful and Entertaining Knowledge on Art, Science, Pasttimes, Belles-Lettres, and Many Other Subjects of Interest in the American Home Circle (1882) standard chapters on letter writing, speech making, elocution, and the etiquette of conversation (see chap. 4). Popular conduct books such as Sarah J. Hale's widely reprinted *Manners; or, Happy Homes and Good Society All Year Around* (1868) and Alfred Ayres's *The Mentor* (1884) promised readers a general education in the social graces for both sexes and typically included chapters on letter writing and conversation as indispensable topics (see chap. 3).[3] Instruction in rhetorical skills offered by conduct books and encyclopedias was supplemented by rhetoric manuals written particularly for the home learner that treated elocution, oratory, argumentation, composition, or letter writing in greater detail. Popular texts of this genre included elocution manuals such as Frank H. Fenno's *The Science and the Art of Elocution* (1878) that is dedicated to the "home circle and for private study" (title page) and letter-writing handbooks such as *Martine's Sensible Letter-Writer* (1868) which provided "model letters, on the simplest matters of life, adapted to all ages and conditions" (title page).[4] The fact that rhetorical skills of speaking and writing were so widely promoted in the range of texts that made up the postbellum parlor curriculum indicates how prized as well as how institutionalized rhetorical education had become in nineteenth-century American life by the latter decades of the century. Rhetorical training was marketed as tantamount to an advanced formal education.[5] The parlor-rhetoric curriculum, comprised of rhetoric manuals, encyclopedias, and conduct literature, had achieved wide popularity by 1885 and continued to engage the public's interest into the early decades of the twentieth century.

The parlor-rhetoric movement achieved the significant goal of promoting rhetorical literacy to a greater number of Americans than otherwise would have obtained it. However, the obvious good achieved by the successful promotion of rhetorical training to the general public in the postbellum period and the late decades of the century is complicated by a tension in parlor pedagogies between egalitarian education and ideological conservatism that plays a dominant role generally in nineteenth-century discourses about gender and rhetorical performance. Although parlor rhetorics ostensibly promised each and every American the opportunity to speak and write more impressively, that promise was ideologically inseparable from an accompanying agenda about gender that limited how rhetorical opportunities for women were defined and reiterated the normative view that women had no use for training in the more culturally powerful forms of rhetorical performance.

The conservative ideology that characterized how postbellum parlor

rhetorics represented rhetorical opportunities for women drew upon a pre-existing cultural context of institutionalized efforts to confine women to "feminine" rhetorical roles and restrict their access to public rhetorical space.[6] Lucy Stone, a prominent speaker on women's rights and abolition during the antebellum period, reported that although Oberlin College admitted women, an education in the art of public speaking was denied to her. Stone said, "I was never [before] in a place where women were so rigidly taught that they must not speak in public" (qtd. in Blackwell 71).[7] Stone was allowed to join formal classes in rhetoric only on the condition that she remain silent. Even women like Stone, who secured a college education when few American women did, faced the repercussions of a cultural anxiety that ran deep about the possibility of women moving into the rhetorical arenas in which cultural power was brokered. Those forms of literacy that were denied to Lucy Stone and nineteenth-century women in general were the very modes of rhetoric through which social, political, and cultural power were disseminated: the arts of argumentation and public speaking.

Lillian O'Connor has made irrefutably clear in *Pioneer Women Orators: Rhetoric in the Antebellum Reform Movement* (1954) that the experience of Lucy Stone was far from singular. O'Connor elaborates on the mentality of "let you women be silent in churches" that characterized antebellum attitudes toward women speaking in public by observing that one of the deepest objections against women orators appeared to be the belief that when women strayed from their proper sphere, their moral character became suspect and their words untrustworthy:

> So long as woman confined her efforts for reform to attendance at prayer meetings and at sewing circles, and to contributions of money, her activities were not subject to criticism. Such activities were all appropriate to her sphere and, therefore, acceptable. Custom forbade that she make use of public address so widely utilized by her father, brother, and son; "ladies" could not speak before a group of men and women. On the other hand, when women addressed only members of their own sex, there was no disapproval of the activity. It was socially acceptable for ladies to speak at sewing circles. (24)

O'Connor profiles antebellum prejudice against women speakers in greater detail by quoting from widely publicized documents of rebuke of abolitionist speakers Angelina Grimké and Sarah Grimké whose public lectures against slavery to mixed audiences of men and women certainly did not keep the sisters in the sewing circle. The Grimké sisters were characterized as "degenerate" for speaking in public, and their male supporters among the

clergy were also chastised for encouraging "females to bear an obtrusive and ostentatious part in the measures of reform and countenance any of that sex who so far forget themselves as to itinerate in the character of public lecturers" (qtd. in O'Connor 32). Not only did reform speakers like the Grimké sisters who forgot themselves have to deal with hostility for violating the boundaries of their proper sphere as women, they also had to press their cause in the face of suspicion that their discourse was fallacious and misleading because, as women, they could only beguile rather than argue logically. O'Connor recounts a strongly worded admonishment of abolitionist speaker Abby Kelley by Henry C. Ludlow, moderator of a meeting of the Connecticut State Anti-Slavery Society in May, 1840, who is quoted in *The Liberator* as equating Kelley's speaking in public with an attempt to pervert the minds of men through feminine wiles:

> Where woman's enticing eloquence is heard, men are incapable [*sic*] of right and efficient action. She beguiles and blinds men by her smiles and her bland and winning voice. The magic influence of Miss Kelley's voice and beauty has carried the vote. . . . Men have not enough strength of mind to resist the magic of woman's appeal, when it is made to their gallantry.[8] (36)

O'Connor makes clear that the rhetorical range of women was extremely circumscribed in the antebellum period, not only because women who spoke in public were considered out of place, but also because existing attitudes prejudged female oratory as drawing from feminine emotions and charms rather than the intellectual integrity of sound ideas.

In *Man Cannot Speak for Her* (1989), Karlyn Kohrs Campbell similarly observes how extensive the challenges were for women who left the private sphere to speak in public:

> Women encountered profound resistance to their efforts for moral reform because rhetorical action of any sort was, as defined by gender roles, a masculine activity. Speakers had to be expert and authoritative; women were submissive. Speakers ventured into the public sphere (the courtroom, the legislature, the pulpit, or the lecture platform); woman's domain was domestic. Speakers called attention to themselves, took stands aggressively, initiated action, and affirmed their expertise; "true women" were retiring and modest, their influence was indirect, and they had not expertise or authority. Because they were thought incapable of reasoning, women were considered unsuited to engage in or to guide public deliberations. (10–11)

O'Connor and Campbell establish that the denial of rhetorics of power to women in the antebellum period was rationalized by leading nineteenth-century educators, clergymen, and social commentators who consistently reiterated objections to women speaking in public. These objections and critiques of the women's rights movement, which was perceived as encouraging women to forsake their parlors for the public lecture hall, were standard fare in various prominent cultural dialogues in the decades preceding the Civil War. The most frequently asserted arguments were that women were intellectually incapable of the analytical skills on which the logic and development of argumentation and oratory depended and that women were delicate (or worse, beguiling) and lacked the emotional and moral forces to convince others of their ideas. These assumptions supported the popularity of separate types of rhetorical education for women and men and promoted the notion that women should receive only that kind of rhetorical training that helped them become more effective in their sphere. As O'Connor reports, while young women at the Troy Female Seminary were being trained in a kind of female deportment that dictated that they could not read their prize-winning compositions aloud because school authorities felt to do so would be to place "too great a strain on the modesty of the young ladies," young men at Harvard were being trained in rhetorical theory, oratory, and declamation and expected to give speeches on a regular basis (29–30).

The assumption that rhetorical training for women should support the development of femininity reveals itself rather obviously in the prefaces to antebellum rhetoric manuals designed for use in female academies and colleges in which authors frequently emphasize the fact that only certain material is suited for the refined delicacy of the tender sex. In *Elegant Lessons for the Young Lady* (1824), Samuel Whiting leaves no doubt about the type of rhetorical performances he believes are appropriate for women:

> [Since] the purity and delicacy of the young Female mind cannot be too assiduously guarded . . . the graver and more serious topics of religious and moral reflection and sentiment are dwelt upon with caution, calculated to avoid the danger of becoming irksome to the gay and volatile. (91)

Echoing similar views about the relationship between a particular kind of rhetorical training and the development of an appropriate feminine sensibility, T. S. Pinneo stresses that delicacy of the female mind had been a "prominent consideration" in the compiling of *The Herman's Reader for Female Schools* (1847):

Every article has been carefully studied with reverence to . . . its appropriateness . . . to the cultivation of the female mind and heart, the development of correct sentiments and taste, the encouragement of gentle and amiable feelings, and the regulating and maturing of the social affections. (5)

The gendered link between rhetorical material and the development of the feminine sensibility stressed by both Pinneo and Whiting stands in contrast to the general principle at work in antebellum rhetoric treatises written for male students that highlight the importance of rhetorical study and practice that prepares young men for the responsibilities of professional and public life. Although Pinneo and Whiting are concerned that the materials included in their collections of prose and poems for study and performance are suited to the delicate female mind and character, J. Agar, author of *The American Orator's Own Book* (1859), is equally concerned that "the young men of America" read and imitate the best examples of patriotic and commanding discourse so they might better prepare themselves for service to the nation as speakers and men of action (iv). Introducing his collection of patriotic, martial, and political speeches with the call "the young men of America have a responsibility which none but a thoughtful mind can fully appreciate," Agar goes on to define the study of oratory as the best kind of education in the ideas and character that prepares young men to protect the health of the nation with their words and their actions (v–xii). By promoting *The American Orator's Own Book* as a "good book" that reproduces the "master-minds of the past" and places before the young men of the nation "worthy motives and ends, in the pursuit and accomplishment of which ambition may have its fullest play," Agar directly connects the study and practice of oratory with an active public life and rhetorical career that he assumes is the ambition of all young men. With a rousing "Let the young men of this nation see to their work," Agar urges his readers to study and imitate the orations of great men such as Edmund Burke, Lord Chatham, Patrick Henry, George Washington, and Daniel Webster (xii–xv). Leaving little doubt that he regards "the American Orator" to be a title that only falls to the "Young Men of America" to whom he dedicates the collection, Agar articulates the commonplace assumption that the proper rhetorical sphere of men was public and political life and that the appropriate type of rhetorical training for their "sensibilities" is the study of great political and military men who have "changed the world of men" with their orations (dedication page).[9]

Although approaching the relationship between gender and rhetorical space from the opposite point of view from Pinneo and Whiting, Agar's

intense definition of public oratory as a performance of patriotic masculinity indicates that he shares their fundamental assumption that the rhetorical spheres of men and women were entirely separate realms. Although Agar's *The American Orator's Own Book*, Pinneo's *The Herman's Reader*, and Whiting's *Elegant Lessons* are not rhetoric texts that were widely reprinted in the antebellum period, these manuals are representative of how gendered rhetorical pedagogies were in the first part of the nineteenth century and the extent to which rhetorical behavior was associated with the appropriate performance of conservative gender roles.

Treatises that were theoretically influential and widely reprinted that also reinforced this view of gender and rhetorical space in the antebellum period included Samuel P. Newman's *A Practical System of Rhetoric* (first published in 1834) and Ebenezer Porter's *The Rhetorical Reader* (first published in 1827). Newman makes a point of framing the purpose of his elocution text as an intention to develop the masculine qualities of intellectual judgment and forceful expression that are the foundation of eloquence: "It is a received maxim that to write [and speak] well we must think well. To think well, implies extensive knowledge and well disciplined intellectual powers" (16). Similar to Agar's rationale, the principle of selectivity governing Newman's choice of material focuses on the relationship between the study of exemplary models of writing and oratory and the development of the ability to produce successful public discourse. One of the most popular rhetoric treatises circulating before the Civil War, *A Practical System of Rhetoric* represents the male orientation of influential, antebellum academic rhetorics addressed to young men who would soon enter public life. Porter observes that the art of reading is an indispensable skill for anyone who expects to be a public speaker, yet he also constructs the public rhetorical sphere as the destiny of young men. Porter goes further to argue that elocution is also a generally useful skill and that it should be part of the complete education that prepares "sons" and "daughters" alike for "a respectable rank in well-bred society" (13). Although Porter promotes elocution as a rhetorical art that both sexes can learn and benefit from, he makes it explicitly clear that he assumes that women would never be applying that skill to public speaking:

> But beyond this, the talent may be applied to many important purposes of business, of rational entertainment, and of religious duty. Of the multitudes who are not called to speak in public, including the whole of one sex, and all but comparatively a few of the other, there is no one to whom the ability to read in a graceful and impressive manner, may not be of great value. (13)

Porter inscribes "public speaking" as a male domain and implicitly defines the rhetorical world of "the whole of one sex" as social or domestic ("rational entertainment"). Porter's confirmation of the view that women needed only those rhetorical skills that enhanced their conventional roles is more than simply representative of general public opinion. Porter's *The Rhetorical Reader* was frequently cited by other elocutionists and was reprinted several times between 1838 and 1880. The high profile of Porter's text implies that it would have been at least modestly influential in reinforcing in the academy and among rhetoricians themselves the generally held cultural assumption that although women could be trained in effective oral expression, they were not assumed to be potential public speakers or expected to apply the arts of expression outside the home.[10]

The bias that Porter and Newman display against women receiving a rhetorical education that would prepare them to be public speakers makes the point that there was a well-established link between rhetorical performance and gender in the popular mind well before the Civil War. Parlor rhetoric manuals marketed in the second half of the century generally reinscribe this same restricted definition of rhetorical behavior for women rather than advocate a more egalitarian vision of rhetorical opportunities for both men and women in public forums. Echoing the ideological position of antebellum rhetoric manuals, the authors of parlor-rhetoric manuals urge their readers to view rhetorical skills as indispensable to any gentleman's or lady's education, yet they inevitably maintain at the same time a clear distinction between the domestic rhetorical world of women and the public and political worlds of men in their discussions of where and how Americans could speak influentially. The seemingly contradictory nature of this construction of rhetorical opportunities would only appear so to nineteenth-century readers who were prepared to look past a naturalized construction of rhetorical performance that encouraged women to be better speakers within their own proper sphere and men to be more effective speakers in theirs. The compelling popularity of parlor rhetorics and of other types of self-improvement literature in the decades following the Civil War implies that a relatively conventional view of who should be talking and where strikes a positive chord in readers eager to see the familiar architecture of the home and family refurbished and preserved.[11]

A typical example of a parlor-rhetoric manual that promises on the one hand instruction in valued rhetorical skills and maintains on the other the dominant nineteenth-century cultural assumption that men and women moved in separate rhetorical worlds is Fenno's *The Science and Art of Elocution*. Fenno was one of the most successful parlor rhetoricians who wrote

texts for "the home circle, and for private study." He promotes his texts in terms strikingly similar to the argument that Porter had made decades earlier: that elocution is a useful skill for everyone but of particular use to men in their public and professional lives. Fenno initially assures his readers in the preface that "no person of fair natural abilities, by carefully studying and applying the principles presented in this book, and by giving the examples a reasonable amount of practice, can fail to become a good, effective reader and speaker" (v). However, Fenno goes on in a later chapter, "Helps to the Study," to provide a clear portrait of exactly who he thinks that reader and speaker is likely to be:

> It is impossible to zealously pursue any branch of knowledge without a realization of its importance. No work can be cheerfully performed without an expectation of some good arising from it, either to ourselves or to another. We labor not from a love of exertion, but from a desire to produce results. These results may be in the form of remuneration to us, or a benefaction to mankind in general, or to one or more persons in particular. In any case, we are prompted by an expectation of a reward in some shape, and this anticipation gives us a zest in our work. It is this that gives us a zeal and ambition to excel in whatever we may be engaged. The business man is actuated by the same impulse; the professional man, the statesman, the man of letters, all labor for one common end. (69)

Fenno associates the study of elocution and its rewards with the energy that animates the traditional male domains of business, letters, professional life, and politics and implies by this construction that the "results" that the study of elocution offers would likely be of the most value in those spheres. Although Fenno will say later in this chapter that elocution "calls into action the noblest manhood and womanhood," his contextualization of the "labor" involved in rhetorical study as similar to that which "actuates" the professional and public lives of men complicates the seemingly genderless construction of the "good effective reader and speaker" to which "any" student of elocution can aspire. By implying that the "zeal" needed to study and apply elocution is best found in the businessman or statesman, Fenno takes for granted that it is men and not women who are rhetorical agents in the public and professional spheres even while asserting at the same time that elocution is an art that improves the lives of men and women alike. In the unacknowledged tension of Fenno's position, we see the extent to which a gendered construction of rhetorical space predisposes the cultural mindset that Fenno inhabits as he subtly erases the rhetorical performance of

women from public rhetorical forums in which the affairs of "mankind" are brokered.

The fact that Fenno's *The Science and Art of Elocution* and many parlor rhetorics like it erase women from the public sphere rather than encourage women to aspire to rhetorical roles of leadership in public and political affairs gives us further insight into the highly normative position that rhetorical education continued to occupy after the Civil War. Fenno and other parlor rhetoricians mirror the ideological orientation of prominent, postbellum academic rhetoricians like G. P. Quackenbos, John Franklin Genung, and Adams Sherman Hill, whose treatises defined oratory as the rhetorical art that contributed the most toward the proper workings of the political process, the disposition of justice, and the maintenance of the public welfare and social conscience.[12] These rhetoricians persistently defined the rhetorician as male, and they discussed the ethics and epistemology of rhetoric with the male as the universal prototype. As Quackenbos observes in his treatise, *Advanced Course of Composition and Rhetoric* (1879), spoken language is employed by man alone and language use in general is the sole province of men because men alone possess reason (13). Quackenbos's assumption that ontological links between reason and language use are gendered is clear also in his explanation of argumentative discourse:

> The Writer should select such arguments only as he feels to be solid and convincing. He must not expect to impose on the world by mere arts of language; but placing himself in the situation of a reader should think how he would be affected by the reasoning which he proposes to use for the persuasion of others. (388)

Quackenbos's gendered attention to the relationship between reasoning and persuasion is echoed in Genung's explanation in *The Practical Elements of Rhetoric* (1886) of the role of "personal character" in persuasion:

> In order to persuade men, the speaker must make them tacitly recognize him as one to be trusted. . . . Of such trust and respect the initiative must be taken by the speaker. Not with cringing or flattery, not with any brow-beating air of superiority, but with a manly, self-respecting frankness, he is to approach his audience as men occupying a common ground with himself. (449)

The distinctly gendered construction of rhetorical character Genung outlines is underscored by his representation of male speakers as exemplars, including Henry Ward Beecher, Burke, Henry, Abraham Lincoln, Thomas

Macaulay, and Webster (450–69). Genung's creation of a canon of exclusively male model speakers is even more significant when we note that both his and Quackenbos's influential academic treatises were published in an era when prominent women abolitionists and women's rights advocates such as Lucretia Mott, Anna E. Dickinson, and Elizabeth Cady Stanton had traveled the country widely and had their speeches avidly reviewed in the popular press. Yet, given the ostensible opportunity to include such women as notable exemplars of persuasive public speakers, Quackenbos and Genung do not cite them, a move of canonization that "erases" the contribution of women orators while reaffirming public rhetorical space as a male sphere.[13]

Similarly, Adams Sherman Hill, author of *The Principles of Rhetoric* (first published in 1878) that was the only academic rhetoric text to rival the popularity of Genung's *Practical Elements* in the last two decades of the century, follows disciplinary conventions by citing only male speakers such as Beecher, Burke, Rufus Choate, Henry, Lincoln, and Webster as model examples of persuasive speaking (390–400). Hill further affirms public speaking as the rhetorical province of exemplary men by citing Emerson's maxim that "a man who believes anything with his whole heart is sure to make converts" as well as Emerson's authoritative characterization of John Brown's address at Charlestown and Lincoln's address at Gettysburg as "the two best specimens of eloquence we have had in this country" (qtd. in *Principles* 398–99).[14] The celebration of male speakers as the best American orators in influential academic treatises by Hill, Genung, and Quackenbos echoes the reinforcement provided by Newman, Porter, Agar, and other earlier theorists of the normative nineteenth-century cultural assumption that great eloquence was a masculine virtue and oratory a masculine art. Hill and Genung argue that the key to the art of rhetoric is the adaptation of principles of form and style to whatever situation the reader may require, yet the authors persistently mark out public rhetorical space as a place where only exemplary men give speeches and write essays that change events and persuade others to the truth. In ideological terms, the relationship between gender and rhetorical behavior that texts like Hill's *Principles of Rhetoric* and Genung's *Practical Elements* promote is entirely consistent with the general import of Porter's and Agar's texts that promote elocution as a universally applicable skill yet define the public sphere as a space where only men are likely to apply it. The unacknowledged tension between a democratic interest in extending rhetorical literacy and the highly gendered construction of how rhetorical skills were to be deployed, so evident in Fenno's *Science and Art of Elocution* and antebellum rhetoric texts, is equally obvious here in the

postbellum academic tradition upon which the parlor-rhetoric movement relied theoretically and ideologically.

We cannot underestimate the significance of the fact that within the most prestigious discourses on rhetoric in nineteenth-century American culture, the effective and powerful public speaker was persistently characterized as male. We cannot say that the use of *he* or the references to *men* simply reflect stylistic features of the conventional discourses of the time. The constructive force of the relationship between words and ideology is clear here: deliberately not writing women into public rhetorical space was the same move as writing them out. Before the Civil War and after, the rhetoricians who structured rhetoric courses at prominent and emerging colleges across the country fused the concepts of "the great orator" and the "American man" into such a seamless amalgam that from the beginning of the nineteenth century to its end, the aspirations of women to move into the sphere of influential rhetorical space were characterized as a breach of the natural rhetorical order. The nineteenth-century view of the "great orator" was so essentialized by the postbellum period that the conspicuous careers of female speakers after the Civil War such as Mary A. Livermore, Frances E. Willard, and Susan B. Anthony did little to revise the dominant construction in the public mind that the "great American orators" were exclusively men (see chap. 4).[15]

Consistently equating the moral obligations of the public speaker with the preservation of democratic culture, the academic and parlor discipline of nineteenth-century rhetoric promoted the assumption that training in speaking, elocution, and composition increased intelligence, deepened character, and promoted social status. Nineteenth-century Americans were keenly interested in activities and publications that offered instruction in the rudiments of oratory and elocution for the average citizen, and parlor rhetorics were enthusiastically received in the decades following the Civil War. The opportunity to have "all one needed to know" between the hard covers of large, impressively embossed manuals promising economic and social success to the home learner struck a responsive chord in a postbellum climate nurtured by the contradictory impulses of expansion and social nostalgia. One might think of middle-class Americans of this era as standing on a rise looking toward the western horizon with hope and excitement and looking backward in almost the same moment to be sure that an idealized homeplace could still be located in which a wise and loving mother was on guard. Constructing self-improvement as an individualized form of expansion requiring only the intellectual journey of study and practice, the parlor rhetoric movement capitalized on the nation's desire to put energy

into productive enterprises. Parlor rhetorics and other materials for the home learner provided a means to do so. Advertising their contents as certain means of self-improvement while reinscribing conservative gender roles, parlor rhetorics offered Americans that enviable opportunity to believe that life could get better while staying essentially the same.

Parlor rhetorics included a range of types of elocution manuals that varied in theoretical detail from extensive treatments of principles of elocution and oratory to anthologies that included abbreviated treatments of rhetorical theory and copious collections of selections for practice. Elocution speakers or reciters were a particularly popular type of parlor handbook between 1870 and 1910. Unlike treatise-length manuals such as Henry Mandeville's *The Elements of Reading and Oratory* (1880) and William Russell's *Orthophony: Or the Cultivation of the Voice in Elocution* (first published in 1845), that were successfully marketed to both the academy and the home learner between 1850 and the 1880s, texts in the speaker genre typically included only brief explanations of principles of delivery that Mandeville, Russell, and other parlor elocutionists such as Fenno devoted entire chapters to (e.g., the qualities of the voice such as modulation, force, and pitch).[16] Usually comprising only one introductory chapter or preface devoted to rules of delivery, discussions of rhetorical theory in speakers took up far less space in these hefty texts than did extensive selections for study, practice, and performance. Imitating loosely the belletristic orientation of academic elocution manuals that defined texts according to genre, speakers grouped rhetorical selections under widely recognizable genre categories such as "Patriotic Recitations," "Holiday Readings and Recitations," "Descriptive Readings," "Pathetic Selections," "Humorous Recitations," and "Historical Poems and Orations" (Lumm, *New American Speaker* 17–19).[17] The range of selections in speakers reflects the assumption of authors and publishers that rhetorical performance was a central activity in the home and community. Advertising its contents in 1902 in terms that had changed very little since the beginning of the popularity of speakers in the 1870s, *The American Star Speaker and Model Elocutionist* (1902) presents itself as

> *a manual of vocal and physical culture [and] elocution . . . with appropriate selections for Readings and Recitals, both public and private, embracing the serious, comic, patriotic, heroic, sublime, humorous, descriptive, didactic and ridiculous, Suitable for Home, School, Church, Lodge, Club, Literary Societies, and Public and Private Recitals, with a variety of selections for use at all Holiday and Special Day Celebrations.* (title page)

Although *The American Star Speaker* was published at the turn of the century, its contents are typical of the many popular speakers that were published in the latter decades of the century. Many speakers initially published in the 1880s and 1890s were reprinted in various editions as late as 1910, establishing an influence over how rhetorical performance was defined in the American parlor for almost half a century.[18]

Contextualized theoretically by the nineteenth-century academic discipline of rhetoric that promoted rhetorical training as the mark of the well-educated citizen, and ideologically by the gender bias of the same tradition that steadfastly refused to recognize the possibility (and accomplishments) of women orators, the speaker tradition reinscribed a conservative definition of rhetorical options for women by constructing a clear distinction between a domestic rhetorical sphere for women and a public rhetorical sphere for men. The popularity of the speaker tradition in the latter decades of the century helped to extend the force of that ideological conservatism into the early-twentieth century. By affirming conservative definitions of gender identity while promoting the importance of rhetorical skills for every individual, the speaker tradition represented rhetorical space as a site where gender categories could be restabilized and the icon of the ideal American woman preserved.

Promising "something for every one," texts like George M. Baker's *The Handy Speaker* (1876), *The Speaker's Garland and Literary Bouquet* (1884), Emma Griffith Lumm's *The New American Speaker* (first published in 1898), and Brown's *The American Star Speaker* (1902) slipped onto the sideboards and into the bookcases of the middle-class American home, carrying the message that speaking well would yield a range of rewards.[19] Compilers of rhetoric speakers promoted the notions that training in vocal expression should be sought in all settings, private and public, and that the study and practice of elocution are an obvious benefit to everyone. The editor of the collection *The American Star Speaker* puts it this way:

> The power to charm the heart and steal away the senses; to divert the mind from its own devising and hold an audience in breathless spell as the orator paints the rosy tints of heavenly longings, or leads the imagination down through the labyrinths of wonderland, or depicts with lightning tongue and thunder tones the horrors of the doomed, comes not by nature, but by work, work, work. (20)

The message here seems to be that everyone, in every setting, can and should acquire formal elocutionary skills. On the surface, such advertisements seem to transform an academic view of what constitutes ideal public speech into

practical instructions for private and home use. But if we look at the introductions to these parlor rhetorics more closely, we notice that the orator whose skills are so highly regarded is not the inclusive category it first appears to be. Lumm, editor of *The New American Speaker* (first published in 1887), makes this quite clear when she describes the skill of oratory as a male attribute: "The gift of speaking, of being able to make people listen to what you say, of inspiring men with ideals and convincing them of truths, is the most superb power a man can possess" (28). Although parlor rhetorics were seemingly designed to provide the opportunity for improvement in speaking for the general public, definitions of rhetorical genre and performance in these texts are linked overtly to gender roles. In the vast contents of speakers, selections marked for performance by women can often be differentiated in subject and genre from those intended for performance by men. A range of subtle evidence suggests that rhetorical genres such as orations, serious literary poems, and essays on intellectual and political issues were considered the province of men, and descriptive poetry and poems about marriage, children, or traditional female duties and virtues were considered appropriate for women to perform in the home and on community occasions.

One of the most revealing internal inconsistencies in speakers is the contrast between their claim to a genderless interest in preparing the home learner for public life and the number of textual features that make the opposite and conventional case that men's and women's rhetorical performances should be defined differently. It is quite typical of the compilers of speakers to imply that anyone could hope to be a great speaker through study and practice. For example, Josephine W. Stratton and Jeannette M. Stratton, compilers of *The New Select Speaker* (1902), encourage all of their readers to think of themselves as prospective public speakers:

> A great demand exists for just such a book as this Popular Speaker. We are all interested in oratory, eloquence, public school and all other kinds of entertainment. Every person holding a public position is expected to be a speaker, one who is able to address an audience on popular questions and furnish information in a convincing and pleasing manner, such as will enlighten the people and form the basis of action. To this end it is necessary that young persons should be instructed in elocution and they should be furnished with books for this purpose. The trembling boy or girl who timidly appears before a public assembly may yet become renowned as an orator, which, all will agree, is one of the noblest uses to which intellect and genius can be devoted. (iv)

The framing here of the prospective orator as either boy or girl would seem to imply that the gendering of rhetorical space had been overcome by 1900. However, a close reading of *The New Select Speaker* and other texts like it reveal that the discursive and pictorial force of the speaker tradition tended to keep in place the cultural expectation that ideal orator was male and subtly defined the rhetorical roles of women in domestic terms.

As the reader turns the first pages of *The New Select Speaker,* even before reaching the exuberant title page on which Stratton and Stratton promise "directions for expressing written thought in a correct and pleasing manner," two illustrations appear facing each other. In the first, "Recitation at an Evening Entertainment," a tall, dignified man in evening attire is addressing a salon gathering of attentive men and women who generally seem to be hanging on his every word. Following this illustration, which is a black-and-white drawing, is a photograph collage of four small pictures depicting a woman performing the poem "She Would Be a Mason." The young woman is dressed in a long, loose-fitting gown with neoclassical lines. The juxtaposition of the male orator on the previous page with the woman in what would strike any turn-of-the-century reader as an acting pose, sets up in bold imagery a disparity between the kinds of rhetorical roles parlor rhetorics were willing to support (see figs. 1.1, 1.2). What we must recognize is what any of the Strattons' readers would have understood about "She Would Be a Mason." As an anti–women's rights poem with the explicit subtext that women should keep to their own sphere, "She Would Be a Mason" is intended to be funny and is included by the Strattons under the generic heading "Humorous Recitations." The photograph of the woman reciting the poem with rather melodramatic overtones is intended to illustrate how the poem should be performed. It is certain that the Strattons' readers would get the "joke" of the poem that mocks "the ridiculous Mrs. Byrde" who wanted to be a Mason. Referred to in the body of the poem as "ridiculous," "inquisitive," "nabbing" [nagging], and "teasing," "poor Mrs. Byrde's" efforts to join a traditionally male organization are lampooned mercilessly:

> The funniest story I ever heard,
> The funniest thing that ever occurred,
> Is the story of Mrs. Mehitabel Byrde
> Who wanted to be a Mason.
>
> Her husband, Tom Byrde, is a Mason true,
> As good a Mason as any of you;
> He is tyler of lodge Cerulean Blue,

And tyles and delivers the summons due,
And she wanted to be a Mason too
This ridiculous Mrs. Byrde.

(275)

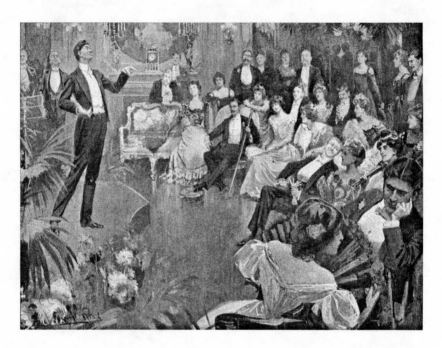

Fig. 1.1. "Recitation at an Evening Entertainment," *The New Select Speaker,* 1900

By positioning the performance photograph of "She Would Be a Mason" following the commanding–male speaker illustration and by representing a photograph of an actual performance of a woman presenting "She Would Be a Mason" as a humorous joke on a woman's temerity, the Strattons undercut their promise to educate one and all for public life. The images of performing bodies collectively make the opposite case: the young men should study the arts of expression and plan to claim the serious attention of their peers, and the young women can expect to put on costumes and embody the "in" joke that women make fools of themselves when they try to move out of their proper spheres. The Strattons would be the last to see how this pair of gendered images compromises their ideological claims to be offering an enabling pedagogy regardless of gender. The contradiction is so obvious that it has to be read as one of those moments when the grip

Fig. 1.2. "She Would Be a Mason," *The New Select Speaker*, 1900

of normative ideology is so strong that it reasserts its presence at the level of subtext no matter what the ostensible surface conversation might be. In all of the 464 pages of *The New Select Speaker*, there is not a single illustration of a woman giving a speech. Instead, women are shown in a series of several photographs presenting dramatic readings of emotionally stirring poems or showing their elocutionary talents in acting out emotions with

gestures and facial expressions. In poses evocative of statues, women are represented acting out emotions such as fear, hope, mirth, and lamentation; the women in these tableaux appear not be using their voices nor to be representing these emotions in the service of any intellectual argument or persuasive, political effort.

The subtext of ideological imagery in *The New Select Speaker* is the rule and not the exception in the speaker tradition. One of the consistent, generic features of these texts is their use of photographs and drawings to represent performance styles and topics. Functioning in much the same way as pictorial representations of women in the periodical literature of the time, the visual images in speaker manuals present women as the embodiment of the ideal woman devoted to maternal feeling and instruction.[20] A set of illustrations appearing side by side in Henry Davenport Northrop's collection *The Ideal Speaker and Entertainer* (1890) provides another vivid and representative example of how this ideological subtext regarding gender constructs a serious rhetorical role for men and a sentimental or frivolous one for women. Two illustrations appear across from one another in the *The Ideal Speaker and Entertainer*. A young boy in a suit poses seriously as if about to begin a speech in a photograph entitled "The Boy Orator." On the opposing page is "The Gypsy Tambourine Girl," a smiling young woman dressed in gypsy-like clothing and holding flowers and a tambourine in her hand (see figs. 1.3, 1.4). The woman is presented as an entertainer in costume, performing a selection as a gypsy; the boy is presented as an intent apprentice of oratory. In a culture in which oratory was viewed as a major form of cultural influence, this pairing of images is highly revealing. Like the ideological argument made by the juxtaposition of the illustration of the elegant male speaker with the photographs of "poor Mrs. Byrde," the visual rhetoric of the pairing of the boy orator and the gypsy woman reinscribes explicitly that men and women operate in different rhetorical spheres. The persistent inclusion of illustrations like "The Gypsy Tambourine Girl" and the critical absence of any female equivalent of likenesses such as "The Boy Orator" in *The Ideal Speaker* and other texts like it reminded the reading public that women needed only to acquire those rhetorical skills that corroborated their roles as wives, mothers, or lighthearted entertainers.

The representation of women in the speaker tradition is further complicated in that illustrations depicted women performing material from only certain genres of readings. By looking closely at the relationship between the titles of illustrations and the selections being performed, it becomes obvious that women are being encouraged to associate themselves with types

Fig. 1.3. "The Boy Orator," *The Ideal Speaker and Entertainer,* 1910

of subject matter such as "exercises with musical accompaniment," "holiday readings," and "the pathetic and homelike." The titles of illustrations, typically first lines of poems, give us some indication of the associations being encoded between gender, genre, and rhetorical space. Even a cursory review of illustration titles from a cross-section of speakers makes the case that in ideological terms, the cultural message promoted by parlor rhetorics is that

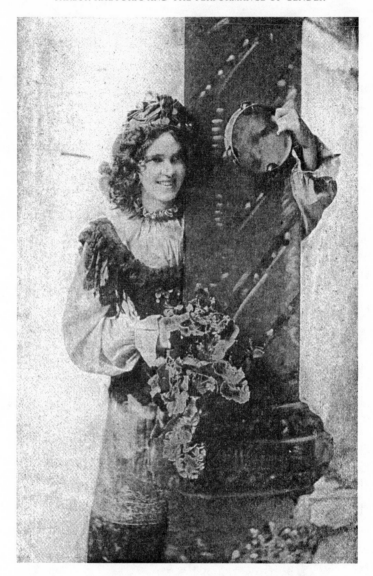

Fig. 1.4. "The Gypsy Tambourine Girl," *The Ideal Speaker and Entertainer,* 1900

women should be associated primarily with the performance of sentimentality. For example, note common titles such as "Breaking hearts without regret, a winsome, sparkling, gay, coquette" of a photograph of a smiling, flirtatious, young woman in street wear, in *The Ideal Speaker and Entertainer* (80); or "I'm Sitting Alone by the Fire Dressed just as I Came from the

Fig. 1.5. "Alike to Those We Love, and Those We Hate," *The Home School Speaker and Elocutionist,* 1898

Dance," a photograph of a sad, young woman holding her head in a pensive pose in *The Complete Speaker and Reciter* (1905) (63). A particularly striking example of a woman performing gender appropriately is "Alike to Those We Love, and Those We Hate," a photograph of a young woman in a gracious pose seemingly just having read a letter from Lumm's *The Home School Speaker and Elocutionist* (see fig. 1.5). The title to this photograph also contains in parenthesis "See Poem, 'Good-bye.'" Included under the generic heading "Pathetic Selections," the poem "Good-bye" is a sentimental

poem focusing on an idealized emotional response to a loved one's final departure. The selection of the line "Alike to those we love, and those we hate," as a heading for the performance photograph stresses what a post-bellum readership would interpret as an ideal-woman's emotional generosity in the face of personal grief:

> We say it for an hour or for years,
> We say it smiling, say it choked with tears . . .
> We have no dearer word for our heart's friend,
> For him who journeys to the world's far end,
> And sears our soul with going; this we say,
> As unto him who steps but o'er the way,—
> "Good-bye."
>
> Alike to those we love, and those we hate,
> We say no more at parting at life's gate,
> To him who passes out beyond earth's sight,—
> We cry, as to the wanderer for the night,—"Good-bye."

(193)

In the photograph, the softly dressed and carefully turned out young woman enacting the stricken feelings of a woman receiving bad news looks sad but composed. Such an image confirms the idealization of the nineteenth-century woman as a being of deep feeling but also someone who characteristically is strong and wise in the face of life's emotional trials. Although this illustration stresses the "best" of the nineteenth-century woman, the space in which these virtues are enacted is clearly the home and the occasion being depicted, receiving news of the death of a lover, brother, husband, father, or friend, falls into the sphere of domestic life. Although admirable and serious, unlike "poor Mrs. Byrde" or the gypsy tambourine girl, this idealized image similarly shows a young woman performing gender appropriately using rhetorical skills.

The ideological association in the speaker tradition between gender and rhetorical genre exemplified by performance photographs of gay coquettes and sensitive young women caught up in emotional moments is reinforced by the fact that illustrations of women are not typically linked to the performance of selections from other frequently anthologized genre headings such as "patriotic recitations," "selections from the heroic and warlike," "historical poems and orations," or "the religious and sublime." These more intellectually significant genres are directly linked to men through illustrations featuring them in formal evening attire or occasionally in costume. Across the

pictorial record of the speaker tradition, men are presented in costume far less frequently than women. In those rare instances in which men are depicted in costume, they are shown as famous Shakespearean characters such as Lear or Mark Anthony or are photographed in biblical garb acting out scenes from poems with religious or philosophical themes.

That men are depicted far less often as parlor entertainers in costume and that the visual representation of male rhetoricians in the speaker tradition includes as a matter of course drawings or photographs of men giving speeches or depicting heroic male deeds points to yet another formal textual feature of speakers that reinforces a conservative agenda about what men and women should be speaking about and where they should be doing it. The manner in which speakers treat the performance categories "the pathetic and homelike" and "tableaux" also makes this distinction between rhetorical roles and rhetorical spaces.

The "pathetic and homelike" category explicitly focuses on domestic and maternal themes and is one of the genre's most obviously marked female in speaker collections. The assumption lying behind the inclusion of such a category is that the performance by women of selections dealing with the themes of filial devotion, motherhood, and the care of children will universally touch the heart. In the performance of such themes, women would be presenting themselves at the apex of their social significance. However, when we review typical titles from this category, we find that the sentimentalization of the roles of women and mothers only calls attention to the ways in which women's rhetorical influence is defined in the nineteenth-century context by constructions of the feminine sphere. Consider the relentlessness of domestic and maternal themes in these selections from the "pathetic" category: "Rock Me to Sleep Mother," "The Preacher's Mother," "Only the Baby Cried for Lorraine," "Just Two Wee Shoes," "A Child's Dream of a Star," "How Tim's Prayer Was Answered," "The Gambler's Wife," and "Saving Mother."[21] Performances of this kind of material by women would be expected to engage the feelings of audiences; in rhetorical terms, that effect would be considered the appropriate response to a woman speaking on the subjects she knew best. In contrast, men could plan to change minds and affect moral responses through their persuasive rendering of selections with powerful patriotic or religious themes such as "Liberty and Union, One and Inseparable," "Patriotism Assures Public Faith," and "The Crucifixion" (Hoyle, *World's Speaker* 22).

In addition to depicting women speaking lovingly on the significance of children and spouses, women are encouraged to act out feminine themes in tableaux performances. One of the most pictorially gendered of the rhe-

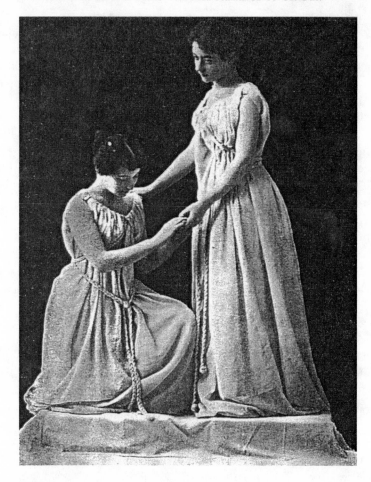

Fig. 1.6. "Forgiveness," *The American Orator,* 1900

torical genres anthologized in speaker manuals, tableau (also defined as
statuary) consists of acting out famous scenes from history or events from
widely known dramas or poems, re-creations of paintings, idealized emo-
tions, and lessons of life. Subjects for tableaux vary in type, ranging from
the enactment by male performers of famous historical events, such as
Lee's surrender to Grant at Appomattox and the major battles of the Revo-
lutionary War, to the portrayal by women of typical domestic scenes such
as the preparation for a party or the care of children as well as the enact-
ment of idealized emotions associated with the female sensibility. Speakers
encouraged women to identify with tableau selections covering topics such
as hope and mirth as illustrated in the *The New Select Speaker* (92) or for-

giveness as illustrated in "Forgiveness," a performance photograph from *The American Orator* (1900) (see fig. 1.6). In this tableau, the two women strike an idealized pose of one woman obviously dispensing forgiveness to the other. The tone of this illustration is one of gentle kindliness, a quality nineteenth-century readers would associate with the maternal qualities of the ideal woman.

In many tableau selections depicted in photographs such as this one, women are shown essentially saying nothing but embodying feminine virtues of various kinds. Both men and women are shown enacting tableaux of domestic scenes under titles such as "Courtship Under Difficulties" (described as "For Two Males and One Female"), "A Family Jar" (a selection depicted in a photograph showing a mother-in-law and a young couple with the title "Too much mother-in-law"), and "My Feelings are Hurt Beyond Measure," in which a man seems to be attempting to console a woman who is distressed (Hoyle, *Complete Speaker* 351, 428). Making the point that the gendering of this type of rhetorical performance is conventional in all respects, men are shown in these domestic tableaux acting out their roles as suitors and husbands. In other pictorial representations, men are shown performing historical, literary, or biblical male characters (e.g., "Washington Irving and His Literary Friends"; "Mercutio, The Friend of Romeo") or decisive men of action. For example, in a tableau photograph entitled "Let It Be Patriotism First—Then Love," an older man in a Union officer's uniform is seen urging a younger man dressed as a Union soldier to put love of country and duty ahead of his love for the lady, who stands with her arms beckoning to the young man (see fig. 1.7). The placement in this tableau of the Union officer center stage with the two young people on either side of him centralizes his moral authority in this scene and adds greater emphasis to his gestural argument that the woman's importance is not equal to that of the noble male task at hand (*Home School Speaker and Elocutionist* 155).

What we can observe in these performance photographs of tableaux is yet another instance of how the speaker tradition allocated rhetorical categories along the lines of gender. Women were encouraged to involve themselves in acquiring rhetorical skills for the kinds of performances that ranked the lowest on a scale of rhetorics of power. Instead of being given rhetorical instruction that would enhance their access to rhetorical power in any real sense, women are encouraged by the speaker tradition to affirm their roles as guardians of domestic morality by perfecting the rhetorical skills of enacting tender, humorous, or domestic sentiments. Although parlor rhetorics often advertised their offerings as "golden cargo" and represented

Fig. 1.7. "Let It Be Patriotism First—Then Love," *The Home School Speaker and Elocutionist,* 1898

the study and practice of speaking and reading aloud as a precious opportunity to better oneself, the invitation offered to women, far more often than not, was an invitation to remain in their place.

> "Reading aloud with propriety and grace is an accomplishment worthy of acquisition," says Mrs. Sigourney. ". . . It is peculiarly valuable to our sex, because it so often gives them an opportunity of imparting pleasure and improvement to an assembled family during the winter evening or the protracted storm."[22] (*International Speaker* 35)

Although parlor rhetorics such as speaker manuals performed the service of extending the range of formal rhetorical education by transforming academic training into popular pedagogy, there is a troubling move here exemplified by the association between female rhetorical performance and the roles of "pleasing" and "improving" the family. By characterizing rhetoric as a necessary form of literacy and simultaneously making certain genres gender specific, the compilers of popular speakers left most women still stranded in the parlor, earnestly, even movingly, reciting poems and striking poses while ever greater numbers of men received the training to have the conversations and arguments that shaped intellectual, political, and cultural life.

What the example of the gendering of rhetorical space by parlor speakers makes discomfortingly clear is that informal rhetorical pedagogies had

institutional status in late-nineteenth-century America. The power of that institutional status was wielded in the service of a highly conservative agenda of gender behavior—not in the service of expanding public rhetorical opportunities for women as well as men. The very traditional rhetorical spaces defined for women by texts like *The International Speaker and Popular Elocutionist* and *The New Century Speaker* indicate that although the boundaries of what could be called a woman's sphere stretch a little in the decades after the Civil War, the debate about what rhetorical roles a woman could perform was far from over. In particular, the rhetorical construction of the white, middle-class woman continued to be an ambiguous one as the century ended. To look directly at the role that rhetorical pedagogies played in the construction of gender identities and to weigh at the same time the complicated ways that rhetoric dispenses power and restricts it is to read the history of nineteenth-century rhetoric as a multilayered text. This text does tell the story of notable women who gained rhetorical voices, but it also tells the story of ridiculous Mrs. Byrde and the gypsy tambourine girl who smile from the page, innocent of how their performances construct their irrelevance.

2

REIGNING IN THE COURT OF SILENCE: WOMEN AND RHETORICAL SPACE

> Nervous, enthusiastic, and talkative women are the foam and sparkle, quiet women the wine of life. The senses ache and grow weary of the perpetual glare and brilliancy of the former, but turn with a sense of security and repose to the mild, mellow glow irradiating the sphere of the latter. We associate all ideas of rest with quiet women. They are soul-divinities reverently guarding their sacred trusts in the Court of Silence. When she speaks, her words are aptly chosen and fitly spoken. She is wise and thoughtful, but loving and meek. "Still waters run deep," but not in the world-applied sense; babbling rills do not wear their channels deep, but streams of calmest flow have hidden depths undreamed of, unsuspected.
> —"Quiet Women," *Ladies Repository*

In an article entitled "Quiet Women" appearing in *Ladies Repository* in 1868, an anonymous author argues that "quiet women [are] the wine of life." Capturing the deep cultural longing of the postbellum period for the icon of the American woman as angel of the hearth, this portrait deifies the quiet woman and constructs other possibilities negatively: the enthusiastic woman, the talkative woman, the brilliant woman, and the babbling woman. The mild and mellow queen of the court of silence is graceful and calm, and most important of all, she is quiet. In this characterization, an idealized woman is defined as necessarily rhetorically meek. By worshipping the quiet woman, influential proponents of public opinion such as the *Ladies Repository* reinscribed for a postbellum readership a definition of true womanhood that equated silence with feminine virtue and enthusiastic vocality in women as true womanhood's opposite. The argument that the rhetorical conduct of the "wise and thoughtful" woman could be contrasted instructively with the trivial and ultimately inconsequential rhetorical behavior of loud and

talkative women is one made in so many cultural conversations of the postbellum period it achieved the power of an ideological trope.[1]

Efforts to regulate women's rhetorical behavior intensified rather than abated in the decades following the Civil War as women pursued education, the vote, property rights, and mobility in public life. In conduct literature, a genre that proliferated in the postbellum period and was comprised of etiquette guides as well as general advice manuals, the preferred construction of the quiet woman is a mainstay in an ideological agenda that supports the generally held nineteenth-century view that character and the nature of one's rhetoric were mutually revealing.[2] Like other types of self-help materials marketed in the last decades of the century such as speakers, elocution manuals, and letter-writing guides, conduct manuals included among their vast tables of contents the matters of how and where one ought to speak.[3] In their coverage of deportment in all areas of life, conduct manuals promised the aspiring, middle-class American an education in the home in the culturally valuable skills of public speaking and writing. The collective enterprise of the parlor rhetoric movement and of conduct literature in particular was to offer happiness and success to women and men alike who would follow certain rules. Enormously popular in the postbellum period and well past the turn of the century, conduct literature argued a conservative gender agenda that appealed to the middle-class readers who seemed eager to accept the idea that correct deportment in daily life could help to restore the social calm the postwar nation longed for. Although by the 1880s the American public had well in mind notable examples of women, such as Susan B. Anthony, Mary A. Livermore, Elizabeth Cady Stanton, and Frances E. Willard, who had assumed powerful reformist voices in the causes of abolition, temperance, and women's rights, the rhetorical space these women occupied in the shaping of political and cultural life was viewed as the exception rather than the rule (see chap. 5).[4] In spite of the high-profile rhetorical careers of a handful of women, or perhaps because of them, postbellum America wondered uneasily just how public women's lives were becoming and with what results. In this historical moment of uneasiness, the icon of the quiet woman, the wine of life, seemed to erase the complexity of the woman question and return the American woman to the home where she belonged.

Conduct literature participated in the rhetorical repatriation of the woman back to the parlor by overtly discouraging women from having strong voices, literally and culturally, and by reminding American readers that if happiness was to be secured, women should keep to their former place in the home and do it quietly. Postbellum readers seeking trustworthy ad-

vice to leading a happy life found inscribed in the text and illustrations of manuals promising to serve as guides to fulfillment the persistent message that women's claims to rhetorics of power compromised their virtue and the moral health of the nation. By locating the negotiation of cultural power so squarely on rhetorical grounds, the genre of postbellum conduct literature provides a revealing example of the historic tendency of rhetorical pedagogy to gain its influence by reinscribing rather than rewriting normative cultural ideologies.

In her analysis of how success manuals constructed the identity of the idealized American man in *Character Is Capital: Success Manuals and Manhood in Gilded Age America* (1997), Judy Hilkey has made the case that advice manuals for men published widely between 1870 and 1910 taught American men how to pursue success and reinforced the importance of the essentially masculine sphere of industrialization. Although she concentrates on how conduct for men is defined and reinforced by maxims and pictorial evidence, Hilkey also corroborates that the implications of the gendering we see in conduct manuals of this period are ideologically far reaching:

> The genderized concept of success built upon, reinforced, and elaborated existing stereotypes about sex roles and gender relationships. The conceptual power of the equation of success and manhood was based on the opposition inherent in the two terms: success versus failure and manliness versus womanliness. To put it another way, the power of the linkage of success with manhood was underwritten by the power of the overt linkage of failure with womanhood. Insofar as the equation of success and manhood became normative, it became difficult to imagine a successful woman who was not "manly" or to believe that a woman could be "a success" in the world of work and politics outside the home. (9)

Hilkey makes the astute point that the highly gendered focus in advice manuals on masculinity and success as equivalent terms meant that the ideological argument was being made synonymously that women could not achieve success in public life because they could not embody masculinity except in the perverse sense. As Hilkey implies, public space was so deeply inscribed as masculine that women who ventured into it were perceived as having forfeited their femininity. Although an exploration of this consequence is not her project, Hilkey's insight to the barriers being inscribed for women in discourses that taught men how to overcome obstacles is helpful as it makes quite clear that conduct literature can be read as a generic site where the overt and subtextual complexities of gender and power

were negotiated. When we read conduct literature as an ideologically laden genre as Hilkey suggests we do, even more layers to the gendering impact of these texts can be identified when we recognize that one of the most persistent categories that conduct manuals address is rhetorical behavior. In these discourses, American women are instructed over and over again that their only and best power lies in their quiet occupation of the home. Specific advice regarding how women are to speak and converse, offered under typical headings like "Marriage," "The Wife," and "The Mother" in conduct manuals published in the last decades of the century, reinforces the conservative, postbellum desire to keep the American woman at home, a queen in her court of silence.[5]

In her article "What is Worth While" in *Three Minute Readings for College Girls,* a representative late-nineteenth-century advice manual (1895), Mrs. Samuel Lindsay confirms what had become a conventionalized contrast between the good, quiet woman and the untrustworthy, vocal one in her discussion of female conduct. Noting that it was potentially harmful to the development of feminine virtues such as tenderness and a loving nature for women to receive too much education, Lindsay points to a woman asserting her rhetorical voice in public as the unfortunate consequence of a woman losing sight of her true nature:

> Little by little that intellectual ambition will draw us away, if we are not careful, from our true place in life, and will make cold, unloved, and unhelpful women of us, instead of the joyous, affectionate and unselfish women we might have been. If the instinct of a daughter, sister, wife, or mother dies out of a college-bred woman, even in the course of a most brilliant career otherwise, the world will forget to love her; it will scorn her, and justly. . . . and if she herself is not cheery and loving, dainty in dress, gentle in manner and beautiful in soul as every true woman ought to be, the world will feel that one thing needful is lacking,—vivid, tender womanliness, for which no knowledge of asymptotes or linguistics can ever compensate. It is better for a woman to fill a simple human part lovingly, better for her to be sympathetic in trouble and to whisper a comforting message into but one grieving ear, than that she should make a path to Egypt and lecture to thousands on ancient Thebes. (241)

The intensity of Lindsay's suspicion of education for women is rivaled only by her condemnation of a woman lecturing to the public in a far-off land, clearly a metaphor for Lindsay's view of just how threatening the distance is between the home and the public sphere. In her account, the more pub-

licly influential a woman's rhetorical behavior becomes, the more true womanhood is compromised. She constructs the woman lecturer, however knowledgeable, as the worst result of a woman mismanaging her rhetorical place in the scheme of things. Lindsay's late-nineteenth-century readers would hardly miss the tone of this piece of "there but for the grace of God go you," a tone that indicates just how strongly nineteenth-century conduct literature advocated an ideological conflation among gender, virtue, and rhetorical behavior. The link Lindsay makes between appropriate rhetorical behavior and feminine virtue also indicates that rhetorical performance was publicly acknowledged as a powerful variant of cultural capital in the 1890s and that the cultural debate about who was entitled to it was fraught with tension. By constructing rhetorical performance as a conduct issue and by bringing speaking under the watchful eye of advisers, conduct books participated in a widespread cultural project to police the borders between domestic space and public space and to keep the average woman in her home and off the podium.

The cultural debate about gender roles in late-nineteenth-century America raged with force between the covers of a variety of advice books promising reliable guidance on topics such as where to live, how to secure an education, whom to marry, where to work, how to write a letter, how to memorize, how to entertain at home, what to read, how to be agreeable, how to raise children, and the art of conversation. Carrying their message of rhetorical regulation and its importance in achieving happiness, popular manuals like James Henry Potts's *The Golden Way to the Highest Attainments: A Complete Encyclopedia of Life* (1889) and B. R. Cowen's *Our Beacon Light, Devoted to Employment, Education, and Society* (1889) encouraged women to see themselves as powerful persuaders but only in their own homes:

> It is as a mother that woman's most signal triumphs are achieved. The home is her kingdom, the domain of her greatest and most lasting influence. Within the boundary of that kingdom there are not to dispute her sway. . . . In that holy kingdom, ruled by the wise and loving influence of the mother, those impressions are made that are to rule and govern society. The laws of the home are the miniature of those laws and influences which rule the State. There are dropped the tiny seeds, which falling upon the good soil of receptive minds in after life, "in the world's broad field of battle" will grow into a great tree, and be known as public opinion. (Cowen 341)

In this passage, conduct author Cowen offers women the persuasive force of secondary influence as their only source of rhetorical power: through their

influence on their children's minds and subsequent actions, women's ideas could influence public opinion.[6] The effort being made by Cowen to curtail women's direct rhetorical power on public opinion could not be more clear. Offering women indirect rhetorical expertise and praise for using it, conduct manuals told women again and again that their voices were powerful ones only in the home. Women were urged to think of themselves as "the angel spirit of the home" and to see their role in shaping human affairs as important but negotiated in rhetorical terms only in private.

In *The Imperial Highway: Essays on Business and Home Life with Biographies of Self-Made Men* (1888), author Jerome Paine Bates makes the case that women's rhetorical skills in the home are crucial to the family and indispensable to the nation's well being. Favoring the "queen and her kingdom" trope, Bates defines a woman's rhetorical role in the home as indispensable:

> In a true home, woman is the God-ordained queen. Nature placed her on that throne, and she practically rules or ruins her kingdom and its subjects. Accordingly, home takes its hue and happiness principally from her. If she is in the best sense, womanly,—if she is true and tender loving and heroic, patient and self-devoted,—she consciously or unconsciously organizes and puts in operation a set of influences that do more to mold the destiny of the nation than any man, uncrowned by the power of eloquence, can possibly effect. There can be no substitute for this. There is no other possible way in which the women of the nation can organize their influence and power, that will tell so beneficially upon society and the State. Neither woman nor the nation can afford to have home demoralized, or in any way deteriorated by the loss of her presence, or the lessening of her influence there. As a nation we rise and fall as the character of our homes, presided over by woman, rises and falls. (493–94)

Bates's voice is but one in a large chorus of postbellum advisers making the point that the spheres of rhetorical power for men and women are separate ones. Bates's text, *The Imperial Highway*, was an extremely popular manual that went through several editions and was still in print in the early 1900s. *The Imperial Highway* can be read not only as representative in its ideological agenda but also as widely influential (Hilkey 21).[7] When Bates urges the American woman to see herself as powerful an orator in the home as a man might be outside the home, he draws the lines of rhetorical power sharply between the parlor and public space and constrains his wide readership to draw the conclusion that a "true" woman would never consciously

seek rhetorical power outside her kingdom. Upholding with one hand the persuasive impact of the woman who knows her place and how to exert moral force within it, Bates reinscribes with the other the image of the eloquent public speaker as male by natural design. Bates's argument and others like it play upon the public's high regard for oratory in general by assigning to the American wife and mother as significant a rhetorical role in the home as the man can be expected to have in the world of public affairs. Arguments like these could only have been successful in a cultural context that perceived the eloquent orator as key player in how the political and moral fabrics of the nation were created and sustained and would only be necessary in a historical period when women were putting more and more pressure on the gates barring them from the public arena.

Underlining Lindsay's maxim that it is better for the woman to influence even the life of one child than to speak to thousands, Bates adds what by the 1880s is a familiar admonition that women forfeit the great rhetorical power they possess when they leave their natural domain for public life: "When women for any reason, leave the home as their post of honor and duty, they do thereby immediately lessen the quantity and weaken the quality of their power, in exact proportion to the extent of their wanderings" (498–99). The image Bates draws of the mother and wife as naturally rhetorically forceful only in her proper sphere is a common one in postbellum conduct literature and reinforces a long-standing, nineteenth-century assumption that women had no need for formal training in the rhetorical arts. By arguing that the domestic eloquence of women was a natural consequence of femininity, conduct authors joined the ranks of the nineteenth-century academic discipline of rhetoric that routinely denied women training in oratory and argumentation on the grounds that women had no need for these arts in the home. What conduct authors add to the strength of this cultural bias against rhetorical education for women is the vivid depiction of just how powerful an orator the good wife and mother can be. As Hugh Blair observes in an 1839 article on "Woman" in an issue of *Ladies Companion,* "Nothing delights men more than [women's] strength of understanding, when true gentleness of manner is its associate, united, they become fraught with the sweetness of instruction, making the woman the highest ornament of human nature" (62).[8] By similarly glorifying the female sensibility as a potent moral force fifty years later in the century, conduct authors made the then-appealing case that when domestic eloquence is properly deployed in the home, women can affect events that lie outside it. Instead of offering women no rhetorical role at all, conduct authors offer the seductive construction that women are just as responsible

for shaping the affairs of the nation with quiet eloquence as their husbands and sons would be with public oratory.

In *The Golden Way*, the Reverend Potts constructs a revealing distinction between the rhetorical roles of men and women and the kind of rhetorical space each should occupy when he remarks, "Men, trained in the schools, have been eloquent and great, but woman, in her artless earnestness, has been more eloquent and greater still" (231). Offering this observation in his chapter "Woman," Potts recounts an anecdote to prove his point that women are naturally persuasive when in the grip of their devotion as wives and mothers:

> Oliver Cromwell was one day engaged in a warm argument with a lady upon the subject of oratory, in which she maintained that eloquence could only be acquired by those who made it their study in early youth, and their practice afterward. The Lord Protector, on the contrary, maintained that there was no eloquence but that which sprung from the heart; since, when that was deeply interested . . . it never failed to supply a fluency and richness of expression, which would in the comparison render vapid the studied speeches of the most celebrated orators. This argument ended, as most arguments do, in the lady's tenaciously adhering to her side of the question, and in the Protector's saying he had no doubt that he should one day make her a convert to his opinion.
>
> Some days after, the lady was thrown into a state bordering on distraction, by the unexpected arrest and imprisonment of her husband, who was conducted to the Towers as a traitor to the government.
>
> The agonized wife flew to the Lord Protector, rushed through his guards, threw herself at his feet, and with the most pathetic eloquence, pleaded for the life and innocence of her husband.
>
> Cromwell maintained a severe brow, till the petitioner, overpowered by the excess of her feelings, and the energy with which she had expressed them, paused. His stern countenance then relaxed into a smile and extending to her an immediate liberation of her husband, he said, "I think all who have witnessed this scene, will vote on my side of the question, in the dispute between us the other day, that the eloquence of the heart alone has power to save." (231–32)

Potts's story of Cromwell and the lady can be read as a gendered parable about power and rhetoric in which we can see that rather than being given any rhetorical power, the lady is being put in her rightful and predictable

55

place of rhetorical subservience. The lady does not have the power that controls life and death but rather she is manipulated by terrifying circumstances into performing her gender in appropriate rhetorical terms. When read closely, it is clear that the story of Cromwell and the lady is not a narrative about rhetorical roles but about gender roles. The overtly convenient plot of the argument between Cromwell and the woman followed by arrest of the husband begs the question about whether or not the Lord Protector arrests the woman's husband so that Cromwell might prove his point to a woman who has foolishly clung to her own convictions. In this tale, the woman's pleading and the Lord Protector's response of clemency for the husband are a drama about the complete powerlessness of women in the political arena. It does not matter finally whether the woman is naturally eloquent or not. It is clear here that it is not eloquence that changes events but power. The key to the resolution of the issue is not, as Potts would have us believe, the woman pleading from the heart on her knees, but the absolute power of the Lord Protector who exchanges the husband's life for the lady's complete public humiliation. Cromwell's emphasis in his final remark to the lady is not on how well her rhetorical performance proves the point that heartfelt eloquence is the most effective, but on the fact that all must agree witnessing the event, including the woman herself, that his was the right opinion. Potts unwittingly describes a high-stakes game of rhetorical poker in which the Lord Protector has all the right cards and is determined to win. The woman does not have "the power to save," the Lord Protector does. The lady, who we might notice never has a name and thus acquires a kind of everywoman status, has only the power to earnestly plead at a great man's feet.

Potts intends this anecdote as a positive example of how women can exert significant oratorical force if they speak with the power of aroused wives and mothers, and he seems innocent to the deeply reinscribed gender inequities and traditional consolidation of power in male hands that his tale embodies. However, the narrative itself and Potts's polemical intention to use it to prove his point that feminine eloquence of the heart matters tell us just how deeply entrenched conservative gender roles are in the cultural context of the postbellum period. Potts can assume that his readers will view the tale as an example of how a loving wife can save the day. Potts's readers would be unlikely to see the irony we do in the situation in which the woman who dares to disagree in a debate with a powerful man at the start of the narrative ends up begging for his mercy at the end. Postbellum readers turning the pages of *The Golden Way* are much more likely to read the story of an emotionally overwrought woman pleading at the feet of a powerful

man as a perfectly natural accounting of the rhetorical worlds of men and women as distinctly different ones.

In *The Golden Way,* Potts constructs an image of the woman as a quiet variant of a culturally important rhetorician; the woman influences public affairs indirectly but decisively if she maintains her place in the home and exerts her natural rhetorical force as a wife and mother. This portrait amplifies the image of the quiet woman created by Lindsay, Bates, and a host of other authors who encourage women to identify with domestic rhetorics rather than public rhetorics and to see their ontological worth confirmed in feminine, emotional appeals rather than logical argumentation. It is useful to note that the ideological arguments made about gender roles in conduct manuals are often reinforced by pictorial representations of the true woman that leave little doubt about where she is intended to use her voice or about how the ideal woman is to define herself. Immediately after relating the story of Cromwell and the woman, Potts includes an illustration entitled "O Fairest of the Rural Maids," which depicts a lovely and demure young woman enjoying the praise of an attentive young man overtly admiring her from across the garden fence (see fig. 2.1). Following a discussion in which Potts compares American women to notable women like Queen Victoria and the British warrior-queen Boadicea, the incorporation of this illustration disarms the tension between Boadicea, woman of action, and Victoria, the queen who was also wife and mother, by reinstating the moderate image of the passive and lovely ideal woman holding court in her own back yard, and most importantly, saying absolutely nothing. Women may be valiant in the protection of their homes and may be raised to the honored place of queen mother, but in the end, it is the fair maid staying close to the homeplace who steers the best course.

Pictorial confirmations of a woman's virtuous influence in her domestic kingdom are standard fare in conduct literature and lend visual texture to the conservative rhetorical construction of women through illustrations depicting the American woman as a quiet queen of the parlor. A particularly polemical drawing in *Our Beacon Light* illustrates Cowen's definition of a woman's domestic rhetoric as direct moral influence. Directly across the page from a discussion of woman's rhetorical influence in the home in a chapter on "Women's Work," Cowen foregrounds a collage drawing featuring a large central circle in which a woman is sitting sewing by an open hearth. Positioned around her in smaller circles are five scenes depicting women at work: a woman holding a child, gardening, instructing a young child in household chores, delivering a food basket, and reading to a child. The entire collage fills the page and is titled "Earth's noblest thing, a wom-

Fig. 2.1. "O Fairest of the Rural Maids," *The Golden Way,* 1889

an perfected" (342) (see fig. 2.2). Although Cowen closes the chapter "Women's Work" with the observation, "Woman . . . finds almost every field of industry and enterprise and study open to her," the ideological force of the entire chapter with its textual reminder that women never exert direct force on public affairs and its visual confirmation of the limits of the woman's sphere makes a conservative argument Cowen's readers would find familiar: any seeds of influence women plant had best be sown close to home.[9]

Fig. 2.2. "Earth's Noblest Thing, a Woman Perfected," *Our Beacon Light,* 1889

In rhetorical terms, there is very little middle ground in conduct litera-
ture between the quiet queen of the court of silence and the lamentable (or
worse) status of the female public speaker. Seemingly, a woman could be
one or the other but never both. Even the most progressive conduct manu-
als, those that recognize that women had already achieved prominence at
the podium, reveal the cultural anxiety that women's public roles will com-
promise the American home. Nowhere in this vastly successful genre of self-
help literature is the American woman encouraged without qualification

to aspire to the ranks of those celebrated for their public rhetoric. Instead, any cautious celebration of women's widening role in public life is typically accompanied by an explicit warning that the public woman should not neglect her true calling.

Expressing views in *The Golden Way* similar to many of his contemporaries, Potts is once again an able spokesman of his times as he unwittingly articulates the paradox of praise and suspicion evidenced in many conduct and etiquette manuals regarding women speaking in public:

> The time has come when women, as well as men, have a practical interest in business and professional life. They have monopolized the work of teaching, and are doing so with clerking, besides establishing various kinds of business houses, and entering the learned professions. It is pleasing to observe how well women succeed in all these new undertakings. In authorship and journalism they are showing marked adaptation, and wielding much influence, and on the platform are demonstrating their eminent capabilities. Thoughtful observers regard as conclusively settled that woman is competent to speak in public. The interest with which the masses hang upon her lips, and the persuasive power she wields, are not novel and transient impressions. Woman has a God-given mission to execute as a public speaker. In Christian America every interest of society must undergo thorough discussion, on the platform in the pulpit and through the press, and in the defense of the right, providence is summoning our mothers, wives, and daughters. (159)

We can read Potts's enthusiasm for the widening rhetorical role of women in public life as a spirited defense of an issue still contested. His argument that women's right to speak is God-given and that the issue is now settled as to whether women should be orators tells us a great deal about how provocative the issue of women's entrance into arenas of rhetorical power had been and continued to be. If the issue was not still a matter of intense debate in 1889 when *The Golden Way* was published, Potts would not need to make such a point of defending women's rhetorical rights. Were his commentary to end with his sermonic pronouncement that the right of woman to speak was God-given, we might interpret his remarks as an indication that the cultural taboo against women in public life had at long last begun to fade in some degree. However, as he ends his celebratory exposition of women's advances, Potts reveals mixed feelings about women's public role by offering a cautionary tale that echoes Bates's warning that the American home is demoralized without a woman's presence. Having praised the ac-

complishments of public women, Potts then defends the sanctity of the woman's role in the home by creating a noble picture of the woman of the house for a "gentle reader" who might prefer to aspire to the hearth rather than public life:

> But our homes must be maintained, and some for pure love's sake must labor there. Possibly you, gentle reader, may be of the number. If so, somebody has written for you these beautiful lines:

> Sometimes I am tempted to murmur
> That life is flitting away,
> With only a round of trifles
> Filling each busy day;
> Dusting nooks and corners,
> Making the house look fair,
> And patiently taking on me
> The burden of woman's care.

> Comforting childish sorrows,
> And charming the childish heart
> With the simple song and story
> Told with a mother's art
> Setting the dear home table
> And clearing the meal away,
> And going on little errands
> In the twilight of the day.

> One day is just like another!
> Sewing and piecing well
> Little jackets and trousers
> So neatly that none can tell
> Where are the seams and joinings—
> Ah! the seamy side of life
> Is kept out of sight by magic
> Of many a mother and wife!

> And oft when I am ready to murmur
> That life is flitting away,
> With the self-same round of duties
> Filling each busy day,
> It comes to my spirit sweetly,

With the grace of a thought divine:
You are living, toiling for love's sake,
 And the loving should never repine.

You are guiding the little footsteps
 In the way they ought to walk
You are dropping a word for Jesus
 in the midst of your household talk;
Living your life for love's sake
 Till the homely cares grow sweet—
And sacred the self-denial
 That is laid at the Master's feet.

<div align="right">(160–61)</div>

Potts's effort to confirm the noble calling of the traditional wife and mother who in her daily, loving labor smoothes away the "seamy side of life" and guides children in the right direction, leaves his "gentle reader" with the image of the sacrificing woman who goes about her irreplaceable duties quietly and without fanfare. The appearance of this poem at the end of the chapter "Women Are Interested in Business Life" complicates Potts's celebration of women's entrance into public life and betrays a widely held anxiety that although women might be speaking for just causes, their presence in public life must surely have meant that home fires across the nation were going out. The tension in Potts' rhetorical construction of the American woman as either inspiring public lecturer and professional woman or a quiet, loving mother who tells stories, sings songs, and mends up the tears of the world, reinscribes the fact that for women to step outside traditional feminine space was still considered risky business. As if to put the final, ideological touches on his mixed message, Potts follows the poem "You Are Guiding the Little Footsteps" with "The Days of Youth Advance," a brightly colored drawing (here shown in black and white) of a courting couple (see fig. 2.3) and a lengthy treatment of home life including chapters on love, choice of a companion, the wedding, the marriage state, married life, hints to husbands, hints to wives, children, and the home.

Potts's mixed feelings about whether or not the American woman should aspire to public life captures the moody attitude of the nation regarding the place of women. Potts recognizes as do many late-nineteenth-century commentators that the tide has turned in a very material way and that women's advances must be recognized. Even as he struggles to value women's contribution to the public sector, Potts betrays his fear that if women seek rhetorical power outside the home, they will lose it and their moral influence

Fig. 2.3. "The Days of Youth Advance," *The Golden Way,* 1889

in the home. If women lose moral influence in the home, the home will fall apart. If the American home falls apart, so does the nation. Potts is unable to imagine that a woman could minister to the home and the public affairs of the nation at the same time, and his failure of imagination reflects the limited vision of a nation that cannot let go of the icon of that quiet woman, the wine of life. The price American women were asked to pay for this status in the home was access to all rhetorical arenas except their highly restricted rhetorical opportunity and space.

Not all of Potts's contemporaries in the 1880s and 1890s are willing to view the advance of women into public rhetorical space with even mixed enthusiasm. The demonization of the talkative woman who has forsaken her proper place is a prevalent theme in an era during which the woman question would simply not go away. In the more-polemical advice manuals, essays on the moral lapses of vocal women are a prominent feature. For example, in *Social Abominations, or the Follies of Modern Society Portrayed by Many Eminent Writers* (1892), compiler Russell H. Conwell, whom Hilkey identifies as one of the most successful of all conduct manual authors, includes the female public speaker among his list of evils to be eradicated (Hilkey 55).[10] Conwell intends his manual to "stand like a sentinel at the door," and he expresses the wish that he could send it "into every home on this great continent. . . ." (xxii). Echoing the sweeping claims that conduct manuals typically make, Conwell insists: "This book will make childhood more sweetly obedient, maidenhood more purely innocent, manhood more grandly noble, married life more sacred, business more honest, politics more honorable, social life more enjoyable, and religion more sincere" (xxiii). The list of "abominations" addressed by Conwell's manual is a long one: chapters cover sabbath desecration, swearing and cursing, social extravagance, swindlers, divorce, drinking, "the tobacco evil," "fallen women," discourtesy, gambling, misuse of wealth, dishonesty, and false claims about the rights of women.

In the chapter "Real Rights of Women" in *Social Abominations,* essayist Rose Terry Cooke makes the point that the social and economic rights of women are "frequently ignored" but she points the finger of blame for delay in awarding women equality before the law to "those freedom shriekers who forget their position and their womanhood, who leave their families neglected and their homes forsaken to rant on platforms and usurp pulpits" (444). Far worse than the image drawn by Lindsay of the unloved lecturer who has abandoned her quiet kingdom for meaningless travel in a foreign country, Terry's image of shriekers and ranters is a damning one that constructs the public rhetorical performance as an act near to madness and one that compromises the efforts of sensible women to move forward. Certainly the image of the female public speaker as a shrieker is the antithesis of the quiet woman and makes the point again that the stronger a woman's rhetorical voice, the more suspect she became. For the middle-class woman considering her rhetorical options, the specters of the unloved, wandering lecturer and the abominable shrieker who alienates everyone around her haunt the pages of *Social Abominations* and texts like it that are heavy with encouragement to prefer the icon of the quiet angel of the home. As if there

Fig. 2.4. Mother and Infant, *Social Abominations,* 1892

could be any doubt about the ideal woman Terry implicitly contrasts with "those abominable shriekers and ranters" (441), positioned midway through Terry's chapter is an illustration of a young, matronly dressed woman in an apron holding an infant. The young mother is saying nothing, and in her voicelessness, she stands as the perfect idealized foil to Terry's construction of those shriekers and ranters who have forsaken their silent roles as ministering angels (see fig. 2.4).

Advice manuals typically take in far more ranging topoi of how to live the good life than just deportment, offering advice on subjects ranging from how to arrange a marriage to the care of the aged. Although more narrowly focused on manners, etiquette manuals of the postbellum period also represent woman in her glory in the domestic setting. Guidelines for conversation in etiquette manuals addressed to women typically stress the virtues of the rhetorically meek woman that Florence Hartley makes clear in her advice on conversation for "the lady in polite society" in her widely circulated treatise, *The Ladies Book of Etiquette and Manual of Politeness* (1882):

> In conversing with professional gentlemen, never question them upon matters connected with their employment. An author may communicate, voluntarily, information interesting to you, upon the subject of his works, but any questions from you would be extremely rude. If you meet a physician who is attending a friend, you may enquire for their progress, but do not expect him to give you a detailed account of the disease and his manner of treating it. The same rule applies to questioning lawyers about their clients, artists on their paintings, merchants or mechanics of their several branches of business. Professional or business men, when with ladies, generally wish for miscellaneous subjects of conversation, and as their visits are for recreation, they will feel excessively annoyed if obliged to "talk shop."
> . . . Never, when advancing an opinion, assert positively that a thing "is so," but give your opinion as an opinion. Say, "I think this is so," or "These are *my* views." (15–17)[11]

Hartley's advice to women not to ask questions of professional men not only makes the point that women have no need to know about the details of the male-dominated professions, but also stresses a rhetorical profile of silence or accommodation. Women do not ask questions, and they do not assert their opinions. Hartley's encouragement to women that they strike a pose of accommodation in conversation reinforces an ideological link between gender and rhetorical behavior by constructing yet another version of the noble queen who rules quietly in the home blending the correct atmosphere of politeness with the wine of silence. Advice manuals generally construct a trade-off between feminine silence and feminine influence; in other words, although women are encouraged by Bates, Conwell, Lindsay, Potts, and a legion of their professional peers to be silent in public affairs, women are offered in exchange the prestige of being characterized as having limitless influence in the home. A similar bargain about rhetorical labor is struck by etiquette writers like Hartley who stress the connection between rhetorical

reserve and taste and the deep love and admiration that a woman who converses with grace, chastity, and discretion will inspire. In etiquette literature, taste and culture function as ideological synonyms for virtue, and Hartley and other etiquette writers who address correct manners stress that female deportment in conversation wins the woman admiration and trust.

Postbellum etiquette literature is consistent in treating conversation as an art that depicts a "lady" at her best and furthers her rhetorical influence in the home. An article on "Conversation as a Fine Art" appearing in the *Ladies Repository* in 1868 shows that Hartley's characterization of female conversation was already well established in the years immediately after the Civil War:

> To women especially is there opened here a field in which cultivated powers may be employed for the noblest ends. In the social circle her influence is almost unbounded, and by the exercises of the cultured graces of thought and speech she may diffuse everywhere in social life enrichment of intellect, as well as refinement of manner. (10)

This argument encourages women to believe that they will have influence if their conversation is refined and cultured in much the same way that advice authors promise domestic rhetorical power to the woman who confines her voice to the home. When we note Hartley's advice that cultured conversation depends upon women not asserting their opinions and acting as if they have no interest in public affairs, it is obvious that the feminine performance of taste is another attribute of the quiet woman who, in rhetorical terms, never raises her voice and opts to reign instead over her home calmly and wisely.

The equation drawn in etiquette literature between feminine virtue and rhetorical reserve becomes more obviously ideological when we compare advice on conversation addressed to women with that addressed to men. In this comparison, the contribution etiquette manuals make to the rhetorical repatriation of women to the parlor becomes even more clear. In *The Mentor: A Little Book for the Guidance of Such Men and Boys as Would Appear to Advantage in the Society of Persons of the Better Sort* (1884), author Alfred Ayres shares with Hartley the general assumption that it is egotistical to try to claim more than one's share of attention in a conversation and that the best conversation is one in which there is tolerance of a range of opinion. However, in giving specific advice to the aspiring gentleman, Ayres does not urge the young man to qualify his opinions but only to be sure before he offers them that he "has attained to a position that entitles him to speak as one having authority" (134). Similarly, in *Room At The Top or*

How to Reach Success, Happiness, Fame, and Fortune (1883), Alan Craig advises the young man to assert himself but do it politely: "In general conversation avoid argument. If obliged to discuss a point, do so with suavity, contradicting, if necessary, with extreme courtesy" (313). In contrast to the young woman who is counseled to qualify her statements of opinions and never contradict another, the young man is counseled to speak his mind if he has authority. Authority is never a consideration in the discussion of women's conduct. In her home kingdom, the quiet woman's authority is moral but rarely intellectual.[12]

Although etiquette literature advises young men to cultivate conciseness and accuracy in their conversation and the general skill of speech making, young women are advised to concentrate on grace and discretion in conversation and to never proclaim their opinions or make speeches. It is with the goal of discreet rhetorical femininity in mind that Hartley advises women not to engage men in shop talk, as this is not what men come to talk with women about. Approaching the same conversational rule from a male perspective, Ayres admonishes men not to be rude by discussing professional matters that will bore their female companions. Giving similar advice to men in *Manners, Culture and Dress of the Best American Society Including Social, Commercial and Legal Forms* (1892), Richard A. Wells makes it clear that a woman has the right to be annoyed if a man converses on topics with which "ladies are seldom acquainted." The topics on which ladies are seldom acquainted include not only professional shop talk but also "political, scientific or commercial topics." Instead of engaging in dialogue with women on these subjects, Wells urges men to "lead a mother to talk of her children, a young lady of her last ball."[13] It is hard to miss the construction of the woman in conversation as someone who should not show interest in worldly subjects or is ill equipped to. From Wells's point of view, the woman is not intellectually prepared to engage in serious dialogue; from Hartley's point of view, she is too polite to offer an opinion on subjects outside her sphere. Either way, the performance of politeness expected of the ideal woman removes her from the kind of rhetorical exchange of serious opinion men would routinely expect from each other and renders her more quiet than ever, a rhetorical position that contrasts sharply with the readiness to speak up associated with the good manners of the gentleman (65–66).

Etiquette manuals published in the 1880s and 1890s such as *The Mentor, Room at the Top,* and *Manners, Culture and Dress of the Best American Society* reflect a tradition in nineteenth-century etiquette literature of des-

ignating public speech as an expected part of a man's day-to-day life. In the structure of its contents and in its appeal to gentlemen who expect to "become brilliant or conspicuous in general society," *The Perfect Gentleman; or Etiquette and Eloquence* (1860) is representative of the approach of many etiquette manuals written for male readers that presume that knowing how to speak in public is an etiquette issue for men. The full title of *The Perfect Gentleman* defines a range of cultural mobility for men that contrasts sharply with the domestic sphere defined for women by Hartley and other conduct authors who encourage the theme of the quiet woman reigning in the domestic court. The fusion of public-speaking repertoire and gentlemanly manners is inscribed for the readers of *The Perfect Gentleman* on the title page: *"The Perfect Gentleman; or Etiquette and Eloquence. A Book of Information and Instruction for those who Desire to Become Brilliant or Conspicuous in General Society, or at Parties, Dinners, or Popular Gatherings, containing Model Speeches for All Occasions, with Directions How to Deliver Them"* (title page). The full promise offered by the author of *The Perfect Gentleman* stresses that in social as well as public situations a gentleman would naturally encounter, the skill of speechmaking is as indispensable as a knowledge of the rules of politeness. The link between male etiquette and public eloquence is further inscribed in *The Perfect Gentleman* by the inclusion of chapters on "Speeches at the Dinner-Table," "Toasts for all Professions," and "Table Wit and Anecdotes" (23, 147, 287) that discuss oratorical and public rhetorical performances. Chapters describing the rhetorical etiquette of these types of occasions never appear in etiquette manuals on female behavior such as Hartley's *The Ladies Book of Etiquette* or advice guides such as Potts's *The Golden Way* that stress instead the importance of feminine rhetorical reserve and the essential role of women in facilitating, rather than commanding, rhetorical attention in the parlor.

The association of the proper rhetorical role for women with the icon of the quiet woman who reigns wisely in her home speaking graciously and never assertively remains standard in etiquette and advice literature throughout the decades following the Civil War and continues to be reinscribed in conduct discourses in general at the turn of the century. Popular encyclopedias such as *Collier's Cyclopedia* (1882) and James D. McCabe's *The Household Encyclopedia* (1882) sold widely to parlor readers from 1880 to 1910 contribute yet another strand to conservative constructions of rhetorical behavior for women by recapitulating conventional etiquette advice about rhetorical conduct alongside treatments of subjects of general knowledge such as history, literature, bookkeeping, farming, dancing, and parlor games.

Texts in the late-nineteenth-century encyclopedias represent a major genre in the postbellum parlor curriculum and contribute to the parlor-rhetoric movement by providing instruction in elocution, oratory, composition (the art of writing well), letter writing (see chap. 4), and conversation for thousands of readers whose only opportunity to study rhetoric was through parlor reading. The enormous success of parlor encyclopedias and the high profile awarded in this genre to rhetoric instruction confirm the high cultural status that rhetorical skills retained throughout the nineteenth century and indicates that public interest in rhetorical education remained enthusiastic even at the turn of the century. However, like other genres of the parlor-rhetoric movement, such as elocution manuals and speakers (see chap. 2) that offer a complicated invitation that both affirms the importance of rhetorical skills and simultaneously keeps in place gendered distinctions between the public rhetorical world of men and the domestic rhetorical world of women, nineteenth-century parlor encyclopedias also extended the authority of gendered concepts of rhetorical space and skills by upholding the gendered connection between correct deportment and rhetorical behavior.

Readers of postbellum encyclopedias are assured by authors that the contents of these hefty, richly embossed volumes are a "Treasury of Useful and Entertaining Knowledge" (*Collier's* title page). Although by 1900, the encyclopedia tradition had begun to move in the direction of becoming strictly compendiums of information, parlor encyclopedias of the 1880s and 1890s included advice on etiquette as a matter of course.[14] Encyclopedia authors of the late-postbellum period and 1890s organize their volumes as a blend of genres, combining the discrete functions of etiquette, oratory, elocution, letter-writing, handwriting, grammar, and advice manuals with treatments of subjects of emerging interest to increasingly literate and economically and socially motivated readers: business writing, the conduct of meetings, English and American literature, agriculture, American history, geology, bookkeeping, riding, rowing, and home amusements (Gaskell viii; *Collier's* 1). Conduct advice in popular encyclopedias is extensive and covers topics that closely parallel standard topics in etiquette and advice manuals: "Etiquette for Ladies," "Etiquette for Gentlemen," "The Golden Rules of Etiquette," "Party and Ball-Room Etiquette," "Courtship and Matrimony," and "Hints to Housekeepers" (*Collier's* 589–617). Under the heading "Etiquette for Ladies," the authors in *Collier's* offer advice on how ladies should converse that reiterates the popular cultural idealization of the quiet eloquence of women who skillfully manage the expression of others' opinions:

Remember in conversation that a voice "gentle and low" is above all other extraneous acquirements, an excellent thing in a woman. . . . A loud voice is both disagreeable and vulgar. . . . Long arguments in general company, however entertaining to the disputant, are tiresome to the last degree to all others. You should always endeavor to prevent the conversation from dwelling too long upon one topic. . . . Do not be "always" witty, even if you should be so happily gifted as to need the caution. To outshine others on every occasion is the surest road to unpopularity. . . . Never talk upon subjects of which you know nothing, unless it be for the purpose of acquiring information. Many young ladies imagine that because they play a little, sing a little, draw a little, and frequent exhibitions and operas, they are qualified judges of art. No mistake is more egregious or universal. (591)

The portrait of ladylike conversation that emerges from this extract from a long section on conversation that opens by reminding women that their conversation should be "graceful" and "sparkling" is one in which the well-mannered woman is depicted listening to the expression of others' opinions and generally remaining silent as it is unlikely that opinions she has formed are sufficiently informed (591). In conversations in which guests might be attempting to argue various sides of a dispute, the woman is charged with the responsibility of making sure her other guests are not bored. The notion that a gentlewoman might actually enter a dispute and argue a point is so inconceivable that readers are not even warned against it. The role of facilitator and listener rather than speaker is so deeply inscribed as the preferred behavior for women in conversation that the authors of *Collier's* can simply take it for granted that readers already understand that ladies do not engage in arguments.

Many of the principles of polite conversation outlined in encyclopedias apply to both sexes and are meant to be taken as generally applicable maxims. For example, in the section "Conversation" under the heading "Etiquette for Gentlemen" in *Collier's,* several maxims are repeated that are similarly listed in the section on women's conversation, such as the importance of listening well and shifting the topic if arguments go on too long.[15] However, in the opening paragraphs of "Etiquette for Gentlemen," Nugent Robinson, *Collier's* compiler, rehearses standard advice to men that contextualizes this seemingly parallel advice in ways that reinforce the image that men are the authoritative speakers and can be expected to express a far greater range of opinions than women can or ought to. Men are reminded in *Collier's,* as they are by *The Mentor* and *Manners: Culture and*

Dress of the Best American Society, that it is in poor taste to ignore what women are likely to want to discuss:

> Some men make a point of talking commonplaces to all ladies alike, as if a woman could only be a trifler. Others on the contrary, seem to forget in what respects the education of a lady differs from that of a gentleman, and commit the opposite error of conversing on topics with which ladies are seldom acquainted. . . . In talking to ladies of ordinary education, avoid political, scientific, or commercial topics, and choose only such subjects as are likely to be interesting to them. Remember that people take more interest in their own affairs than in anything else which you can name. If you wish your conversation to be thoroughly agreeable, lead a mother to talk of her children, a young lady of her last ball, and author of his forthcoming book, or an artist of his exhibition picture. (598)

Although ladies are similarly advised to speak to people about their interests, the parallel nature of advice is undermined by the particular directions to gentlemen to take into consideration what would typically be a man's or woman's field of interests. Here, once again, are the familiar directions to men to explicitly avoid political, scientific, and commercial topics when talking to most women that are repeated by rote in all postbellum etiquette literature on conversation. *Collier's* reiterates a gendered view of conversation when it implies that men speak from the context of their public lives and the opinions on political, scientific, and professional events they naturally have and that women speak with interest on only those topics that touch their domestic roles or social activities. The domestication of women's voices reinforced by *Collier's* treatment of conversation takes on more ideological significance when we note that the maxim of asking a woman about her children and the young lady about her last ball is one that is literally repeated as standard advice in other encyclopedia treatments of the etiquette of conversation such as *Gaskell's Compendium of Forms, Educational, Social, Legal, and Commercial* (1881) (403) and Hill's *Manual of Social and Business Forms: Guide to Correct Writing* (1883) (150).[16] The repetition of the gendered maxim that assigns only domestic and social topics of interest to women throughout etiquette literature in general extends the conventional authority of this view to thousands of readers pursuing a general education in the home.

The treatment of the laws of etiquette as forms with rules to be followed as exactly as the form of letters, business relationships, and the conduct of meetings in *Gaskell's* and *Hill's* reveals the powerful normative context that

predisposes nineteenth-century conduct literature in general and gendered definitions of, as the author of *Hill's Manual* defines it in the chapter "What to Say and How to Do It." It is this context that fosters the persistent re-inscription of the public-minded gentleman with much to pronounce on a variety of worldly topics and the contrasting image of the lady of the house whose soft and low voice is mostly heard facilitating the self-expression of others in her parlor and chatting about her social or domestic life.

The conservative construction of the rhetorical nature of women is so extensive and long-lived in the etiquette and advice genres of the latter half of the nineteenth century that its ideological power continues to predispose how women's lives and behavior are defined in the conduct literature of the 1890s. In addition to encyclopedias and the on-going popularity of etiquette and advice manuals, women readers in the 1890s are offered the opportunity to purchase texts that combine the attractive features of encyclopedias and advice manuals into one informative guide to all things female. *The Glory of Woman, or Love, Marriage and Maternity: Containing Full Information on All the Marvelous and Complex Matters Pertaining to Women* (1896) represents a genre of conduct literature that combined the treasury-of-knowledge format of the popular postbellum encyclopedia with the ideological promise of the etiquette guide to provide instruction in correct manners.[17] In the case of *The Glory of Woman*, "full information" includes information on physical health, marriage, mothering, and beauty, and chapters on etiquette that inevitably reassert some version of the quiet woman and her virtues. In addition to etiquette chapters on "The Social Queen," "The Rules of Etiquette," and "The Art of Conversing Well" (along with diverse subjects ranging from "Advice to the Unmarried," "Love and Parentage," "Pregnancy," and "Diseases Peculiar to Women" [v–xiv]), the authors of *The Glory of Woman* devote a section of the chapter on conversation to the woman's role in "Guiding the Conversation" that reinforces the parlor as the proper sphere of female eloquence:

> It is well that every group should have its leader or centre; not always the one who talks most or best, but the one who listens, manages, suggests and draws out or gives opportunities to others. A lady of tact and intelligence does the best. She guides the conversation. . . . A lady who can do this, not only for a single group, but for a drawing room full of guests . . . is fit to be a hostess and social queen. If the first qualification for conversation is to know how to speak, it is, in some ways, a more important one to know how to listen. We draw out, encourage, excite, and elevate by our manner of receiving and accept-

ing what one says. The orator gets life, suggestion and support from his audience. He is borne up by the waves of their appreciation. Good listeners make good talkers. (475)

The readers of *The Glory of Woman,* who are addressed in the preface as "all wives, mothers, and maidens," are encouraged by this passage to see themselves as embodying tact and intelligence in the role of facilitating the conversations of others and to see their rhetorical fulfillment in listening to orations rather than giving them. The compliments of tact and intelligence are awarded to the woman who quietly enhances the oratorical skills of men (e.g., the *he* who is borne up on waves of the woman's appreciation) rather than drawing attention to her own. In that role of rhetorical appreciation, the ideal woman achieves her glory. The ideological association of a woman's glory with a willing silence and a facilitative rhetorical role rather than a direct one permeates the depiction of why and how women ought to speak in books like *The Glory of Woman* that claim to be educational in their aims but typically are persuasive in their intention to shape how women readers saw their rhetorical options.

Various genres of conduct literature make the argument repeatedly that female eloquence can be measured by the degree to which a woman's voice provides background for other speakers. In her treatise *What Can a Woman Do, or Her Position in the Business and Literary World* (1885), Mrs. M. L. Rayne concludes a text that ostensibly celebrates the advances of women in seeking occupations outside the home with a conventional account of "The Good Wife" that echoes decades of conservative advice about domestic rhetorical behavior.[18] Presenting women readers with yet another account of how a woman achieves her glory through rhetorical accommodation, Rayne brings to life on the page the icon of the angel of the hearth:

> It is the glory of woman that she was sent into the world to live for others rather than herself, to live, yes and to die for them. Let her never forget that she was sent here to make man better, to temper his greed, control his avarice, soften his temper, refine his grosser nature, and teach him that there is something better than success. These thoughts will come to help her in the lonely hours when he is receiving homage and she is not. She may be apt to remember, too, that she has been his inspiration, his guiding star, that but for her he would not have been the poet, the orator, or the preacher. (484)

Rayne offers women the glorious status of a guiding star if they will accept their appropriate rhetorical role as the inspiring moral force behind men who pursue their public rhetorical roles as writers, speakers, and preach-

ers. Taking up this rhetorical role of the moral orator behind the public orator, the good wife influences her husband to higher levels of character. In Rayne's portrait, the glorious woman lives for others and never speaks to any public acknowledgment. That the ideal woman is quiet in comparison to the man who is portrayed as enjoying a range of rhetorical opportunities is obvious. This construction is charged with a positive moral connotation that aligns the good wife of Rayne's essay, who does not seek nor question the homage for rhetorical achievements her husband can take for granted, with the varied icons of quiet women who are depicted in postbellum conduct literature as seeking their rhetorical influence within the home.

The gendering of conversation and rhetorical conduct in manuals such as *What Can a Woman Do?* and in postbellum and late-nineteenth-century conduct literature in general contributes one more layer of cultural influence that predisposes American readers to conflate rhetorical behavior with the performance of gender and thus remain vulnerable to the cultural anxiety that change in rhetorical conventions necessarily meant a change in gender relations. Postbellum conduct literature, which defines all aspects of personal, social, and professional life as etiquette or deportment issues, weighs in on a long-standing cultural struggle about gender, power, and rhetorical space. This struggle resisted smoothing out despite the polemics of the Mrs. Lindsays, the Reverend Pottses, the Florence Hartleys, and Mrs. M. L. Rayneses who promised an agitated public that just following the rules would straighten out the confusion about who women were and where they belonged. That there remained in the late-nineteenth century such intense cultural desire to blunt the rhetorical power of women provides ample evidence, even as the new century was about to turn, that American debates about the essential nature of women and debates about how women should speak remained mutually reinforcing discourses that could not be separated.

Joan Wallach Scott has reminded us in *Gender and the Politics of History* (1988) that feminist history should account for those historical moments that give us insight into "the often silent and hidden operations of gender that are nonetheless present and defining forces in the organization of most societies" (27). Without doubt, the historical moment constructed by the fusion of discourses about gender and rhetorical voice in postbellum conduct literature lets us see that popular rhetorical pedagogies that "hid" themselves in the advice and etiquette literature of the times exerted a powerful influence on late-nineteenth-century gender debates. Through various textual operations that stabilized the domestic icon of the American woman as the angel of the hearth, conduct literature of the late-nineteenth century

soothed the fears of a nation that had fixed upon the ideal of the American home as a precious and eternal refuge. Reigning there with wordless wisdom, the quiet woman reborn again and again in the pages of *The Golden Way* and *The Glory of Woman* moved silently about the house shutting the windows to controversy and to change.

3

"Dear Millie": Letter Writing
and Gender in Postbellum America

On the cover of *The Shelby Dry Goods Herald,* a sales catalogue published locally in Shelby, Ohio in 1883, a fashionably dressed, middle-class, young woman holds up a letter in one hand and an envelope in the other as if she has just opened a letter that has brought her good news. Simulated handwriting on the letter and envelope lends realism to this engraved line-drawing in which the smiling woman looks directly out into the reader's eyes. The drawing fills most of the space of this 8-by-11-inch catalog bearing the title *The Shelby Dry Goods Herald.* Below the drawing of the woman displaying her letter is a quotation that tells us the message the woman prominently displayed on the catalog appears to be so happy to have received: "'Dear Millie, You will no doubt be gratified to learn that the New Fall and Winter Stock is simply magnificent. I am sure you never saw such an immense display and their prices are very, *very* low. . . . Do hurry and come prepared to buy as everything is so new and nice'" (see fig. 3.1). The familiarity of the salutation, Dear Millie, in an era when salutations between men and women were either more formal or more sentimental tends to support the conclusion that Millie has received a chatty and informative letter from a friend who just happens to know the latest about bargains at Shelby Dry Goods.[1] The construction of Millie as a pleased recipient of a letter from a helpful chum as the leading advertising strategy for *The Shelby Dry Goods Herald* reminds us of the central role of letter writing in the daily lives of the postbellum middle class and also of the particular role of correspondence in the lives of American middle-class women like Millie.

Millie smiles out at the reader from what is obviously a room in her home. A parlor door is open directly behind her, and standard parlor accouterments such as a large potted plant and massive wooden sideboard are unmistak-

Fig. 3.1. "Dear Millie," *The Shelby Dry Goods Herald,* 1883

able. One can easily imagine the commonplace scenario Shelby Dry Goods has drawn on as an advertising ploy: Millie's friend is sitting at a lady's desk in her parlor writing a note to Millie full of the kind of news that women would take as their province, the price and availability of dry goods. The

construction of the domestic context for this exchange implies that the intended readers for this particular issue of *The Shelby Dry Goods Herald* are the hundreds of Millies in and around Shelby, Ohio, looking to spend the household budget wisely. This assumption seems further supported by the miniature illustration under the banner of the title featuring a male store clerk standing at a counter strewn with bolts of materials and showing yard goods to two women customers. Millie holds her letter up as if to alert the reader of the catalog to important news; the letter that has passed from one woman's parlor to another's is now read once again by a reader perusing the catalog in yet another parlor. The letter linking all three women together— writer, recipient, and reader—can be relied upon here as a successful advertising device because it constructs an everyday discursive event readers will recognize and identify with. *The Shelby Dry Goods Herald*'s advertisement co-opts the high, cultural status of letter writing, uses it as an advertising strategy, and locates Millie right where a postbellum middle-class readership would expect her to be, in the parlor governing the business and well-being of her home. The juxtaposition of the powerful rhetorical capital of letter writing and the conservative construction of the spatial location of its use by women in the home reinforces that sacred cultural icon of the nineteenth century—the white, middle-class woman as guardian and queen of the American home.

The conflation of women's letter writing and the domestic sphere, exemplified so clearly in the illustration of Millie's letter, is a deeply grounded assumption in the American letter-writing tradition.[2] Like other forms of parlor rhetorics designed for the home learner, such as elocution manuals and speakers, letter-writing guides were popular books for the middle-class reader in the decades before and after the Civil War. Letter-writing literature promoted the skill of letter writing as indispensable to anyone hoping to achieve social or professional success and reinforced the already widely held cultural assumption that correct writing, like speaking, was inextricable from character and good manners. In making the argument for the importance of women learning to write effective letters, nineteenth-century letter-writing guides stress not only the everyday function of correspondence in maintaining social relations and a well-run home, but also the inseparable relationship between belletristic manners and what it meant in nineteenth-century American culture to act like a lady. Narrowly defining the discursive field of women's correspondence as ranging from social letters to personal business, nineteenth-century letter-writing literature generally reinforced conservative definitions of female roles rather than expanded the rhetorical territory of women. Participating subtly but overtly in the tense,

nineteenth-century, cultural drama about the woman question, letter-writing literature constructed the white, middle-class, American woman as writing herself again and again back into domestic space.

Assigning the responsibility of official or legal matters to men and the conduct of family correspondence, social invitations, and household business to women, nineteenth-century letter-writing literature reinforced the distinction between men and women's rhetorical worlds as well as a differential in cultural power. While men are encouraged by texts such as Albert Cogswell's *The Gentlemen's Perfect Letter Writer* (1877) to "learn to write with stylistic power" (23), women are reminded in articles entitled "Letter Writing-Ladies Department" to "think your heart full and send it out through your pen" (72). In this piece of advice to women correspondents, J. L. Nichols, author of *The Business Guide; or Safe Methods of Business* (1886) not only makes the point that a women's epistolary voice should appropriate all the power of a good woman's heart but also that the letter-writing needs of women could be bracketed off from general advice on business-letter writing. Nichols's inclusion of a separate chapter on "Letter Writing—Ladies Department" in a volume offering general advice on topics including "How to do Business," "How to Write," "Letters of Recommendation," "Commercial Correspondence," and "How to Apply for a Situation" constructs a separate rhetorical sphere for women that is centered in the home. From there, a woman could exert her influence through "natural, easy, and pleasant" epistles that primarily reinforced social relationships (71). Although Nichols promises in the introduction to his text that the advice he offers in *The Business Guide* is "a necessity to young men and young women to prepare them, by the adoption of correct and safe methods of business, for thoroughness and success," it is clear when *The Business Guide* is read as a whole that what rhetorical success means in this text is predetermined by a conservative view of the contexts in which women and men are writing letters and for what reasons. The gendered subtext of Nichols's text exemplifies the tendency of many nineteenth-century letter-writing manuals to conflate discursive or rhetorical performance with the appropriate performance of femininity or masculinity; this is particularly true in discourses on letter writing that treat the composition of letters as an etiquette issue.[3]

Nichols reminds the woman correspondent that "a well written letter has opened the way for usefulness to many a one, has led to many a happy, constant friendship, and has proved a life-long help" (71). The stress Nichols places on the role of female correspondence in friendship and happiness recalls the moral authority in matters of the heart that his nineteenth-cen-

tury readers would associate with the woman's role in the home. Emphasizing a far more public rhetorical world for the "upright, energetic business man," Nichols reminds his gentlemen readers that masculine honesty and straightforwardness are the winning factors in verbal and written business interactions: "If you wish to change a man's views in reference to some business transaction or other negotiations, respect his opinions, and he will be respectful and listen to your arguments" (8). Although allotting a certain kind of discursive power to women correspondents in their role of oversight over domestic relationships, Nichols defines a more traditionally powerful rhetorical world for men whose correspondence might often need to serve some persuasive function regarding the disposition of events and opinions. Nowhere in Nichols's text or the many like it published before and after the Civil War are women encouraged to view the rhetorical possibilities of "ladies'" correspondence as having agency in arenas of public or professional opinion. While men are invited by Nichols's *The Business Guide* and Cogswell's *The Gentlemen's Perfect Letter Writer* to see letters as yet another site where their cultural power can be negotiated, women are written out of the comparatively powerful discursive space of business and public affairs by having their epistolary influence defined in familial terms and bounded by the walls of the homes they occupied. Although both Nichols's and Cogswell's texts promote letter writing as a necessary skill that no one who hopes to succeed can do without, their instructions to women about when to write and how to write inevitably restrict middle-class woman's sense of her rhetorical repertoire by persistently reinscribing the familiar cultural image of the lady of the house seated at her parlor desk attending to social correspondence, family letters, and notes to the butcher, the baker, and, of course, the dry-goods store.

The degree to which the rhetorical activities of women are necessarily bounded by their domestic sphere in nineteenth-century treatments of the woman correspondent is exemplified by the illustration Nichols chooses to introduce his treatment of letter writing for ladies. This drawing features a well-dressed middle-class woman seated at her parlor desk with quill pen in hand writing a letter (see fig. 3.2). The reader's sense of what the woman writer is doing is contextualized by the advice that Nichols offers in the discussion of "ladies letter writing" that this drawing opens. Among directives to remember the social obligations of writing and never to breach the proper decorum expected of a lady, Nichols observes that "a bright letter brings sunshine to both the writer and the reader" when penned by a lady who applies "the art of careful and prudent letter writing" (70–71).

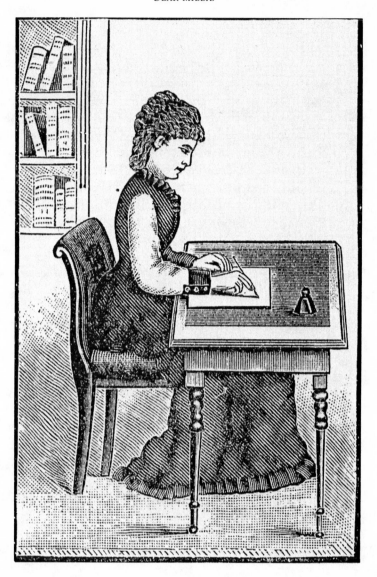

Fig. 3.2. "Ladies' Department," *The Business Guide,* 1894

In a revealing contrast to the emphasis that the drawing of the lady writing at her parlor desk gives to Nichols's ideological association of women's letter-writing with the domestic sphere, Cogswell's text bears an equally gendered and emblematic icon on the cover of *The Gentlemen's Perfect Letter Writer.* In this cover drawing, a gentleman in a suit sits at an office desk busily writing a letter while consulting a book of reference (see fig. 3.3).

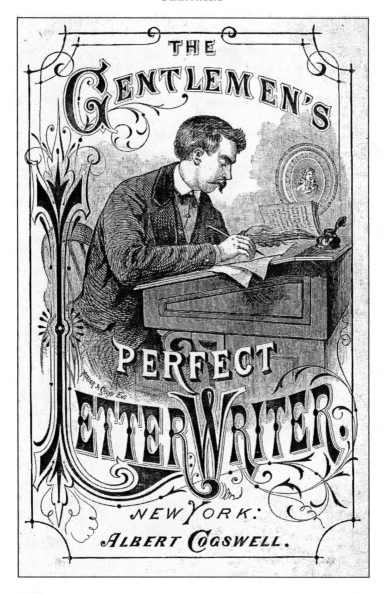

Fig. 3.3. *The Gentlemen's Perfect Letter Writer,* 1877

Whereas the lady sits in front of a nearly bare desk with only one piece of paper and an inkwell, the gentlemen seems to be much busier and involved in a more complicated process of correspondence that Cogswell's readers would surely assume to be a business or professional enterprise. These separate-desks drawings used prominently in *The Gentlemen's Perfect Letter Writer*

and *The Business Guide* represent the contexts in which men and women were expected to write and could not help but reinforce clear images of the different spheres of influence for men and women and of their discursive activities.

The separate-desks motif is a cultural trope that Nichols and Cogswell draw upon rather than establish. Similar drawings adorn the covers and pages of both antebellum and postbellum letter-writing manuals and serve the ideological function of reinforcing in both eras conservative representations of letter-writing functions in the daily activities of middle-class women and men. The separate-desks motif endures throughout the century, appearing in pre–Civil War manuals as well as on the pages of postbellum letter-writing treatises, conduct books, and parlor encyclopedias that often use separate-desks illustrations as chapter logos or as illustrations showing the typicality of correspondence in any gentleman's or lady's everyday life. In a particularly revealing illustration from the postbellum encyclopedia *The Universal Self Instructor: An Epitome of Forms and General Reference Manual* (1882), separate-desk illustrations appear side by side as the introductory logo of the chapter "Letter Writing" (see fig. 3.4). The separate rhetorical domains of the male and female correspondents are exemplified once again by drawings showing a man writing at an office desk and a woman writing at a parlor desk. The introductory paragraph to this chapter underscores what is so often the ideological double message of nineteenth-century letter-writing literature: Everyone needs to be able to write a good letter, but important distinctions must be made between where and how a man writes and where and how a woman writes:

> There is probably no attainment more desirable than the art of Letter Writing, and no lady or gentleman should neglect the opportunity of becoming proficient in this accomplishment. An elegant and well written letter is generally considered a mark of refinement and education, while a letter bearing the stamp of slovenliness and ignorance gives the person to whom it is sent a very poor opinion of the writer's character and ability. (487)

By combining the separate-desks illustration with a reminder to the readers that letter writing is practical necessity as well as a performance of character for gentlemen and ladies, *The Universal Self Instructor* simultaneously constructs letter writing as an indispensable form of middle-class literacy and as a performance of gendered decorum. This fusion of rhetorical literacy and gender identity is one of the distinguishing ideological features of letter-writing literature before and after the Civil War.[4]

Fig. 3.4. "Separate Desks," *The Universal Self-Educator,* 1882

Although *The Universal Self Instructor, The Business Guide,* and *The Gentlemen's Perfect Letter Writer* were published after the Civil War, the format of these manuals and the conservative ideology of gender they reinforce was well established in the antebellum letter-writing tradition that also insisted upon a domestic home base for women and their literate interests. Popular, antebellum letter-writing manuals marketed to the home learner promoted letter writing as a necessary skill for everyday life and as a rhetorical habit that developed intelligence and taste. Like speaking correctly and well, a rhetorical achievement viewed by the nineteenth-century middle class as a mode of self-presentation that distinguished intelligent persons of character from those with lesser education, letter writing had achieved the status of a high art of rhetorical etiquette by 1850. Deeply entangled with nineteenth-century ideology about how men and women should behave, antebellum theories of how to write offered to a public disinclined to question gender roles the picture of a stable, middle-class world governed by rhetorical rules that distinguished reliably between the cultural identities of men and women. This conservative gender agenda was promoted by popular, letter-writing manuals that circulated before the Civil War such as *The Fashionable American Letter Writer* (1837) and *Chesterfield's Letter Writer and Complete Book of Etiquette* (1857).[5] Manuals like these typically promoted their contents by arguing that letter writing was a "universal necessity" affecting every aspect of life. The reader of the *The Fashionable American Letter Writer* is told that letters are "the life of trade, the fuel of love, the pleasure of friendship, the food of the politician, and the entertainment of the curious" (iv). Similarly, *Chesterfield's Letter Writer* points

out, "[G]ood letter-writing is one of the mainsprings of business, and one of the strongest connecting links of common life" (3). What the anonymous authors of these two manuals can assume is that they are reiterating the case for the importance of letter writing to a readership that already assumes that not possessing this skill is a serious hindrance:

> The great utility of epistolary writing is so well known, that the necessity of being acquainted with an art replete with such advantages, is needless to be insisted on. Those who are accomplished in it, are too happy in their own knowledge to need farther information concerning its excellence. And such as are unqualified to convey their sentiments to a friend . . . feel their deficiency so severely, that nothing need be said to convince them, that it is their interest to become acquainted with what is so necessary and agreeable. (*Fashionable American Letter Writer* iv)

Both presuming the cultural status of letter writing and reinscribing it at the same time, antebellum letter writing manuals appealed to a public that responded well to the idea that such a highly valued rhetorical skill could be learned by anyone through study and practice. Defined as an art of conversation on paper, letter writing was promoted as the skill of adapting a few formal and stylistic rules to particular occasions defined generically as the business letter, the friendly letter, family correspondence, letters of condolence, courtship and marriage, and love letters (*Chesterfield's* 3–58). Antebellum manuals are consistent about defining these genres as the major letter-writing occasions and organize their contents around the definitions of rules of style and organization that are to be followed for any letter and around discussions of the characteristics of style and content to be achieved in particular genres. Early-nineteenth-century letter manuals are indebted to Hugh Blair's treatment of "epistolary composition" in his popular rhetoric treatise *Lectures on Rhetoric and Belles Lettres* (first published in 1783) and tend to reiterate Blair's belletristic inclination to treat letter writing as a species of prose composition in which the same high stylistic and developmental standards expected of philosophical or historical writing apply. Blair identifies the genres of business letters, letters of compliment, congratulation and condolence, and familiar letters yet acknowledges that epistolary composition is a genre that can "stretch into a very wide field" (114–15).[6] Antebellum letter manuals typically adopt Blair's generic model for the various types of letters as well as the rules for form and style he outlines. Blair's point that ease and simplicity are the best qualities for the epistolary style is frequently quoted in nineteenth-century letter-writing

literature, as is his warning that stylistic imprudence in a letter can have far-reaching consequences as once a letter is written and received, its message is permanent.

> It ought, at the same time, to be remembered that the ease and simplicity which I have recommended to epistolary correspondence, are not to be understood as importing entire carelessness. In writing to the most intimate friend, a certain degree of attention, both to the subject and the style, is requisite and becoming. It is no more than what we owe both to ourselves and to the friend with whom we correspond. A slovenly and negligent manner of writing, is a disobliging mark of want of respect. The liberty, besides, of writing letters with too careless a hand, is apt to betray persons into imprudence in what they write. The first requisite, both in conversation and in correspondence, is to attend to all the proper decorums which our own character and that of others demand. An imprudent expression in conversation may be forgotten and pass away; but when we take the pen into our hand, we must remember that "Litera scripta manet." (115)

By midcentury, American letter manuals begin to be self-referential, citing other popular, American manuals and rhetorics as sources and unabashedly offering compilations from various letter-writing authors, Blair included. The authors of *How to Write: A Pocket Manual of Composition and Letter-Writing* (1857) explain, "We claim little on the score of originality, having aimed at usefulness rather than novelty; but what we have borrowed from others has, in most cases been re-written, and so modified as to preclude formal credit" (iv). The focus in antebellum letter-writing literature on the Blairian application of certain rules of style and form to a finite set of epistolary occasions remains the hallmark of the genre throughout the century. The theoretical definition of letter writing as an art of rhetoric by Blair and other well-known rhetoricians and theorists awarded letter writing a high literary status and reinforced the pedagogical bias, that, like other rhetorical arts such as oratory and prose composition, the key to writing good letters was the proper understanding of one's subject and proposed readers. Antebellum letter-writing authors not only borrowed Blair's generic list of types of epistolary composition but also relied on Blair's pedagogical approach of defining the characteristics of a genre followed by several examples. Although antebellum authors recognized, as did Blair, that a complete letter-writing guide was impossible as the occasions of life were not predictable, they stressed that the command of form and style would stand up to any writing challenge, as would the study of model examples:

Elegant letter writing is one of those accomplishments, which how-
ever desirable for every man of science, is really attainable by few; it
ought therefore to be studied with great attention by all; and we know
of no way in which it can be studied with greater prospect of advan-
tage, than by fair examples. We may tell the young student, that
Orthography, Grammar, Style, and Punctuation are absolutely nec-
essary to enable him to appear with any degree of respectability as
an epistolary writer; but unless we exhibit before him specimens, by
examining which he may see the propriety of this information, and
the advantage of attending it, we do but little towards perfecting him
in this useful art. (xi)

As this advice from *The Fashionable American Letter Writer* indicates, the
overall theoretical impact of the belletristic debt of antebellum letter-writ-
ing literature was to establish letter writing as a type of writing that em-
ployed the same principles of a good style and organizational facility as other
types of prose composition and to stress that no one could write an effec-
tive letter who offended against "decorum." Letter-writing manuals prom-
ised the home learner, men and women alike, the opportunity to believe
that the valued writing style of the exemplary writers whose model letters
filled the pages of *The Fashionable American Letter Writer* and *Chesterfield's
Letter Writer* could become the accomplishment of the ordinary individual
through diligent study and practice. Subtly but clearly embedded in the
antebellum promotion of letter writing as a means of personal and social
satisfaction was an ideological agenda that defined elegant letter writing as
a performance of gender-appropriate behavior. The ostensible argument
made to readers was that the skill of letter writing made the difference be-
tween a happy and successful life and a chaotic and unfulfilling one. Al-
though practicality and personal cultivation were always the leading argu-
ments for the promotion of letter writing, it is important to note that for
an early-nineteenth-century readership already expecting that practical daily
life would be discussed in gendered terms, the decorum admonishments
regarding appropriate discursive behavior for gentlemen and ladies would
seem to be a normative feature in advice on how to produce effective cor-
respondence. In both antebellum and postbellum letter-writing literature,
women's letter-writing obligations and opportunities are defined in terms
of what interests a lady might pursue. Instructional guides to correspon-
dence rely heavily on the cultural presumptions that women should keep
to their place and that doing so was the primary project of femininity. That
nineteenth-century readers would expect this subtext would only make it

a more powerful influence on readers who would view letter writing as a mode of rhetorical self-presentation that could not be defined in isolation from how gentlemen and ladies ought to behave.

Middle-class, white women are reminded throughout the nineteenth century by a variety of prestige discourses, including articles in periodicals and conduct books published before and after the Civil War, of exactly what they should perceive as the proper rhetorical arenas of their lives. Etiquette author Mrs. L. G. Abell explains the context for this reminder in her conduct manual, *Woman in Her Various Relations: Containing Practical Rules for American Females* (1850):[7]

> The present volume is offered to the public, dedicated to American Females. We are living when the allotments and responsibilities of Woman, in her own appropriate sphere, should be brought before the mind in their true weight and importance. We need this, that the education shall be better adapted to her wants and condition, and that she may be satisfied there need nothing be added to magnify, elevate, or extend her duties. May the precepts of this work find a note of response in every heart; and as it performs its silent mission of love, may it serve to cheer, console, encourage, and guide in the momentous, all-pervading, far-reaching, practical duties of her everyday life. (Introduction)

Abell's stress on the importance of women keeping to their appropriate sphere where they have valuable work to do that needs no elevation gives us an insight into how deeply disturbed the tranquillity of gender relations already was shortly before the Civil War. Abell makes a promise to the middle-class American woman that if she will do her duty, her influence will be "all-pervading." The Mrs. Abells who produced volumes and volumes of conduct literature throughout the century made this promise to American women again and again: Keep to your place and you will be great there.

In the general context of explaining to American women where they belong and how far-reaching their influence could be there, Abell locates letter writing as a domestic category of conduct falling between care of "The Mouth, The Nails, The Hair, The Eyes, The Skin" and "Behavior to Gentlemen." Treated by Abell as a matter bearing on correct female conduct in the home and in social relations, letter writing is presented as a form of appropriate behavior that women must attend to along with other important domestic duties such as "Care of Parlors," "Customs and Courtesies of Social Life," "A Few Rules for the Waiter," "Conduct at the Table," "Early

Care of Infants," "Clothing and Figure," and "Female Piety" (v–viii). By following rules like these, insists Abell, the American female can aspire to a domestic power that defines her and should content her:

> Woman, as mistress of a family, occupies a station where her influence is deeply, if not widely, felt. She is the center flower, the mainspring, the pendulum that keeps all the delicate machinery in regular motion. . . . Few realize how much skill, tact, good sense, and actual effort, is required in the ordering and rightly sustaining all parts and daily routine of domestic duties. (1)

Abell's attempt to sweeten the positive consequences for women keeping to their place could not be more plain. If women aspired to be the center flower that kept the domestic universe running, they had only to be content with their lot to secure that power, and writing correct letters was one way of doing it. Abell stresses tact, good sense, kindness, and courtesy as the important qualities for a lady to project in the social and family letters that keep the home "in regular motion" (1). By including letter writing among her discussion of rules for the American female, Abell co-opts letter writing into a disciplining agenda that confines rhetorical expression within the boundaries of conduct.

The attention Abell gives letter writing is typical of the very high profile that letter writing has in nineteenth-century conduct literature both before and after the Civil War. Across the nineteenth-century letter-writing tradition, there is a marked correlation between the degree to which authors characterize letter writing as an area of etiquette and the narrowing of women's epistolary worlds. Abell's stance that letter writing is one of the American female's domestic duties that keep the home running smoothly is reiterated in a variety of antebellum discussions on etiquette and in the numerous conduct manuals published after the Civil War that promise the parlor learner reliable advice for living a happy and successful life. In *How to Be a Lady: A Book for Girls* (1846), Harvey Newcomb acknowledges in his discussion of female conduct that his "object is to assist them in forming their characters upon the best model; that they may become well-bred, intelligent, refined, and good; and then they will be Ladies, in the highest sense" (preface). Written a decade earlier than Abell's tract, Newcomb expresses the same interest in the formation of a woman's character and suitability for directing life in the home. Covering standard conduct categories for women such as "Behavior at Table," "Education of the Body," "Knowledge of Household Affairs," and "On Being Contented," Newcomb treats letters under "Writing" and describes the importance of ladies writ-

ing letters of "beauty" by "selecting the best expressions, and clothing your thoughts in the best dress" (162).[8]

Postbellum conduct manuals reiterate the theme that female correspondence is a domestic duty and a display of female character in the best dress possible. In two popular conduct manuals published after the Civil War, well-known women's advisors Sarah J. Hale and Florence Hartley reinscribe what had become by the 1860s a predictable pattern of treating letter writing as one of the major ways a woman conveys her character and preserves the serenity of her home. Hale's status as a prominent spokeswoman on the affairs of women and as a conduct author is well established before the Civil War by her editorship of *Ladies Magazine* and *Godey's Ladies Book*. Hale's ideological position regarding the woman question was unequivocal: the proper sphere for women was the home, not the public arena. Her widely circulated manual, *Manners; or Happy Homes and Good Society All Year Around* (1868), reiterated that view in no uncertain terms for a middle-class, white readership who would have assumed that Hale's advice was the final word on women's lives.[9] Sharing with her colleague Abell the anxiety that women would compromise their chances for happiness by seeking influence outside the home, Hale makes the middle-class woman that familiar promise once again: deport yourself appropriately, and true happiness will be yours. Addressing young women in particular, Hale dedicates her book to "all who seek for happiness in this life, or for the hope of happiness in the life to come" (dedication page). Hale's ambition is great; she hopes to prepare women to lead happy lives in the here and now and to ensure that their feminine character earns them happiness in the next life. Hale's entirely serious ambition to link conduct to salvation raises her text to a polemical level reflected in many conduct manuals of the postbellum period that extend the range of conduct beyond table manners and the like to the principles of a Christian life. We cannot be surprised that in such a profoundly ideological context that the correct performance of gender takes on a nearly life or death significance.

In Hale's argument, rhetorical behavior becomes one of many sites where the battle for feminine goodness can be won or lost. Stressing the beautiful letter as the mark of a lady, Hale rehearses standard advice to the woman correspondent to write carefully and gracefully and to speak from the heart. Hale's characterization of writing letters as simply "the power of expressing one's self on paper with ease and grace" is typical of most letter-writing advice (137), and its very familiarity conceals the degree to which Hale's advice is gender specific. Having already devoted a section to discussing feminine traits of conversation in the home and in society in which women

are counseled to appear dignified, affable, and meek, Hale's advice to women to think of letter writing as simply expressing themselves on paper is already a highly loaded directive (92). Making the case of "A beautifully written letter, who has not felt its charm? who has not owned its power?" (137), Hale follows through on her promise of power to the well-mannered woman by showing examples of how a woman's letters can be significant in ways they cannot always anticipate:

> If, then, such power be theirs, does it not become a solemn responsibility to cultivate the power of so expressing ourselves as to enable us to exercise the greatest influence for good? As this is written for the home circle, a few words must be permitted upon the subject of family letters. It is too common for those who are very fond of correspondence with friends to neglect home letters. Granted, that on your arrival at any point, you are weary, worn, and travel stained, and rest presents itself to you as far more welcome than the effort of writing home; never mind, strive to forget self . . . pen a few lines to assure anxious hearts at home of your safety. . . . Some families, when separated, never allow a day to pass without exchanging a chronicle of its events . . . thus a loving bond, a common interest, is kept up and family affection preserved in all its freshness. (138–39)

By focusing exclusively on family letters as a specific example of how women's letters exert influence and by stressing the writing of such letters as an emotional responsibility that women have to keep the family preserved, Hale leaves little doubt about the purpose or range of women's epistolary power. The reader gets the message clearly: A woman has correspondence obligations to her home and family no matter where she is, in the home or out, and in whichever case, her letters are always ministering to the well-being of those at home. When read in the context of Hale's general argument that a woman's happiness and redemption depended entirely on her deportment, a woman's failure to cultivate the skill of loving correspondence that strives to do good could compromise her character and her home. In the simple composition of a letter, Hale assumes a woman had *much* to lose or gain.

The high-stakes enterprise that Hale makes of letter writing as a deportment issue is echoed by Hartley in her extremely popular etiquette manual for women, *The Ladies Book of Etiquette, and Manual of Politeness* (first published in 1873), a text that like Hale's went through several editions in the 1870s and 1880s and typified the stability of conservative discussions of gender behavior in the last decades of the century.[10] Hartley treats letter

writing as a performance of politeness, which she considers to be akin to Christian feeling:

> True Christian politeness will always be the result of an unselfish regard for the feelings of others. . . . [T]o be truly a lady one must carry the principles into every circumstance of life, into the family circle, the most intimate friendship, and never forget to extend the gentle courtesies of life to every one. . . . Give to such a woman the knowledge of the forms and customs of society, teach her how best to show the gentle courtesies of life, and you have a lady, created by God. (3)

Although Hartley's argument about deportment and salvation is more subtle, her message is the same as Hale's: Behave as a lady should, and the rewards of a Christian life will be yours. Hartley discusses a number of standard conduct topics including conversation, the etiquette of visits, evening parties, traveling, dress, and dinner company. Immediately following a discussion of conduct in the street and preceding the chapter "Polite Deportment and Good Habits," Hartley treats letter writing (7–9). Like Hale, Hartley at first reiterates general rules about letter writing such as the importance of writing with clear and legible handwriting and accurate spelling, in correct grammar, and addressing letters appropriately. Hartley also adds her voice to the unanimous choir of conduct authors who advise women to think of writing as "conversation carried on with the pen" (118). Also like Hale, who tips her hand ideologically when she presents only familial examples to represent women's letter writing, Hartley emphasizes a gendered view of women's correspondence when she cites family obligations and the bonds of friendship as the only specific examples of writing occasions women would encounter. The overall message of her treatment of letter writing is that women should display gentleness of spirit and generosity in writing letters such as letters of advice to a child, letters of affection to a female friend or a relative, and letters home to a family awaiting news as to where in the wide world wife and mother might be. Like so many of her contemporaries who are unable, or perhaps unwilling, to construct the epistolary reach of women as a rhetorical power that extends beyond the walls of the home, Hartley stresses domestic and social relations as the motivating factors for women's correspondence.

Throughout a variety of types of conduct literature ranging from general etiquette manuals to etiquette advice directed specifically to women, letter writing is addressed as a skill no lady who hoped for happiness could do without. Letter writing retains its status in conduct literature of the

postbellum period and at the end of the century. The endurance of letter writing as an archetypical conduct issue throughout the nineteenth century indicates not only that the American middle class remained avidly interested in rhetorical skills and their high cultural value, but also that the ideological link between letter writing and decorum never loosened its hold on the public mind. Although it might seem predictable to find a conservative definition of women's discursive space and influence promoted in nineteenth-century conduct literature that typically advertises itself as ballast in changing times, the persistent fusion of gender and genre in nineteenth-century letter-writing guides indicates that the definition of epistolarly occasions and the stipulation of gender roles were one and the same move.

By combining a guide to letter writing with a "complete book of etiquette," *Chesterfield's Letter Writer* dramatizes rather vividly the close relationship that rhetorical behavior and correct manners had in the public mind at midcentury. Making the general argument that letter writing is one of the "strongest connecting links of common life," *Chesterfield's Letter Writer* makes the case to the reader that its contents are more valuable than earlier letter-writing manuals because these manuals claim to provide models for all possible writing occasions. Calling this claim an "absurdity" and a "sham," *Chesterfield's Letter Writer* explains to the reader that one must learn basic rules about letter writing and apply them to the variety of occasions that come up in everyday life. The advice that *Chesterfield's Letter Writer* offers here reiterates the rhetorical approach to letter writing outlined by Blair who stresses that applying rhetorical principles of style and form to occasions and persons one knows well is the soundest approach to becoming a good correspondent. *Chesterfield's Letter Writer*'s advice to readers that letter writing requires rhetorical common sense and not simply the copying out of a model letter from a handbook "dragged out from the darkness of the drawer" is typical of how letter-writing manuals authors attempted to compete for the public's attention. What is also typical, however, is the highly gendered context which predisposes how *Chesterfield's Letter Writer* constructs correspondence in every day life. What we must note here is that even while claiming to offer sound rhetorical advice to one and all, *Chesterfield's Letter Writer* inevitably characterizes letter writing as a thoroughly gendered activity:

> The time comes for another letter; the "Complete Letter Writer" is dragged out from the darkness of the drawer in which it had hoped to conceal itself forever, and an hour is spent in the search for a model letter that will just express the writer's feelings and ideas. But, alas! among the three hundred and forty-seven specimens of every style

of correspondence, there is not one in which James is politely re-
quested to not forget the boots, or Eliza is reminded that Walter still
hopes to meet her, with sentiments unchanged, when next she visits
New York; there is nothing in the "domestic letters" to meet the case
of baby's teeth, or Susan's blistering, or Jeremiah's illness and recov-
ery, or the death of Mrs. Jones. The business letters say not a word
about the administration of Jones' will, they do not even mention the
apprenticeship of young Waggles. As to the "love letter," the writer
thereof has made no provision for Jemima's acceptance of Joseph on
condition that he will at once shave off his moustache, and take to
all-round collars, and give up punning at the dinner-table. The "com-
plimentary letters" are certainly very pretty, but they don't help one
to present compliments to Mrs. Popejohn, and thank her for her kind
present of a green cat, and a pair of turtle doves. . . . The fact is a
complete letter writer is a complete sham and absurdity. People want
to write letters, out of their own heads, and it is impossible to give
them ready made letters, which like ready made shirts, shall fit every
subject that may require clothing. We know a case of a gentleman—
at least, a person—who offered his hand to a lady with the help of a
letter writer. The letter began, "Reverend Miss"; how it finished the
reader need not be told, but, of course the lover was rejected, and his
"billy dux" went into the lady's museum of curious autographs. Per-
haps he should have copied it "Revered Miss," but he should not have
copied it at all. (7–8)

The author of *Chesterfield's Letter Writer,* who is clearly going to some
lengths to be amusing, takes for granted that his or her readers will find
extremely funny the mistake in proper greeting that results from the un-
fortunate suitor following a model letter too blindly. How ludicrous, it is
implied, that a young woman would be addressed as "Reverend," and what
an offense to her true station of "Revered Miss" is such an inappropriate
salutation. The entire force of the author's critique of the folly of the claim
of "complete letter writer" depends on the reader's recognition of the prac-
tical circumstances of everyday life that make compilations of "complete"
model letters an impossibility. The author gives descriptive texture to the
everyday by numerous examples that show conservative gender roles and
interactions as a matter of course under generic headings like "domestic let-
ters," "business letters," and "complimentary letters." The point is, of course,
that the circumstances addressed by these categories of letters change daily
and that all the permutations of variables of subject and addressees cannot
be anticipated. Yet to illustrate that very practical point, *Chesterfield's Letter*

Writer brings a very "normal," middle-class world to life with vivid references to the love matches of Eliza and Walter and Jemima and Joseph and to the ailments of children, the securing of a job by a young man Waggles, the receipt of gifts from a generous matron, a gentleman's dinner-table conduct and collar choice, and the crucial function of the courtship letter, as the rhetorically illiterate young man learns to his regret. What *Chesterfield's Letter Writer* allows us here is an insight into the unremarkable but typical features of a nineteenth-century middle-class world at midcentury in which men and women are expected to play out their roles with the aid of letters that attend to the practicalities as well as the decorum of gendered spheres.

Postbellum letter-writing manuals extended the tendency of antebellum letter-writing guides to entwine gender roles with the enterprise of letter writing by equating gender spheres with particular kinds of writing tasks and reinscribing with textual directions and illustrations the differences between the domestic writing site of women and the more public business and professional spaces of men's work. Business letters and letters to public officials were to be written by gentlemen, while letters supporting social relationships such as letters of introduction and condolence could be written by either sex, as could love letters. Family letters were particularly the province of women. After the Civil War, the reading public was no less inclined to support a cultural program of rhetorical decorum than *Chesterfield's Letter Writer* readers, who would expect that Eliza and Walter were doing exactly what one would predict of them in writing letters. The many images in letter-writing manuals of women busy writing at their parlor desks and men hard at work on office correspondence reassured anyone with the twenty-five- or fifty-cent purchase price of one of these pocket-sized manuals that writing the right words to the right person in the right way was something one could put one's faith in. The postbellum public had its choice of a range of popular letter-writing manuals including those designed to meet the different writing needs of men and women. The assumed distinction between the rhetorical worlds of men and women was not in question.

In the introduction to *Dick's Society Letter-Writer for Ladies* (1884), editor William B. Dick clearly defines the sphere in which the woman was expected to be writing: "This volume of Society Letters has been carefully prepared to meet the daily or occasional wants of ladies in their intercourse with society, their household duties, their business, and all the demand upon their pen"[11] (5). *Dick's Society Letter-Writer* provides hundreds of sample letters intended to guide the "ladies" in their composition of letters on the subjects they were most likely to pursue, such as letters of social introduction, letters accepting invitations, letters of apology, letters asking

favors, notes soliciting charitable donations, letters of condolence, and family letters. Loosely organized around the antebellum generic headings of familiar letters and business letters, numerous sample letters in *Dick's* under these headings give us an insight into what daily correspondence meant in a middle-class woman's life and just how typical Millie's letter regarding the price of dry goods would be to a readership that was predisposed to expect women to be writing about household affairs or social relationships. For the woman of the house, business correspondence included writing notes of solicitation for charities and good works typically associated with enterprises outside the home that women were expected to view as their concern: an "Old Ladies Home," "the Orphan Asylum," "the "Sunday-School Library," "the Hospital," and the "Children's Mission." Under the heading "Household Letters and Notes," *Dick's* also makes clear that women's business also took in a variety of domestic writing tasks: letters of inquiry regarding potential employees in the home such as a maid, laundress, seamstress, nurse, governess, housekeeper, gardener, coachman, and housekeeper; letters of complaint to tradesmen; and letters regarding house repairs, school schedules, and purchase of household goods by mail (5–18).

The construction of the range of women's business interests in *Dick's* corroborates a conservative domestic sphere for women's activities and restricts the rhetorical force of their correspondence to the maintenance of home and family and by extension to the support of public interests such as hospitals or orphanages that women were expected to see as the natural extension of their caretaking roles. The model letters *Dick's* offers as guidelines for composition present women as quite persuasive within their appropriate sphere. This is one of the most subtle consequences of the conservative gender ideology embedded in nineteenth-century letter-writing literature, and it mirrors the promise of conduct authors like Abell and Hale: women are encouraged to see themselves as forceful with pen in hand but only in rhetorical situations that are appropriate. Under the title "Notes Soliciting Donations," *Dick's* model letters show women correspondents being persuasive in the service of feminine causes.

My Dear Mrs. Newbold:

There is an old saying that a 'willing horse' is always driven to death, and I am afraid you can only too readily see its personal application. Your prompt response to appeals for charity tempts your friends to apply to you whenever an occasion arises, and I, alas, am no exception to the rule.

I have undertaken to beg for our "Children's Refuge" again to sup-

ply various crying needs, coal and flour amongst others. Many of the new arrivals are still waiting for suitable clothing, as we have had more applicants than we had provided for and such cases as we could not refuse, trusting to be able to provide for them later.

If you can help us will you send me a line? and I will call as I make my collecting rounds.

Hoping you will not weary of my frequent appeals to you, I am,

Very truly yours,
T. Moore (137)

Moore's persuasive appeal relies on whether or not she can successfully appeal to Mrs. Newbold's sympathy for the plight of homeless children who will stand to remain cold, unfed, and unclothed without her generous intervention. Appealing essentially to what Moore can anticipate as Newbold's feminine nature, Moore seems to favor a rhetoric of self-effacement and deference as she presents herself as one caring woman appealing to another. The message the reader of *Dick's Society Letter-Writer* receives is that an elegantly written letter can make the difference between protection and despair for the needy, and the well-meaning lady of the house is just the person to write it. None of the model letters in *Dick's* manual or others like it published after the Civil War represents women writing persuasively to officials, politicians, public figures, magazine or newspapers editors, or even clergymen. Models of this kind of public correspondence written by women are conspicuously absent.

Even when distinct generic categories such as the ladies department do not appear as format features in the organization of letter writing texts, women's correspondence is anchored in the domestic sphere by other textual features such as the contrast between female-authored model letters of social relationship and male-authored model letters transacting public business. A staple of the pedagogy of letter-writing literature before and after the Civil War, model letters instruct readers on the particulars of form and style and also reinforce appropriate gender roles at the same time. The simultaneous reinscription of discourse conventions and gender conduct is illustrated in J. B. Duryea's manual *The Art of Writing Letters: A Manual of Correct Correspondence* (1894), a text that reveals that theories of letter writing as a decorum performance are still influential as late as the 1890s.[12] Although published late in the century, Duryea's handbook is remarkably typical of manuals from earlier decades and incorporates standard features of the nineteenth-century letter-writing tradition as a whole, such as the treatment of letter format, the qualities of an effective style, and the major

types of correspondence. By urging his readers to see letter writing as indispensable to one and all and a skill that constructs how others assess the writer's character and worth, Duryea reiterates the high cultural status of letter writing as an enterprise that

> tells the story of our education, our character, and our business ability. If we are neat and orderly or slovenly and careless, these traits will be brought out most forcibly in our letters. If we are educated or ignorant our letters convey the fact more certainly than an interview. "Your letter is a full-length portrait of yourself," says De Tocqueville. (viii–ix)

The gendered implications of writing one's "portrait" can be read in several features of Duryea's text that reinforce the domestic rhetorical world of women and the more public discursive world of men. In Duryea's discussion in "Various Kinds of Letters," for example, all the model letters for business occasions outside the home such as letters of job application are written from men to men, while the model letters provided for instruction in writing the letter of condolence are all written from women to women. As in the example of "My Dear Mrs. Newbold" used in *Dick's Society Letter-Writer,* the distinction between the public world of work and the private domestic world of women is made clear by the use of sample letters that present women writing eloquently when performing a social role that would be expected of them. In these models, Duryea presents women writing letters comforting a bereaved friend and congratulating a friend upon her upcoming marriage:

> Lima, Ohio. Sept. 1, 1894
>
> My dear Friend,
>
> I feel that my words are weak and lame when I attempt to tell you what is in my heart today. Your sister's letter, announcing the death of your kindest and dearest friend on earth, is before me, but I cannot write—I can only weep. . . .
>
> > Your affectionate friend,
> > Claudia

> Sperry, Iowa, Nov. 6, 1892
>
> My dear Marguerite,
>
> Your letter announcing your marriage to Mr. Charles Watt, is just at hand, and I could not have been better pleased. I have known Mr.

Watt long enough to form a very good opinion of him, and have not the slightest fear but that you will spend many happy days together. . . . I feel a genuine joy over the occasion—it is my joy as well as yours, and I sincerely hope for your everlasting happiness. It would please me much to hear from you at your earliest convenience.

> Believe me, my dear,
> Ever your loving,
> Julia

When we read across Duryea's text and note that letters by women are not offered as models in sections treating more public correspondence such as letters of recommendation and letters of application, the inclusion of these personal letters by Claudia and Julia are notable not only because they inscribe a portrait of an idealized, loving, sensitive, and generous female nature but also because these letters deal only with social relationships. With a few pages of examples, Duryea's text constructs women writing within their proper sphere as well as performing femininity in conventional rhetorical terms.

The gender roles dramatized by Claudia and Julia's social letters of condolence and congratulation are further reinforced by the position in the overall organization of Duryea's treatise these feminine letters occupy. Claudia's and Julia's letters are immediately preceded by model job-application letters written only by men. Earlier in the text, Duryea juxtaposes female authors and male authors in a similar way when he presents model letters of recommendation written by men with letters of social introduction by women. Similarly, Duryea places letters of inquiry by men about business and educational opportunities side by side with letters of inquiry from women who seek information about family matters, such as a letter of inquiry from a "loving sister" asking when her "dear brother" will be home for Christmas (94–95). These pairings of letters in which men and women are clearly writing very different kinds of letters corroborate the point made by the separate-desks motif: the rhetorical worlds of men and women are separate ones. Nowhere in Duryea's 172 pages of text are model letters provided for imitation that present women writing business inquiries, job-application letters, letters of recommendation, or any kind of epistle at all that does not focus on the social and family relationships.

The gendered nature of Duryea's treatment of letter writing is reinforced by frequent statements in the text such as these that link the preparation of letters specifically to the different needs of men and women: "Many a young man has lost a position by poor spelling"; "For gentlemen, and all

business correspondence, nothing but pure white, or blue white should be used"; "It is in better taste for ladies to have their address or initials printed in one corner"; "Square cards are used for short notes but the thick, plain white, English note folded square and put into a square envelope, has never changed and never will change. It is used by ladies the world over"; "Ceremonious notes are usually sealed with wax of any color suggested by the writer. Red for gentlemen, and gold or blue for ladies is perhaps as good as any" (160–63). In gendering the writing process right down to the tint of paper and color of sealing wax, Duryea stands in a long line of nineteenth-century letter-writing advisors who spare no detail in defining the domestic context of the woman's discursive world and how it contrasts with the considerably more public outreach of male discourse. Although Duryea and his contemporaries are adamant in their defense of letter writing as an indispensable skill, there is little recognition in the rhetorical world they urge women to live in of the shifting social and economic status of women in the latter decades of the century. By their relegation of women's discursive roles to comforting and consoling friends and negotiating family ties, Duryea and his colleagues such as Cogswell and Nichols contribute to a conservative cultural discourse that would assure their middle-class readers that Claudia and Julia, like Millie, are exactly where they are supposed to be—taking care of the only business that is in their purview, the affairs of home and family.

The conservative agenda of writers like Duryea and Cogswell, who would have their readers assent to the limits of Claudia's and Julia's worlds, is never displaced in the nineteenth-century letter-writing tradition as the most dominant argument about women, correspondence, and rhetorical space. When taken as a whole and read as an extended conversation about the interdependence of rhetoric and gender in the construction of social identity, nineteenth-century letter writing literature betrays an ambivalence regarding the roles of women that is particularly obvious in the last few decades of the century. In letter-writing texts of the 1880s and 1890s, the profile remains high of treatments of letter writing as both a conduct issue and characterizations of letter writing and as a practical art of general composition. This profile indicates that as the century draws to a close, the dual identities of letter writing as an art of rhetoric and an art of gender decorum remain unresolved. Postbellum encyclopedias also include letter writing as a subject under "all one needs to know" and cautiously extend the rhetorical boundaries of women's world to include writing letters to secure employment outside the home. Other letter-writing guides published in the last decades of the nineteenth century continue to construct letter writing

for women as if it functions only as it appears to for Millie, to maintain social relationships and maintain the well-being of the home. In the difference in liberality between the construction of the writing woman in these groups of texts, we can read evidence of the high level of tension in the public mind about roles for women that are increasingly in a state of flux as the century winds down.

That letter writing is treated as a matter of course in encyclopedias that typically advertise their contents as a complete and comprehensive book of reference confirms the status of letter writing as a rhetorical skill that nineteenth-century Americans considered indispensable and indicates that the cultural value of letter writing had by no means diminished as the century ends. Aimed at a person who appears to be a genderless and general reader, encyclopedias like James D. McCabe's *The Household Encyclopedia of Business and Social Forms, Embracing the Laws of Etiquette and Good Society* (1882) appear to approach letter writing as more of a practical issue than a gendered one:

> There is no accomplishment more useful to the educated person than the ability to write a good and attractive letter. Some persons possess this capacity as a natural gift, but it is within the reach of all who seek to acquire it. The first and greatest truth that should be kept constantly in mind is that in writing a letter you are talking with your pen instead of your mouth, and your aim should be to express yourself as simply and naturally as you would in conversation. Your letters should bear so strong an impress of your personality, that your correspondent, upon reading it, will involuntarily exclaim, "That's like Smith, isn't it?" (238)

Although Smith, who is obviously a man, gets represented here initially as a representative correspondent, fewer gender markings overall texture this discussion of how to write a well-formed letter and how to adapt to the generic expectations of particular types of correspondence. *The Household Encyclopedia* presents general advice relatively uncontextualized by explicit considerations of gender decorum. Model letters for imitation under family correspondence, letters of condolence, and congratulation are not exclusively tied to the domestic sphere of women and include hypothetical examples written by both men and women. Similarly, in the discussion of genres often characterized as male genres such as letters of recommendation and application, women's letters are included among those of men as samples. *The Household Encyclopedia* and other representative texts of the same genre such as G. A. Gaskell's *Gaskell's Compendium of Forms, Educa-*

tional, Social, Legal, and Commercial (1881), and Thomas Edie Hill's *Hill's Manual of Social and Business Forms: Guide to Correct Writing* (1883), extend the epistolary range of women by representing them as authors of a wider range of public letters and by giving less-gendered advice about style and letter preparation. The greater liberality in the presentation of women's epistolary range in these texts is constructed by large, textual features such as the generic range of model letters and the shifts in traditional advice regarding how a letter is to be prepared. Letters by women appear as model texts under business letters and letters of application in *The Home Encyclopedia, Gaskell's,* and *Hill's.* Absent altogether from these encyclopedia treatments of letter writing is gendered advice about writing styles urging women to be delicate and warm and men to be clear and efficient. Tips about writing paper and the proper color of sealing wax for men and women drop out as standard advice and are replaced by general directions to one and all on penmanship, choice of paper and wax.

Although readers of late-nineteenth-century encyclopedias would see a more purely rhetorical presentation of letter writing as a composition skill and less-conservative presentations of the range of female correspondence, treatments of letter-writing encyclopedias are not free from vacillation on exactly what boundaries ought to encircle the middle-class woman's rhetorical world. Although encyclopedia treatments often provide model business letters written for women and assume that women also might be writing letters of application for employment, this tentative extension of the middle-class woman's discursive activity is often complicated by pictorial representations of women reading and writing letters in strictly domestic circumstances. Separate-desks illustrations are common in postbellum encyclopedias, as are other kinds of illustrations depicting women correspondents in the home. For example, three engravings included in *The Household Encyclopedia* illustrate the tension between a conservative agenda regarding women's rhetorical space and a more realistic one that reflected the fact that by 1880 women were seeking employment and education outside the home in record numbers. The advice on letter writing that McCabe offers in *The Household Encyclopedia* is directed to all educated persons and is generally free of the etiquette orientation that constrains many treatments of letter writing. McCabe consistently uses the noun *person* instead of persistent references to *gentlemen* and *ladies* that encourage readers to read advice with gender roles in mind; he also provides sample business letters by women authors. With these features alone, McCabe resists the tendency of more etiquette-oriented treatments of letter writing that characterize ladies as having only social or domestic letter writing obligations. However,

Fig. 3.5. "Shipwrecked Hopes," *The Household Encyclopedia,* 1880

when McCabe's text is considered as a whole, one sees a subtext about gender and writing inscribed by a set of engravings placed at intervals in the text. Two of the engravings appear within the chapter on letter writing itself. The first engraving in the chapter is entitled "Shipwrecked Hopes" and shows a well-dressed young woman with a pose of sadness, standing at a window looking out to sea. A letter and envelope lie at her feet as if they have fallen to the floor in a moment of distress (see fig. 3.5). This engrav-

Fig. 3.6. "Yes or No?" *The Household Encyclopedia,* 1880

ing is intended to show either that the young woman has received bad news of a broken engagement or of the death of a suitor. The second engraving, "Yes or No?" depicts an elaborately dressed young woman at a desk in a stately bedchamber thoughtfully considering the contents of a letter. The title "Yes or No?" implies that the lady has received an important invitation or perhaps even a marriage proposal and must contemplate the appropriate reply (see fig. 3.6). The cumulative effect of these scenes, the only

illustrations included in this chapter, would confirm for the postbellum reader that letters are entwined with the significant events of their lives as well as affirm with equal force, if not more force, a familiar, cultural construction of the discursive events of women's lives as centering around personal relationships.

By offering textual advice that awards women more discursive choices than many of his contemporaries and by positioning these highly idealized and conservative images of women and the function of letters in their lives, McCabe constructs what is finally an ambivalent gaze, a point of view about women and writing that reveals that McCabe cannot make up his mind between the tender icon of femininity and the woman who takes pen in hand to apply for a job. Perhaps most revealing of all in McCabe's uneasy construction of women's epistolary sphere is his choice to position a similarly conservative engraving at the beginning of his volume directly prior to the title page bearing the promise, "Expressly designed to meet the every day needs of the People." This engraving carries the title "The Invitation" and shows three young women leaning on a parlor table reading an invitation that has obviously just arrived (see fig. 3.7). This illustration presents letters in what a late-nineteenth-century reader would certainly perceive as a customary event in the lives of middle-class women for whom, the illustration implies, the receipt of social correspondence provokes excitement and interest. Although comparatively more trivial as an epistolary event than those depicted in "Shipwrecked Hopes" and "Yes or No?", "The Invitation" would remind readers at the very outset of reading McCabe's text of the essentially social and personal nature of women's letter writing. The placement of "The Invitation" as an opening frame for McCabe's encyclopedia contextualizes the reading of his collection of essential facts by ensuring that the reader's perception of the woman letter writer is never entirely free of the entanglement of sentimental views of women as sensitive and emotional beings who are eager to define their lives in terms of their relationships with others and whose virtues are shown to best light in domestic settings.[13]

"Shipwrecked Hopes," "The Invitation," and "Yes or No?" attest both to the prominence of letter writing in all types of nineteenth-century treatises that provided educational advice for the home learner and to the abiding conservative construction in that literature of the woman letter-writer as a correspondent who maintained family and social relationships and kept the home in regular motion. The cultural status of the epistle is undeniably high in both the antebellum and postbellum periods and has to be regarded as the form of composition most generally valued as essential in

Fig. 3.7. "The Invitation," *The Household Encyclopedia,* 1880

everyday middle-class life. It is equally clear, however, that the status of letter writing as an indispensable rhetorical art was supported throughout the nineteenth century by an ideological desire to maintain conservative boundaries around women's rhetorical influence. When well-dressed, middle-class Millie waves her letter from the cover of *The Shelby Dry Goods Herald,* she signals to a reader already predisposed to imagine her epistolary world as bounded by the parlor walls that enclose her. Millie signals that she reads and writes from that space and about that space and is happy to do so.

Inscribed in the public imagination along with a legion of portraits of white, middle-class women with shipwrecked hopes, relationships to attend to, and notes to the baker to get into the mail, the picture of "Millie's letter" serves to reassure a postbellum readership that although the cultural power of the letter was great and useful, the right-thinking American female understood where her epistolary power was best employed.

4

NOBLE MAIDS HAVE COME TO TOWN

Late to our town there came a maid
A noble woman, true and pure,
Who, in the little while she stayed,
Wrought works that shall endure.
— "Hymns of the Ages," qtd. by Kate Sanborn,
in "Frances E. Willard," *Our Famous Women*

In her laudatory sketch of Francis E. Willard in the biographical volume *Our Famous Women: An Authorized Record of the Lives and Deeds of Distinguished American Women of Our Times* (1884), American author and lecturer Kate Sanborn calls this poem to her readers' attention and likens the "noble woman" who comes to town to do good works to Willard, whom postbellum middle-class readers would readily recognize as the well-known president of the Woman's Christian Temperance Union and a popular public speaker. Exactly what Sanborn means by the appellation *noble woman* becomes more clear when she recalls her reaction to hearing Willard speak for the first time and also recounts an anecdote about a clergyman's reaction to attending one of Willard's public lectures on temperance:

> When Miss Willard rose and began to speak I felt instantly that she had something to say; something that she felt it was important that we should hear, and how beautifully, how impressively, how simply it was said! not a thought of self, not one instant's hesitation for a thought or word. Every eye was drawn to her earnest face; every heart was touched. . . . The whole thing was a revelation to me. I had never met such a woman. No affectation, nor pedantry, nor mannishness to mar the effect. Of course it was the humiliating contrast between her soul-stirring words and my miserable little society effort, that drove me from my place, but all petty egotism vanished before the

wish to be of real use to others with which her earnestness had in-
spired me. This is the effect she produces, this is the influence she
exerts. . . . A clergyman who came in late on the occasion of her lec-
ture in Charleston said: "I expected to find a cropped-haired, mas-
culine-looking individual, with hands in pocket and voice keyed to
high C, and could scarcely believe my eyes when I saw a graceful,
beautiful woman, simply and yet tastefully dressed, standing mod-
estly in front of the pulpit, and in soft, sweet tones, pleading for those
who could not plead for themselves. I had not listened two minutes
before I surrendered, and I could not now no more doubt her call to
the work she is engaged in than I could question my own call to the
ministry." (695)

Sanborn's and the clergyman's shared relief that Willard displayed no man-
nish qualities and their similar reaction to Willard's touching and sweet
tones make it clear that Willard's oratorical success is perceived to be linked
with her femininity. In Sanborn's characterization, Willard appears to per-
suade her listeners because she performs an irresistible combination of the
best qualities of the white Christian woman: she is noble, maidenly, and
soft spoken. It seems clear from the reactions of Sanborn and the clergy-
man who both surrender to Willard's eloquence that Willard's performance
of a conventional feminine identity is the perceived key to her inspiring
rhetorical power. We can also surmise that had Willard indeed presented
herself as loud voiced and "cropped-haired," her rhetorical performance
would have been described in far less glowing terms. Sanborn confides ear-
lier in her sketch of Willard that when she learned she was to be at the same
dinner party as "Miss Willard," whom she had never met, she "indulged
in an ignorant and extremely foolish horror of those crusading temperance
fanatics" (692). Sanborn's fear that Willard was likely to be a fanatic and
the anonymous clergyman's negative expectation that a woman lecturer
would be masculine in some obvious way reveal how mixed cultural feel-
ings remained regarding women's rhetorical roles in the decades after the
Civil War.

Although a speaker of considerable fame by the 1880s, Willard's rhetori-
cal character is entwined in Sanborn's biographical essay far more with a re-
assuring femininity than with the cause of temperance with which Willard
was closely associated. In 1874, Willard founded the Woman's Christian
Temperance Union and assumed the presidency of the organization and by
1883 had become a high-profile public speaker on behalf of temperance
and other causes such as women's suffrage and the raising of the law for the
age of consent. Willard traveled thousands of miles every year on speaking

tours and was, like Mary A. Livermore, a popular platform speaker and well known for her reform interests.[1] Yet to read Sanborn's biographical sketch of Willard in *Our Famous Women,* which lists none of these accomplishments, a reader could be struck most by the fact that Willard was a noble woman who spoke modestly and gracefully from the heart. What Sanborn seems to want to impress upon her readers most enthusiastically is that Willard remained a noble woman despite her rhetorical calling to public life.

Included herself in *American Women: Women of the Century: Fifteen Hundred Biographies* (1893), a collection of biographies edited by Willard and Mary A. Livermore, Sanborn would have been a recognizable name to readers of *Our Famous Women.* A popular lecturer and author of literary and travel essays, Sanborn was a pioneer in the women's club movement, a frequent contributor to periodicals, and the author of two books on her experiences as a gentlewoman farmer.[2] The biographical sketch of Sanborn in *Women of the Century* recounts the facts of Sanborn's career as a speaker and writer and ends with a statement that, like Sanborn's characterization of Willard, finally seems to reassure the late-nineteenth-century reader that while a talented woman of words, Sanborn was first and foremost a good woman: "Few women are so versatile and can lay claim to superiority in so many lines of work as Miss Sanborn, who is a teacher, reviewer, compiler, essayist, lecturer, author, farmer, and above all, famed for her cooking and housekeeping" (630). Similarly, the entry on Sanborn that appears in a subsequent biographical volume, Mary S. Logan's *The Part Taken by Women in American History* (1902), seems to depend upon the *Women of the Century* sketch of Sanborn for content and concludes a paragraph-long description of Sanborn's career with nearly the same words: "She is teacher, reviewer, compiler, essayist, lecturer, author, and farmer, and is famous for her cooking and housekeeping" (869).

The standard inclusion of Sanborn in several biographical volumes published at the turn of the century indicates that her public reputation was significant and explains why she is included among the thirty eminent authors of *Our Famous Women.* Sanborn's characterization of Willard as a noble woman who exuded feminine virtue at the podium would have authority with readers already predisposed to view Sanborn as a commentator of some note. That Sanborn's emphasis on Willard's performance of femininity bears a clear similarity to how Sanborn herself is characterized in Willard and Livermore's biographical volume points to a particular generic characteristic of how the lives of white, middle-class women who achieved popularity as public speakers were constructed in biographical literature (and autobiographical literature) after the Civil War. By using the

theme of "a noble maid has come to town" in her biographical sketch of Willard in *Our Famous Women,* Sanborn defines Willard's display of femininity as a crucial component of her oratorical performance, a display made all the more impressive and appealing by Willard's embodiment of a compelling femininity in a public rhetorical space that Sanborn and the clergyman so thoroughly associate with male privilege that they both expect that any woman giving a public lecture would surely be mannish in demeanor. Even though it seems necessary to remind nineteenth-century readers that the well-known Kate Sanborn was really just a woman who loved to stay at home and cook, it seems to be even more important to the maintenance of cultural conventions to domesticate the rhetorical careers in the biographical construction of the lives of nineteenth-century women who achieved public fame as orators and lecturers, such as Susan B. Anthony, Livermore, Elizabeth Cady Stanton, and Willard.

In postbellum biographies of prominent women rhetoricians, of which Sanborn's sketch of Willard is typical, a general cultural anxiety over the entrance of women into public rhetorical forums reveals itself in the pointed attention given to describing the domestic interests and conventional feminine dispositions of women such as Willard, Stanton, and others who achieved influence through high-profile rhetorical careers. In the many biographical sketches in *Our Famous Women,* for example, and in volumes like it published in the last decades of the century, there is a close ideological affinity between popular constructions of prominent women speakers as noble maids (and also as mothers of the nation) and the conservative construction of women's rhetorical roles offered to white, middle-class women in general during the same era by parlor rhetorics and a wide array of conduct literatures that reinscribe conservative definitions of where and how women should speak and write. By characterizing women like Willard and Stanton as noble women always modest and gentle in their speaking roles and essentially maternal in their motives, popular postbellum biographies (and autobiographies) of prominent women speakers portray the public podium as an extension of the domestic site of white, middle-class women's traditional cultural power and characterize women speakers as achieving their public influence only as a result of an inspired extension of their feminine powers and natural domain. Contributing to an ongoing cultural conversation about rhetorical space as a site where gender and power relationships could be reinscribed and negotiated, postbellum biographical treatments of women orators reinscribe the dominant nineteenth-century cultural assumption that a woman's rhetorical status depended upon whether or not she performed gender appropriately when speaking or writing.

Biographical literature published after the Civil War conferred the title famous women only upon a white, middle-class elite, comprised of Anthony, Livermore, Stanton, Willard, and other reformers including Clara Barton, Harriet Beecher Stowe, and Julia Ward Howe who were promoted collectively as exemplary, female role models. In biographies profiling women who led active careers as public speakers, a preferred characterization emerges of the noble maid or wise mother called reluctantly from her domestic duties to the podium only because her female sympathy impels her to speak out for the helpless and the weak. Sanborn's characterization of Willard as the noble maid who came to town implies that Willard speaks out because she was motivated to do so out of a deep sense of commitment to the nation analogous to the devotion an ideal mother would exert on her children's behalf. Elizabeth Stuart Phelps's characterization in her biographical profile in *Our Famous Women* of Livermore as a woman who "mothered half the land" similarly constructs Livermore as a concerned mother who takes to the public lectern only out of feminine sympathy (412). According to this ideological narrative, women orators were not out of place at the public lectern but instead were watching over the affairs of the nation as they would their own households. The noble-maid and mother-of-the-nation characterizations are so typical in the popular press of the second half of the nineteenth century as to function as standard conceptual tropes in the nineteenth-century biographical construction of Willard, Stanton, Livermore, Anthony and other well-known, white, reformist speakers and writers. The popularity of these tropes enabled women like Willard and Stanton to exert tremendous influence on political events of the last half of the nineteenth century, because both their words and reformist efforts could be read as exemplary performances of the very best of American womanhood.[3] However, the rewriting of the lives of powerful female rhetoricians like Willard and Stanton into the conservative idealizations of the noble maid and wise mother roles did little to shift the dominant nineteenth-century cultural assumption that women ought to confine their rhetorical activities to the parlor and fireside.

The noble-maid and mother-of-the-nation roles implied that women speakers were co-opting the public lectern as a domestic site from which to exert their feminine moral force. The foregrounding of these cultural tropes in biographical and autobiographical constructions of famous women orators in the decades following the Civil War regendered public rhetorical space in conservative terms by representing women speakers as performing at the podium only those actions that good women would naturally do at home—intercede for the weak and voiceless and offer words of comfort

and counsel to their children and family. This construction of what the
formal eloquence of women could comprise corroborated the generally held
nineteenth-century view that women speakers, and women in general, were
eloquent not because they were skilled, but because they were moral and
loving women who were naturally persuasive in their proper sphere. Bio-
graphical profiles of prominent women speakers, such as Stanton's sketch
of Willard, were ostensibly designed to diffuse cultural prejudice against
women speaking in public by reassuring readers that Willard and others like
her were bringing the best of feminine sensibilities to the podium. How-
ever, the biographical contextualization of Willard's rhetorical career, as well
as the careers of other well-known women, within a gendered discourse that
stressed the podium as a domestic space and naturalized women's rhetori-
cal power, only served to deepen a general cultural ambivalence about the
place of women in public rhetorical space and affirm the ideological mes-
sage promoted by parlor rhetorics and conduct literature that women spoke
best when they spoke at home on domestic issues. As the century ended,
the prominent women orators of the nineteenth century were venerated in
the public mind not because they were considered to be great orators but
because they were represented as great women, a perception that left virtu-
ally unchanged the cultural assumption that women were only eloquent
when they spoke from the moral authority of their roles as wives and moth-
ers. Writing Willard back into the rhetorical space of the parlor with every
stroke, Sanborn's sketch of Willard as a noble maid and others like it that
capitalize on the tropes of noble maid and mother, encouraged a white,
middle-class readership to believe that the rhetorical power of women in
public forums could be viewed as one more demonstration of how noble a
good woman could be when her domestic authority was dispersed in the
proper words and in the proper place.

In addition to Sanborn's sketch of Willard, *Our Famous Women* offers
thirty other biographies of the "lives and deeds of distinguished American
Women of Our Times" including Willard, Stanton, Livermore, and An-
thony as well as several other well-known nineteenth-century women such
as Louisa May Alcott, Catherine E. Beecher, Margaret Fuller, Julia Ward
Howe, Lucretia Coffin Mott, Elizabeth Stuart Phelps, and Harriet Beecher
Stowe (viii–ix; 135). In addition to its highly conservative rewriting of gen-
der identities for women who had, in fact, exceeded existing categories for
women's behavior and occupations, one of the most obvious features of *Our
Famous Women* is the failure to include African American women among
the famous. This omission betrays the extensive racism of the postbellum

period and mitigates against interpreting the motives in entirely altruistic terms of editors and authors of biographical volumes like *Our Famous Women*. *Our Famous Women* bears a striking resemblance in content and ideological orientation to a previously published biographical collection on notable nineteenth-century women, *Eminent Women of the Age: Being Narratives of the Lives and Deeds of the Most Prominent Women of This Generation* (1868), a volume that claims to be the first "authentic . . . record of the lives and achievements of those women of our time who have distinguished themselves in their various occupations and conditions of life" (v). Citing "excellence" or "eminence" as the criteria for inclusion, the publishers of *Eminent Women* include a variety of sketches of women perceived to be notable immediately after the Civil War including orators Anthony, Anna E. Dickinson, Angelina Grimké, Sarah Grimké, Abby Kelley, Mott, and Lucy Stone (v). Initiating a format that would be imitated in *Our Famous Women,* the publishers of *Eminent Women* follow the practice of enlisting the famous to write about the famous. For example, Stanton contributes all the essays on the "champions" of the woman's rights movement as well as the profile of Dickinson, an abolitionist speaker who was, in 1868, the most famous woman orator in the country.

The exclusionary construction of who counts as eminent in *Eminent Women* relies on *eminent* functioning as a cultural synonym for *whiteness* in the same way that famous serves this coded function in *Our Famous Women*. While it is not the stated intention of the publishers of either *Eminent Women* or *Our Famous Women* to celebrate the achievements of only white women, both volumes achieve exactly that by positing whiteness as the unmarked context that authorizes the exemplar terms *famous* and *eminent* and eventually femininity and motherhood. The extent to which these first influential biographical collections of notable nineteenth-century women erase the lives and contribution of African American platform speakers such as Sojourner Truth and Frances Ellen Watkins Harper implies that the readers of volumes like *Eminent Women* and *Our Famous Women* were intended to be white, middle-class, Americans who not only wanted the essential stability of gender roles to remain the same, but who were also highly invested in holding onto a raced icon of the ideal American woman. The exclusion of African American woman reformers and speakers from the categories eminent and famous and the simultaneously reinscription of the icons of noble maids and mothers of the nation in sketch after sketch allowed the readers of *Eminent Women* and *Our Famous Women* to assume that women were really still in their rightful place acting as women should

and also allowed those same readers to go on imagining an America in which great deeds and great words remained the property and the opportunity of the white middle class.[4]

Of the total of thirty biographical sketches in *Our Famous Women,* ten are written by women who are themselves profiled in the volume. For example, Stowe contributes the essay on Beecher; Phelps writes the profile of Livermore; and Stanton profiles her close colleague and friend Anthony. (There is no rhetorical pretense of objectivity in this set of essays in which close friends portray each other, and daughter Maud Howe profiles her mother, Julia Ward Howe.) In an impressive maneuver of ideological re-inscription that celebrates every essentialist ideal of the American woman, these famous women reinforce each other's portraits as either noble maids or mothers of the nation who have claimed the public sphere rhetorically as an arena of good works. This gendered rationalization for public speaking, which is obvious in Sanborn's noble-maid sketch of Willard, is also prominent in other sketches of well-known reformist speakers such as Livermore, whose life story biographer Phelps characterizes as the "womanly story of a noble woman" (387). Phelps also attributes to Livermore the "most motherly face that the Lord ever made" (412).[5] Phelps recounts Livermore's career as "the full development of a wholesome natural life." Phelps's final paragraph on Livermore is remarkable in its efforts to leave the reader with the idealization of a good mother who never countered her "natural" disposition as a noble woman:

> It is good to have her power, her wisdom, her influence, and her fame. It is better to have her tenderness, her self-oblivion, her human happiness and her home. It is best to know that she has been able to balance these qualities and quantities with a grace which has not fallen short of greatness, and that she has accomplished greatness without expunging grace. (414)

Phelps emphasizes Livermore's maternal nature and her love of home rather than Livermore's career accomplishments such as her active leadership in the United States Sanitary Commission, a nursing and hospital service during the Civil War, her organization of one of the first Woman's Suffrage Conventions, or her popularity as a speaker on the Chautauqua circuit in the decades after the war. Phelps's choice to stress Livermore's maternal credentials makes it clear that in the latter decades of the century, there was a perceived desire to rewrite the characters of public women like Livermore into the iconography of the noble, American woman by downplaying their prominence as public speakers and social commentators and reassuring the

public that successful rhetoricians such as Livermore (and Willard) were *really* fulfilling rather than compromising their conventional roles as noble maids and mothers.

In her sketch of Stanton, which also appears in *Our Famous Women,* Laura Curtis Bullard calls Stanton a "perennial eminence in our political history" and chronicles Stanton's leadership in the suffrage movement and to the cause of abolition (623).[6] However, Bullard also emphasizes for the readers of *Our Famous Women* what was a familiar picture by the late 1880s of Stanton as a devoted mother of seven and an ideal wife to lawyer and editorialist Henry Stanton. Bullard balances a detailed description of Stanton's early speaking career and eventual leadership of the women's rights movement (along with Anthony) with a narrative about Stanton's married life, her relationship with her children, and the legendary warmth of her home. Early on in the sketch, Bullard observes confidentially to the reader that certainly Stanton entered the life of a public speaker with reluctance: "I am sure that Mrs. Stanton with her studious tastes and love of domestic life had never planned for herself a public career" (609). Toward the end of Bullard's overview of Stanton's public career, the reader gets the impression that domestic life remained foremost among Stanton's priorities:

> Mrs. Stanton is the mother of seven children (five sons and two daughters), all of whom are living. Her sons are young men of culture, two of whom are successfully following their father in the law. Both her daughters are married and beginning life for themselves. All these children, in the words of the Wise Man, "rise up and call her blessed." John Stuart Mill said long since that the homes of clever and public-spirited women were the pleasantest which he had ever seen. Mrs. Stanton has been one of the most successful home-makers in the land. Of late years she has lived at Tenafly, N.J., where as a visitor I have witnessed her skill in the art of housekeeping, and have seen her matronly cheeks aglow from sporting with her full-grown children in the open air under her ancient chestnut and cedar trees. (621)

In a biographical sketch that recounts several examples of Stanton's impressive oratorical successes, Bullard's tribute to Stanton's ideal domesticity reveals how very important it was for postbellum readers to imagine Stanton, not at the many lecterns at which she wielded such power, but at home playing with her children, all aglow with maternal pride and love, overseeing family life in an idealized, pastoral setting that preserved a domestic frame for Stanton's public accomplishments. Although Stanton was widely recognized by 1883 as one of the major architects of the women's suffrage

movement, readers of *Our Famous Women* are left with the dominant impression of Stanton as woman who presided lovingly over her home and who sent out her good works and words from that sphere where she exerted her most profound influence of all.

The cultural assumption that underscores the popularity of Stanton's domestic image is the widely held nineteenth-century view that the most important rhetorical role for American women was their healthy moral influence over domestic life. For eloquence, no one could match the devoted mother instructing her children or the wise and loving wife counseling her husband. The ideological force of this assumption exerted its influence before and after the Civil War and well into the turn of the century. The conservative spirit of this bounded construction of women's rhetorical lives is captured in the following excerpt from the *Ladies Repository: A Monthly Periodical Devoted to Literature, Art, and Religion* (1854) that tells a moral tale of the rhetorical life of the ideal woman and stresses that the words of the "true hearted woman" and the impact of "a mother's voice" are the most profound forms of persuasion. In this article, entitled "The Eloquence of Woman," author William H. Barnes offers the American mother the mantle of the greatest orator of all time in exchange for keeping to her quiet fireside:

> Earnest and powerful are the words of a true-hearted woman. When aroused by the call of duty or sympathy, she can do great deeds and speak deep-meaning words. Then her noble thoughts come forth clad in the simple language of nature. Her tearful eye and sweet-toned voice, employed in behalf of those she loves, have melted the stout hearts of war-worn veterans, and moved kings to deeds of mercy. . . .
> If permitted to visit their quiet firesides, you might hear words that would linger upon your memory forever. The youth of our land compose a vast auditory assembled in the ten thousand beautiful cottages that crown the hill-tops and nestle in the valleys of America. They are favored above every other audience ever congregated upon earth. They listen to the eloquence which gushes from a loving heart, while most assemblies of the world are addressed by the cold-hearted sons of policy. The mother feels a interest in those before her such as Demosthenes never felt in those who listened to his thunders. The tendrils of her soul's affection are entwined about the very lives of those to whom she speaks. The orator is eloquent in proportion to the importance of the occasion which calls him forth. Surely the mother has motives which should arouse the mightiest energies of the human soul. (174–75)[7]

In this seductive invitation to view her circumscribed domestic world as an oratorical kingdom without compare, the American woman is awarded every possible accolade for eloquence that comes naturally to any "true hearted woman." Cast in this narrative as an orator more persuasive than the "cold-hearted sons of policy" who address audiences on political topics of the day, the noble mother, who cares only for the well-being of her children and not the events of national life, keeps burning an oratorical flame greater than the eloquence of the famed classical orator Demosthenes, who is frequently cited in rhetoric and elocution texts of the nineteenth century as an exemplary orator who shaped political and historical events. The eloquent mother is placed in a conventional rhetorical situation described with familiar terms such as audience and occasion in which she is triumphant in a rhetorical space that is represented as somehow more significant than, but still not approximate to, the rhetorical arena in which public and national policy are at stake. The eloquent mother's power flows from a loving heart, the call of duty, and feminine sympathy, qualities that any "true-hearted woman" possesses and deploys daily as she persuades her children, that most favored of audiences, to a moral and wise life. Barnes's fable-like style, with its romantic imagery of simple but beautiful cottages nestled in valleys and on hilltops, confers a tone of universality to his tale of the eloquent mother that only serves to deepen the iconic inscription of the American woman as a sweet-toned angel dispensing sympathy and wisdom from her fireside. Barnes ends his moral tale with the observation that if the true history of those orators who had "swayed mankind" were to be written, it would become clear that the words and ideas of "men of genius" were "heart-born thoughts first started by a mother's voice" (175). Barnes's construction of the eloquent mother confirms the parlor as a woman's proper rhetorical world and limits the rhetorical impact of women to a context in which their influence on public events and policy is indirect at best, felt only through the influence of their fireside eloquence on their sons.

To American readers at midcentury, Barnes's fable of "The Eloquence of Woman" presents an appealing scenario by reinscribing the "natural" power of women's words while framing that power as entirely bounded by the cottage walls within which the eloquent mother speaks. Although written two decades later, an article entitled "The Model Woman," appearing in the *Ladies Repository* in 1874, confirms the construction of the home as the seat of female rhetorical power in closely related terms. This article makes the point that although women speakers might ascend to the lectern, they could not be perceived as having left their domestic sphere too far behind without forfeiting the respect of audiences who felt free to scrutinize women

speakers for signs that they retained a domestic orientation. Opening with a quote from Charles Haddon Spurgeon, "'I have no faith in that woman who talks of glory and grace abroad, and uses no soap at home,'" author Mrs. O. W. Scott observes:

> [T]he English divine has but echoed the sentiment of a critical world. A woman, a *married* woman, we mean—may be a noted author, charming platform-speaker, a very Lady bountiful in her charities; but the inquisitive public, before which she stands, inquires: "Does she use soap at home?" "Is she a good wife, mother, and housekeeper?" One evening, after listening to the eloquent pleadings of a lady who is well known as a leader in reformatory movements, a friend near by exclaimed, "O, if I could be *sure* she is as lovely at home as she is here, I should be perfectly satisfied." A man is not thus criticized. He may have left his wife at home alone, with five small children; but who inquires about that? Worse, still: he may have entirely forgotten to provide "kindlings" for her use; but what man, woman, or child cares? He may not have left her money enough to buy a postage-stamp; but bright eyes beam upon him from the galleries, and unstinted applause greets the "talented speaker." (432)[8]

Scott obviously regrets that women speakers are required to present proof of their domestic credentials to sway their listeners while male speakers are heralded for their eloquence having made no show whatsoever of their domestic obligations as husbands and fathers. This difference may be unjust, Scott goes on to say, but it is inevitable and represents the moral law of the land: "Man is first, and naturally judged by what he does abroad, woman by what she does at home" (432). We could not see articulated more clearly than in Scott's anecdote of the doubting listener who would be persuaded by a woman speaker if one could only be sure she "used soap at home," how absolutely necessary it was that women rhetoricians convince their audiences that they had not *really* left the parlor at all, but simply relocated the moral integrity of their domestic identities to the platform where they could still appear to be good wives, mothers, or housekeepers who knew, among other things, when to use soap. The "does she use soap at home" story points out that women speakers in the postbellum period remained essentially in the same constrained rhetorical space Barnes describes the eloquent mother as inhabiting. Women speakers could be successful only to the degree that they were able to perform an essentialist feminine identity in some recognizable way. In Scott's anecdote, soap and housekeeping stand in a kind of synecdochic relationship to domesticity

in general; evidence that the Lady Bountiful speaker uses soap at home would be proof enough to her worried listener that she was all a woman ought to be and therefore, ought to be believed. What Lady Bountiful's audience insists upon is that the primary task of the woman speaker is to convince her audience that the traditional male space of the speaking plat- form has momentarily rematerialized as a domestic site in which the elo- quent mother or noble maid's wisdom would be irrefutable.

Barnes's tale of the eloquent mother and Scott's "does she use soap at home" narrative provide insight into the cultural context predisposing how the lives of women orators such as Stanton, Livermore, and Willard could be written. The appeal and power of the eloquent-mother trope provided an ideological rationale for constructing women reformers as mothers of the nation and legitimizing their public-speaking careers as the acts of vigi- lant mothers who were treating the concerns of the nation as they would the troubles brought to them at their firesides. In the gendered culture of nineteenth-century America, a woman had essentially one of two choices if she sought persuasive influence. If her words were to count, she could speak earnest and powerful words to her children, particularly her sons, and influence their lives far more than any other voice, or she could speak as an eloquent mother or noble maid from a lectern that she had to domesti- cate in some obvious way. By performing domestic virtues unambiguously, a woman speaker could prove that she was a true-hearted woman who ought to be believed. Women speakers could represent themselves as the personi- fication of feminine grace and sweetness or be represented as womanly paragons by their sympathetic biographers. Either way, the woman speaker always had the "does she use soap at home" challenge to satisfy. Although famous nineteenth-century women speakers were admired for their com- mitments to social reform, in ideological terms they are offered no greater rhetorical range than the average, white, middle-class wife and mother who was expected to put her persuasive powers to the service of her family. Whether noble maid or eloquent mother, the woman speaker in postbellum America has to be represented to the public as a concerned and sympathetic woman who was only speaking out to minister to the nation as she would her own home (soap and all).

Biographical and autobiographical representations of the lives of promi- nent women rhetoricians in the post–Civil War years are influenced by a preexisting cultural context that views with favor the eloquent mother and the lovely lady orator whose housekeeping skills, and hence essential mo- rality, would be beyond reproach. With images like these to predispose read- ers positively toward women speakers who could be represented as women

who never strayed ideologically too far from the fireside, middle-class women such as Willard, Stanton, Livermore, and Anthony were remade as icons of the very best of white womankind. Influenced by a general ideological context that fused public speaking with the performance of a narrow range of feminine roles, biographical literature appears to have credited famous women as much, if not more, for their embodiment of conventional feminine virtues as for the progressive reforms they supported and brought about. In *Our Famous Women,* for example, the publishers bend over backwards in their introductory remarks to explain that the famous women in question would certainly have not agreed to be singled out as famous except for the possibly instructive and inspirational message the examples of their lives might convey to other women hoping to find a way to serve the nation and each other:

> Probably no aspect of our time is more significant of progress than the ever-growing discussion of the place and duties of women in the social state. Causes both economical and moral have tended to break up old habits of life and thought, and make new demands upon their capacity and conscience, which experience has not yet taught them to satisfy. All over the land, women are conscious of a ferment and disturbance of thought which is the prophecy of better things. Everywhere they are asking, What can I do to hasten the New Day? It seemed, therefore, to the Publishers of this volume that the time had come when the simple story of what a few women have done would prove an inspiration and incentive to the many women who long to do. The book contains thirty sketches of lives which . . . have made the world richer for their presence. Excepting six, the subjects of the sketches are living and working. With the natural modesty of worth, these ladies shrank from needless publicity, and at first hesitated to allow the use of their names. But when assured by the Publishers that the aim of the book was not to gratify a vulgar curiosity, but to kindle new hopes and ambitions in unknown hearts, and that it was the story of their labors, discouragements, and successes which was desired rather than of their private joys and sorrows, they generously said that if the knowledge of anything which they had done could be of use to other women, struggling for bread, or the right to labor, or an honorable fame, they should hold it churlish to refuse. In no case has the name of a living person been used without its owner's consent. . . . Finally, the Publishers venture to hope that they have not misconceived the temper of the time, and that to every one of the thousands of homes which the book may enter, it will bring something

of the courage, patience, steadfastness of purpose, cheerfulness, and lofty aspirations which fill the lives whose history it records. (publishers' preface v–vii)

The publishers of *Our Famous Women* indicate that the volume had been compiled to venerate the best of American womanhood, and their introduction reads like a roll call of conventional and idealized female virtues: modesty, patience, steadfastness, courage, patience, cheerfulness, and lofty aspirations. In an interesting reinscription of the trope of feminine modesty, the publishers assure readers that the women profiled were only motivated to allow their stories to be told for the edification of other women. In this off-stage allusion to negotiations about the depiction of their fame, the famous women in question are presented here as saying they are willing to be named if their lives were presented as dutiful and virtuous examples. In this rhetorical gambit that frames the entire collection, famous women are depicted using their voices for only two purposes: to modestly object to being thought extraordinary and to agree to have their lives used for edification. Entirely consistent with the eloquent-mother trope, the construction of famous women modestly objecting to prominence and offering the example of their lives as achievements that any woman can "do" encourages readers of *Our Famous Women* to expect portraits of women who remained ladies despite taking up public good works. The ideological homage offered here to the truly modest woman who only speaks out when she must in the service of others lays the groundwork for the portrayal of prominent speakers like Willard, Livermore, and Stanton as soft-spoken, duty-oriented women who offer their eloquence only to "hasten the New Day."

Adding another layer to the complicated relationship between rhetorical prominence and gender that contributes to the ideological substance of *Our Famous Women* is the reinforcement of the eloquent-mother and noble-maid themes that famous women speakers provide by characterizing their own rhetorical contributions within the conservative implications of these same images. Embodying the feminine modesty attributed to them by biographers, the autobiographical commentaries of Willard, Livermore, and Stanton corroborate conventional assumptions about what circumstances should prompt women to "speak out" by defining their own oratorical careers as choices made by well-meaning mothers and daughters of the nation who cannot stand by while others suffer. In a variety of speeches and in her autobiography *Glimpses of Fifty Years: The Autobiography of an American Woman* (1889), Willard consistently represents her political interests in temperance and suffrage and the political intervention of women in general as the natural, moral response of Christian women who love their

country as they would their children and therefore could not help but involve themselves in reforms and public speaking. One of Willard's most widely reprinted speeches, "Safeguards for Women," originally given in 1876 but often redelivered by Willard on her many speaking tours and reprinted in various publications in the last decades of the century, outlines the topics of feminine nobility and maternal courage that would remain mainstays of Willard's self-presentation and of her arguments for the necessary involvement of women in speaking out:

> I thought that women ought to have the ballot . . . but I never said as much. . . . For my own sake, I had not courage; but I have for thy sake, dear native land, for their necessity is as much greater than mine as thy transcendent hope is greater than the personal interest of thy humble child. For love of you, heart-broken wives, whose tremulous lips have blessed me; for love of you, sweet mothers, who in the cradle's sorrow kneel this night, beside your infant sons; and you, sorrowful little children, who listen at this hour, with faces strangely old, for him whose footsteps frighten you; for love of you have I thus spoken. Ah, it is women who have given the costliest hostages to fortune. Out into the battle of life they have sent their best beloved, with fearful odds against them. . . . Beyond the arms that held them long, their boys have gone forever. Oh! by the danger they have dared; by the hours of patient watching over beds where helpless children lay; by the incense of ten thousand prayers wafted from their gentle lips to heaven, I charge you to give them power to protect, along life's treacherous highway those whom they have so long loved. Let it no longer be that they must sit back among the shadows, hopelessly mourning. . . . but when the sons they love shall go forth to life's battle, still let their mothers walk beside them, sweet and serious, and clad in garments of power. (Morris 347)

Willard's construction of the rhetorical obligation of women to speak out for the protection of those who cannot protect themselves and the image of women called to political activity as "mothers walking beside their children" confirm the popularity of the eloquent-mother image as a cultural trope and reveals why Willard herself is so often characterized as the noble maid come to town. Willard's account of her initial reluctance to speak out, which is overcome by a sense of duty and a desire to speak for those who have no voices, deepens the image of the female orator as someone who speaks only when prompted by the most dire sense of moral duty and only then because the silent voices of the suffering must be represented. Willard's

often repeated analogy for women's access to the vote as enabling, loving mothers clad in maternal power to "walk beside" their children reverberates with the ideological symbolism of the eloquent mother whose natural power is unparalleled when allowed to proceed unimpeded.

Throughout her career, Willard's essays and speeches reiterated her vision of the nation as one grand domestic field over which women were obliged to keep watch. In ideological terms, Willard writes a close approximation of the eloquent-mother trope into the politics of the Woman's Christian Temperance Union by traveling the country and promoting a construction of the nation as a "Mother-land that women well might live to serve or die to save" (Campbell, *Man Cannot Speak for Her* 318). That Willard defines women's public involvement in politics as "mothering" acts and persistently reinscribes an image of the nation as a home in crisis needing, more than anything else, the maternal intervention of women is exemplified in the following poem so often quoted by Willard and her followers as the theme of the Woman's Christian Temperance Union and as a description of Willard herself:

> The perfect woman, nobly planned
> To warn, to comfort, and command
> A creature not too bright or good
> For human nature's daily form,
> And yet a spirit pure and bright
> With something of an angel's light.
>
> (Campbell, *Man Cannot Speak for Her* 324–25)

True to the preferred, conventional image of women who do not so much speak out on political issues but rather assume the role of concerned counselor and comforting mother, Willard's portrait of political women as noble, angelic and called to public life to serve the maternal duties of protection and moral vigilance invigorates the noble-maid image that Sanborn labors to construct in *Our Famous Women* and that is so often attributed to Willard in press reviews. In *Well-Tempered Women: Nineteenth-Century Temperance Rhetoric* (1998), Carol Mattingly cites several flattering reviews of Willard's performances that commend Willard's "lady-like and sensible demeanor" and her "womanly rhetoric" (115). Mattingly observes that commentary like this was typical of press reviews of Willard who was "accepted and praised more than any other woman speaker of the century. Even in the South, where women speakers drew the greatest concerns, Willard usually drew accolades because of her womanly appearance and delivery, a style she deliberately and consciously constructed" (115).

When we evaluate how influential Willard's performance and articulation of the "perfect woman, nobly planned" construction of the woman speaker might have been, it is important to consider the extent of Willard's contact with the public. James Kimble reminds us in his essay, "Frances Willard as Protector of the Home: The Progressive, Divinely Inspired Woman," that Willard's public-speaking tours were so extensive and frequent that she "visited over one thousand towns in the United States at least once; in her career she spoke before over seven thousand audiences" (47). Kimble also observes that Willard was "perhaps the most powerful and most famous woman in the United States during the closing decades of the nineteenth century" (47). In her autobiography *Glimpses of Fifty Years,* Willard corroborates the image of "the noble maid has come to town" that Sanborn and others craft in their accounts of her life by stressing a domestic and conventional image. Kimble speculates that Willard deliberately chooses to feminize her persona in *Glimpses of Fifty Years* to compete with the negative response even Willard received for speaking out about "every imaginable reform, including women's clothing, free kindergarten, prisons, age of consent laws, delinquent girls, and labor-saving devices for the home" (50). Through a pastiche of materials including reminiscences, diary entries, anecdotes, speeches, and carefully selected photographs and illustrations stressing Willard's domestic life or noble-maid image, Willard further popularizes her image as a woman who speaks out only for the sake of the suffering and whose "heart" is properly located at home.

Famous for coining *home protection,* the founding motto of the Woman's Christian Temperance Union, Willard goes to some lengths to construct herself as a woman at home with a domestic life her readers would identify with and value. Kimble observes that Willard uses the home metaphor inventively in *Glimpses of Fifty Years* by focusing in part on her childhood life. "Her depiction of the Wisconsin homestead, Forest Home [where Willard grew up] is almost idyllic. The description reveals a type of home that the activist Willard, unmarried, living only with other women, and constantly on the road for the WCTU, could no longer claim as her own except in memory" (52). Kimble argues that Willard's detailed description of her parents' home and her life growing up substitutes as a domestic anchor for her life and is intended to convince her readers that "home protection is not an empty slogan . . . the phrase is instead a heartfelt admonition from a woman who has not only lived in such a home but whose very life story is a search to protect similar ones" (53). Another ideological consequence of Willard's choice to conjure a home place in *Glimpses of Fifty Years* is a subtle reinforcement of the image of the eloquent mother in her cottage,

an image that gives added currency to the strong links Willard makes in speeches like "Safeguards for Women" among mothering, domestic values, and speaking out. While Willard's central ambition in writing *Glimpses of Fifty Years* may have been to pacify her critics at a particularly volatile time in the WCTU's history, one of the indirect effects was to further popularize the image of the woman orator as a good woman counseling the nation as she would her own family at home.

The popularity of *Glimpses of Fifty Years,* which had an "initial printing of fifty thousand copies exhausted in only a few months" (Kimble 49), would have given Willard's corroboration wide dissemination indeed of the eloquent-mother and noble-maid rationalizations for public speaking. Willard honed images of herself in terms analogous to these tropes, and she added to their influence by defining speaking out as an "angelic" act in her descriptions of other woman speakers in *Glimpses of Fifty Years* (571). In her account of first hearing well-known abolitionist Dickinson speak against slavery during the war years, Willard describes Dickinson as an inspirational, modest, and lovely patriot whose "wondrous voice" was unforgettable. Stressing Dickinson's "handsome brow" and "her gray eyes, of which a gifted man had said, 'They make one believe in immortality,'" Willard's portrait of Dickinson's oratorical performance is textured with admiration for her angelic power and womanly force (570).

> I could think of nothing except Joan of Arc. Indeed I suppose she has reminded everybody of that great character more than any other woman could. As she stood there in the prime and plenitude of her magnificent powers, simply attired in a tasteful walking suit of gray, her great eyes flashing, her eloquent lips tremulous . . . she was a figure long to remember. . . . It was not so much her words . . . but it was the mighty spirit that moved upon the hearts and consciences of those who heard. She seemed like an avenging angel. (570–71)[9]

Willard's Joan of Arc image of Dickinson personifies the noble-maid ideal and reinforces an ideological relationship between femininity and rhetorical power that Willard insisted upon throughout her career. Willard's portrait of Dickinson as a lovely, influential angel illustrates Willard's publicly articulated creed that women were eloquent because their words carried all the natural goodness and power of women's nature and also mirrors Willard's own public reputation as the noble-maid orator par excellence.

The force of Willard's widely articulated rationale for the importance of women taking up public speaking for the good of causes like temperance and suffrage is also symbolized by Willard's crafting of the temperance

movement as the "white-ribbon army," a uniquely feminine reform that took the "white ribbon" as a material emblem of an army of women devoted to the nation as they were to their homes (Willard 456). The national motto of the WCTU, "For God and Home and Native Land," emphatically confirms Willard's rationale for women speaking out. Willard herself was the major symbol of the white-ribbon woman who takes up the burden of public speaking and public life, and that image was well represented in the many mementos and publicity paraphernalia of the WCTU that typically bore Willard's photograph. Souvenir cards bearing her picture and printed autograph were handed out at WCTU national conventions and at Willard's public-speaking engagements as illustrated in this card bearing Willard's photograph and autograph (see fig. 4.1). This 8-by-10-inch, oversize card features a photograph of Willard framed by a garland-like, white ribbon and a quote from Willard accompanied by her signature: "The mission of the White-ribbon women, is to organize the motherhood of the world for the peace and purity, the protection and exaltation of its homes." On the back of the card is the inscription, "This Souvenir of our beloved leader is dedicated to the members of the Woman's Christian Temperance Union throughout the world." This portrait of Willard, typical of many souvenir cards dispersed at WCTU conventions and meetings at which orations by Willard and other union members would have been the focal point of activity, folds Willard's political ethos into the conservative ideology of the noble-woman speaker in an intense mutual justification that allowed the simple image of Willard to symbolize why and how a good woman speaks out.

The popular autobiographical writings of Livermore and Stanton also strengthen the dominance of the noble-maid and eloquent-mother images of the woman orator that Willard so successfully popularizes in the postbellum era. Livermore and Stanton write themselves into these tropes by framing their public lives and their lecturing careers as choices motivated by a sense of duty and maternal concern for the nation. In her widely circulated autobiography *The Story of My Life, or the Sunshine and Shadow of Seventy Years* (1897), Livermore, to whom Willard refers in *Glimpses of Fifty Years* as "our present queen of the platform" (572), constructs herself as a loving mother and wife called reluctantly to public speaking and political life. Remarking with requisite feminine modesty on one of the most spectacular lecturing careers of the postbellum period, Livermore enlivens once again the image of rhetorical power undercut by female reticence: "It has been my fortune, during this last quarter of a century, to occupy the position of a public lecturer on the Lyceum platform. It was not of my seek-

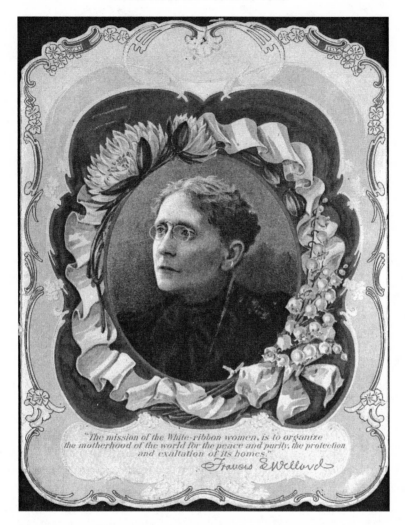

"The mission of the White-ribbon women, is to organize the motherhood of the world for the peace and purity, the protection and exaltation of its homes." Frances E Willard

Fig. 4.1. "Frances E. Willard," souvenir card portrait, Woman's Christian Temperance Union, 1886

ing. I had no ambition for public life" (483). Livermore describes her speaking career as beginning at the behest of others offering her "the entire receipts of the evening to the Sanitary Commission" if she would arrange a lecture on her experiences in the organization of Soldier's Aid Societies during the Civil War (*Story of My Life* 484). Livermore describes this "bribe" as "potent" yet admits that her feminine modesty made her hesitate until her duty was made clear:

If I hesitated from early prejudice against woman orators, or from lack of preparation, a pressure was brought to bear upon me, and I was asked, "Are you not willing to be a voice in the service of your country, after having seen battlefields where tens of thousands of men have given their lives to save it?" And I was obliged to surrender. . . . Everywhere there was a call for women to be up and doing, with voice and pen, with hand and head and heart. "You need not forsake your home, nor your family; [said Mr. Livermore] only take occasional absences from them, returning fresher and more interesting because of your varied experiences." There was force in his manner of stating it, and the matter was settled. (484–86)

Livermore tells her readers that her choice to become a public lecturer was made reluctantly and that her decision had the support of her husband who did not perceive her to be "forsaking" her home. In fact, Mr. Livermore insists that Mrs. Livermore will be all the better wife and mother for taking on new experiences. She even goes so far as to imply that she is actually being obedient to Mr. Livermore's wishes that settled the matter. With this brief anecdote, Livermore eliminates any suspicion that she has left the fireside to embark on a public career or that she is crossing her husband's traditional authority to do so.

Livermore explains that she only surrenders to the invitation of others to speak out for the suffering. In a more-detailed account of her first lecture in her memoir of the Civil War, *My Story of the War: A Woman's Narrative of Four Years of Personal Experience as a Nurse in the Union Army, and in Relief Work at Home, in Hospitals, Camps, and at the Front, During the War of the Rebellion* (1887), Livermore again recounts the story of her first public speech as an unexpected challenge she at first refused. Livermore recounts that she was initially horror struck at discovering upon arriving to speak for war relief to the women of Dubuque, Iowa, that her visit had been widely advertised and a packed lecture hall awaited her. For Livermore, speaking to other women about her cause and addressing the general public were two completely different situations: one she was suited to and one she was not:

I was appalled and dumbfounded. At that time, I had never attempted a public address to a promiscuous audience. I had only addressed audiences of women, sitting in a chair decorously before them, and trying with all my might to keep my hands folded on my lap. I had no idea whether I had voice to reach an audience as the ladies had invoked or courage to bear me through the ordeal. "You never should

have made these arrangements without consulting me!" was my frightened rejoinder. "I am not a public speaker; I have never made a speech in my life, and never have addressed any but companies of women. I have something to say to you, ladies, as the Aid Society, but it is not at all worthy to be presented as an address to the great audience that you have unwisely called together. I cannot do it." (604–5)

Entreated at the eleventh hour to reconsider by Colonel Stone, the governor-elect who had agreed to present Livermore's speech for her, Livermore relents in the face of Stone's appeal to her commitment to the cause. She finally agrees to speak with the proviso that Stone introduce himself as the featured speaker:

> Very well, Colonel Stone, I will attempt it; only do not allow long preliminaries; and after Governor Kirkwood has opened the meeting, let him introduce you as the orator of the evening. You must explain to the people that I am not a public speaker; that I have never in my life made a public address; that I have only come prepared with a small statement of facts for the Ladies Aid Society and then introduce me as quickly as possible, and I will do the best I can. (607)

In this retelling of the story, Livermore describes the first minutes of the speech as terrifying but remarks that after the first fifteen minutes, she

> forgot the audience, the fact that I was a novice public speaker, and only remembered the destitution, sickness and suffering I had seen at the front. And the feeling grew strong within me that the people of Iowa, who had, as I knew, contributed but little to the cause of hospital relief, must be aroused to do their share of the work. (608–9)

Livermore recalls herself so attentive to the passion of her message that she had no idea she spoke to an apparently enraptured crowd for an hour and a quarter nor that their intermittent loud applause was meant for her: "I was so absorbed that I did not understand it for a moment, and looked around to see what had fallen. I thought some of the seats had given way" (609).

Extremely successful, despite her reluctance, at the Dubuque sanitary fair (a fund-raising event for medical supplies and care for the wounded), Livermore would make countless similar appearances at sanitary fairs across the country to raise funds for war relief. Constructed in her own words as "no public speaker," Livermore creates the image in this narrative of a deeply committed woman whose rhetorical force is drawn from a passionate commitment to her cause, not from skill or habit. Livermore knows full well

that on that evening in Dubuque she was being asked to cross over into rhetorical space in which women did not belong. She recounts her success of that evening as a matter of "forgetting the audience" and being unaware of responsive applause. Such performative naivete would only corroborate for Livermore's readers that her eloquence stemmed from her feminine ability to move the audience's feelings; like the eloquent mother her words "flowed from strong feeling" (608). Livermore's initial characterization of her first public speech in *My Story of the War* and her recapitulation of the account in *The Story of My Life* preserve a consistent image of a woman who knew her rhetorical place and reluctantly was forced from it by moral circumstances imposed upon her. Defining her oratorical success as the consequence of concentrating on her mission and speaking for the suffering and the needy, Livermore persistently described her rhetorical career as an accident of necessity.

In an article entitled "Twenty-five Years on the Lecture Platform" appearing in the popular periodical *The Arena* in 1892, Livermore again offers her readers the portrait of a motherly woman of great heart reluctantly called to the podium to serve the cause to which she was devoted. In this essay, Livermore reinscribes the image of herself as having no ambition for public life and stresses that before being pressed into oratorical service, she was a woman at complete peace with the occupation of the care of her family. Livermore also provides an insight into how very gendered public rhetorical space was in postbellum America by sharing with her readers rather confidentially that one of the reasons she did not seek the platform was that she realized her "disadvantages":

> I never sought the place, for I realized my disadvantages. I was no longer young, and lacked grace and beauty and in those days it was heterodox to intimate that there was a ghost of a chance for a woman if she lacked either of these over-prized charms. I had never received an hour's training in elocution or voice culture, and had paid no attention to oratory, for I had no ambition in that direction. (265)

In this remarkably candid revelation, Livermore defines the years right after the Civil War as an era in which women could only hope for oratorical success if they were conventionally beautiful. While viewing such an expectation as "overrated," Livermore nonetheless realizes that some form of conventional femininity is required for any woman speaker who hopes for success. Having neither physical charms nor formal training in oratory to offer, Livermore instead offered her public a moral commitment to the lecture circuit as "a tender philanthropy" that brought education, insight, and

optimism to communities across the nation (266). Although unable, by her own estimation, to present herself as the icon of the beautiful noble woman, Livermore more than succeeded in offering her public a maternal personality that engaged the American public for three decades.

Readers could easily extrapolate from Livermore's portrait of her reluctant and unprepared entrance into public rhetorical space the perception that women were not *really* public speakers, just committed women who were forced by a sense of duty to the public lectern. This perception was reinforced by Livermore's laudatory description of the untutored eloquence of the legendary Civil War nurse and relief worker, Mother Bickerdyke in *My Story of the War.* Mary A. Bickerdyke was a volunteer nurse throughout the Civil War who often worked closely with organizations such as Livermore's Sanitary Commission. More typically, according to Livermore's account, Bickerdyke operated with few funds at the front lines, tending the wounded and dying of both uniforms and begging, borrowing, and stealing food and supplies for thousands of sick and wounded men who would have surely died without her intervention. In *My Story of the War,* Livermore paints Bickerdyke as nothing short of heroic: "'[A] homely figure, clad in calico, wrapped in a shawl, and surmounted with a Shaker bonnet, is more to this army than the Madonna to a Catholic!' said an officer. . . . Every soldier saluted her as she passed. . . . To the entire army of the West she was emphatically 'Mother Bickerdyke'" (477). Although never the frequently heard public orator that Livermore became during the war, Bickerdyke occasionally made appearances at fund-raising events at which her care and attention to the troops were acknowledged. In this account of such an appearance before the Milwaukee Chamber of Commerce, Livermore describes Bickerdyke's argument for more funds to minister to her "eighteen hundred boys" who had suffered immeasurably as a speech of "great power. . . . It would not be easy to match the pathos and eloquence of this untutored speech" (532–33). Livermore's characterization of Mother Bickerdyke, in her calico and bonnet, standing before the gentlemen of Milwaukee, chiding them for not giving all they possibly could to "her boys" (many of whom who had given "one arm, and one leg, and some have given both") (532), and persuading this group of well-heeled men that they could do better than the pledge they had already offered to war relief, would reinscribe for postbellum readers nothing less than complete confirmation of the icon of the eloquent mother made forceful through her love and sense of duty that Livermore indirectly also claims for herself.[10]

Livermore's and Willard's autobiographical accounts of why they took up public speaking and their characterizations of other women who did the

same, such as Livermore's portrait of Bickerdyke and Willard's description of Dickinson, conflate women's rhetorical and political powers with the deployment of a conventional feminine sensibility. This conflation reveals the heavily gendered, ontological climate of nineteenth-century America in which no other public identity was acceptable for women speakers other than gendered characterizations of their motives. Willard's stress on women's participation in public speaking as an act of mothering and Livermore's similar construction of herself as a devoted woman drawn to the lectern only to serve others are reiterated in a variety of similar biographical and auto-biographical discourses in the postbellum period including Stanton's auto-biographical writings. Stanton corroborated a domestic image of herself by framing her public life and her powers at the podium in particular as efforts motivated by her maternal concern for the nation's ills and her feminine interest in the well-being of those who could not speak for themselves. In her autobiography, *Eighty Years and More* (1898), Stanton devotes several chapters to her domestic life, and the volume offers several portraits of Stanton with her children and grandchildren that confirm her commitment to motherhood and reinforce the public's association of her public life and her domestic sensibility. Stanton's contribution to this association is exemplified in *Eighty Years and More* by her choice to cite a particular biographical characterization of her life depicting her association with Anthony initially written by "our common friend Theodore Tilton" (184). Tilton was Stanton's first biographer and author of the biographical sketch of Stanton included in *Eminent Women*.[11] Stanton argues that Tilton captures the essence of her relationship with Anthony and their shared mission far better than some "objective" descriptions and quotes extensively from Tilton's early sketch:

> Both have large brains and great hearts; neither has any selfish ambition for celebrity; but each view with the other in a noble enthusiasm for the cause to which they are devoting their lives. . . . These two women, sitting together in their parlors, have, for the last thirty years, been diligent forgers of all manner of projectiles, from fireworks to thunderbolts, and have hurled them with unexpected explosion into the midst of all manner of educational reformatory, religious, and public assemblies. (Tilton qtd. in Stanton 185)

By including this excerpt from Tilton's sketch in her autobiography, Stanton reinscribes the parlor image that Tilton selects to characterize the central space of Stanton's daily activities and allows the reader to imagine that her rhetorical career (and Anthony's as well) was domestic in origin. Stanton

emerges in this description as a caring mother crafting rhetorical interventions from her parlor, which Tilton implies she rarely leaves. The reinscriptive function of this parlor image is all the more powerful because Tilton's original sketch had already been circulating before the public for thirty years in *Eminent Women*. Stanton's inclusion of this characterization of her rhetorical activism in *Eighty Years and More* enlivens Tilton's parlor image for turn-of-the-century readers who would consider Stanton speaking out from home to be the best possible scenario: a wise mother speaks to the nation as she would to her children at her fireside.

Stanton's obvious blessing on Tilton's earlier biographical sketch gives renewed authority by association to other images of Stanton that Tilton's portrait promoted. It is in Tilton's effusive biography of Stanton that images are first coined that reappear again and again in subsequent descriptions of Stanton and her life, such as her cap of white hair, her maternal bearing, and her devotion to her children. Although Bullard would later provide a history of Stanton's rise to public prominence (interspersed with attention to the domestic details of Stanton's housekeeping and family life) in her sketch of Stanton in *Our Famous Women*, Tilton sets the biographical standard for domesticating Stanton's public image with observations like these that would put readers more in mind of an amiable and loving mother rather than the political stateswoman who by 1868 was widely acknowledged as the leader of the women's rights movement:

> Mrs. Stanton's face is thought to resemble Martha Washington's . . .
> her hair—early gray, and now frosty white—falls about her head in
> thick clusters of curls; her eyes twinkle with amiable mischief; her
> voice, though hardly musical, is mellow and agreeable: her figure is
> of the middle height, and just stout enough to suggest a preference
> for short walks rather than long. . . . The sacred love of motherhood
> is to her a familiar study. Five sons and daughters sit around her table,
> all as proud of their mother as if she were a queen of Fairyland, they
> her pages in waiting. (358, 360)

Taken as a whole, Tilton's biographical construction of Stanton stresses a domesticated view of Stanton's rhetorical activities and likens her to an idealized mother figure dispensing wisdom from her home where she ruled as "a queen of Fairyland." Stanton's choice to reinscribe in *Eighty Years and More* the parlor orientation of Tilton's biography carries the ideological tone of this fusion between her rhetorical career and her domestic disposition into the new century. Stanton's autobiographical contribution to the domestication of her rhetorical career helped to reinforce a conflation in

the public mind of rhetorical performance and womanly virtue and rein-
forces the cultural power of the eloquent-mother trope that portrays the
rhetorical force of women as at its most powerful when issuing from the
parlor or fireside.

Stanton further reinforces this association between domestic virtue and
rhetorical force in the many biographical accounts that she published after
the Civil War of other famous woman speakers, Susan B. Anthony in par-
ticular. As a major essayist in *Eminent Women,* Stanton provides biographical
sketches of central figures in the women's rights movement, a group that
included Anthony, the Grimké sisters, Howe, Abby Kelley, Mott, and Stone.
Stanton shapes a domestic angle to the public lives of these notable women
and elaborates on the feminine virtues and interests of each reformer. She
not only defends their public careers but goes as far as to equate their speak-
ing careers with a unique, feminine nobility and moral honor her readers
would associate with the icon of the American woman. Stanton deals di-
rectly with the prejudice against women public speakers by vehemently
arguing that the public podium was a site where the very best of feminine
virtue could be deployed by the very noblest of women:

> As much odium has been cast on these noble women, I cannot close
> without saying what I feel to be just and true of all alike. It is no
> exaggeration to state, that the women identified with this question
> are distinguished for intellectual power, moral probity, and religious
> earnestness. Most of them are able speakers and writers, as their pub-
> lished speeches, letters, novels, and poems fully show; those who have
> seen them in social life can testify that they are good housekeepers,
> true mothers, and faithful wives. I have known women in many coun-
> tries and classes of society, and I know none more noble, delicate, and
> refined in word and action, than those I have met on the women's
> rights platform. (404)

Stanton attempts to counter the prejudice against women leading public
rhetorical lives by claiming heretofore male-governed rhetorical sites such
as the lectern, the published word, and even the pulpit as appropriate ex-
tensions of the natural, moral sphere of women who far from forsaking their
natural inclinations when they enter public life actually extend them. Re-
futing the idea that women were out of their place on the podium, Stanton
claims the podium as the ultimate domestic site where women (whom
Stanton represents as "housekeepers, true mothers, and faithful wives") can
exert their natural instincts in a rhetorical sphere morally domesticated by
their presence. Stanton constructs the lecture platform as a parlor once re-

moved in which women can fulfill their conventional, moral destinies by exerting feminine influence over the affairs of the nation as they would over their own homes.

This construction of the relationship between public speaking and feminine virtue clearly predisposes Stanton's biographical sketch of Dickinson in *Eminent Women*. Dickinson was at the height of her public fame between 1863 and 1875 when she was touted as the most popular and widely sought after public speaker in the country. Like Willard, who possibly imitates Stanton's characterization, Stanton likens Dickinson to a "juvenile Joan of Arc" possessed of a "purity, dignity, and moral probity of character, that reflects honor on herself, and glory on her whole sex" (479). Chronicling many of Dickinson's more recent oratorical triumphs, Stanton observes that Dickinson softened the hearts of her audiences, particularly those of men determined to resist her, through her sweetness, charm, and simplicity. Quoting a number of recent press reviews of Dickinson's speaking engagements in the eastern United States, Stanton selects accounts that reinforce the image of Dickinson as an unassuming woman speaking irresistibly from the heart. In this description, Stanton quotes an eyewitness to Dickinson's "inspired" speech against slavery to what could only be construed as a hostile audience, the Convention of Southern Loyalists, in September, 1866:

> It was her noblest style throughout . . . tender and often so pathetic that she brought tears to every eye. Every word came through her heart, and went right to the hearts of all. . . . She had the audience in hand as easily as a mother holds her child; and like the child, this audience heard her heart beat. It was ennobled thereby. (510)

Stanton's construction of Dickinson's oratorical efforts as a mother holding her child reinforces for readers a conventionally acceptable interpretation of Dickinson's motives for speaking in public and competes with the critical portraits in the postbellum press of Dickinson and others, including Anthony, pursuing public speaking as a profession and their unladylike willingness to speak out on unpopular political issues such as fair labor practices and the education of women.[12] Throwing the mantle of the eloquent-mother trope over Dickinson's rhetorical efforts, Stanton attempts to persuade her readers, as she does in her sketch of women's-rights speakers, that Dickinson is not a woman out of place on the podium but rather a woman doing exactly what she should be doing, mothering the nation with her words of truth and concern.

Nowhere in Stanton's biographical writings is this effort to feminize women's rhetorical efforts more extensively felt than in her influential and

widely circulated biographical sketches of Anthony. Between the publication of *Eminent Women* (1868) and the appearance of *The Life and Work of Susan B. Anthony* (1898) by Ida Husted Harper, (an elaborate, authorized biography that Harper extended to three volumes in 1908), Stanton was Anthony's major biographer and primarily responsible for crafting Anthony's public reputation for moral leadership and saint-like character. Enduring far more ridicule and rejection in the press than the conventionally pretty Dickinson or the matronly Stanton and Livermore, Anthony frustrated the public's desire for soft-spoken, lovely, or motherly woman orators who inspired worship and devotion. In writing her essay on Anthony in *Eminent Women,* Stanton crafts a gendered persona for Anthony that would offer the public some version of conventional femininity they would recognize and value, and she chooses to emphasize Anthony's ideal feminine qualities of nobility, purity, self-sacrifice, and tireless service to cause and family. In ideological terms, Stanton makes the argument that Anthony's possession of exemplary feminine traits gives her womanly status and makes her just as maternal and feminine a figure as Dickinson or Stanton herself. Stanton's often-repeated descriptions of Anthony as "the connecting link between me and the outer world" and the bearer of the "thunderbolts" forged in Stanton's parlor, first received wide circulation in *Eminent Women* as did Stanton's characterization of Anthony as an exemplar of feminine virtue despite her lack of conventional beauty.

> Miss Anthony, though not beautiful, has a fine figure and a large, well shaped head. The world calls her sharp, angular, cross-grained. She has, indeed her faults and angles, but they are all outside. She has a broad and generous nature, and a depth of tenderness that few women possess. She does not faint, or weep, or sentimentalize; but she has genuine feelings, a tender love for all true men and women, a reverence for noble acts and words, and an active pity for those who come to her in the hour of sorrow and trial. She is earnest, unselfish, and true to principle as the needle to the pole. In an intimate friendship of eighteen years, I can truly say, I have never known her to do or say a mean or narrow thing. She is above the petty envy and jealousy that mar the character of so many otherwise good women. . . . Those who have complained of Miss Anthony's impatience, in pushing our cause to a speedy success, must remember that without the cares of a husband, children, and home, all her time, thought, force, and affection have centered in this work for nearly twenty years. . . . No one knows, as I do, the untiring labors of this noble woman in our cause. (401)

As Stanton rewrites Anthony's public image within a conventional discourse of gender, she likely does so knowing that to many of Anthony's audiences Anthony's lack of conventional feminine charms implied an unwomanly nature. By softening the interpretation of Anthony's appearance and conferring femininity upon Anthony's looks, Stanton essentially remakes Anthony's body into that of a woman whose beauty is on the inside but present nonetheless. Having remade Anthony's appearance, Stanton goes on to praise those qualities that the readers of *Eminent Women* would associate with an ideal woman: purity, nobility, and a loving nature. In an extremely revealing recasting of the facts of Anthony's biography, Stanton reframes Anthony's devotion and love of her cause as analogous to the devotion she would have shown to a husband and children, implying that Anthony is not less of a woman for leading an unconventional life in these terms, but as much a woman as anyone because she devotes herself to her cause with maternal and wifely zeal.

Stanton's revisionist construction of Anthony as an exemplary woman as devoted to the nation as a mother would be to her children or a wife would be to her home and her incantatory praise of Anthony as noble, writes Stanton into the acceptable company of the noble maids come to town and attempts to counter the severe criticism that Anthony often encountered, particularly in the early decades of her career. Stanton's feminization of Anthony's rhetorical motives, as well as Stanton's obvious attempt to write conventional femininity on Anthony's body one way or the other, attempts to resist the hostile reception Anthony often incurred from audiences and correspondents who responded negatively to her "masculine" demeanor:

> Miss Anthony is above the medium height for women, dresses plainly, is uncomely in person, has rather coarse, rugged features and masculine manners. Her piece, which doubtless she has been studying for thirty or forty years, was very well delivered for a woman, containing no original thought, but full of hackneyed ideas, which every female suffrage shrieker has hurled. (Richmond, Ky., *Herald,* 1879, qtd. in Harper 504)

> A "miss" of an uncertain number of years, more or less brains, a slimsy figure, nut-cracker face and store teeth, goes raiding about the country attempting to teach mothers and wives their duty. . . . As is the yellow fever to the South, the grasshopper to the plains, and diphtheria to our northern cities, so is Susan B. Anthony and her class to all true, pure, and lovely women. (Grand Rapids, Mich., *Times,* 1879, qtd. in Harper 505)

This kind of resistance to Anthony and the taking of her name as a synonym for disease and catastrophe typifies a condemnation of Anthony's "unfeminine" public-speaking persona that plagued her throughout her public life. With this evidence of the liability of Anthony's insufficiently feminine demeanor so well documented in the popular press, it is little wonder that in subsequent biographical sketches of Anthony published in the 1870s and 1880s, Stanton continued to feminize Anthony's character and rhetorical persona by lauding her exemplary womanly nature. For example, in another biographical sketch of Anthony included in *Our Famous Women,* the same volume in which Sanborn christens Willard a noble maid and Phelps describes Livermore as having "mothered half the land" (412), Stanton employs the ideological tropes of motherhood and feminine purity to gender Anthony's motives for lecturing across the country. She also insists, once again, that Anthony has exchanged the comforts of a conventional woman's life to serve as a guardian to the nation as she would her own home (53). Stanton also repeats large portions of her essays on Anthony in *Eighty Years* and *More* that reinscribe a feminized construction of Anthony as a public speaker and reformer for late-nineteenth-century readers.

In 1898, Harper capitalized on Stanton's biographical construction of Anthony's public persona by including in her two-volume biography of Anthony excerpts from Anthony's correspondence, scrapbooks, and favorable press reviews that remind readers of her modesty about her speaking career and the feminine morality that motivated Anthony to cross the country for decades carrying the message for women's rights. As committed as Stanton to presenting Anthony as an exemplary woman who excelled in the feminine virtues of self-sacrifice and loving devotion, Harper frames her treatment of Anthony's life and career with a characterization that sustains Anthony's membership in the noble-maid-has-come-to-town tradition of women speakers:

> During the fifty years which have wrought this revolution, just one woman in all the world has given every day of her time, every dollar of her money, every power of her being, to secure this result. . . . Never for one short hour has the cause of woman been forgotten or put aside for any other object. Never a single tie has been formed, either of affection or business, which would interfere with this supreme purpose. Never a speech has been given, a trip taken, a visit made, a letter written, in all this half-century, that has not been directly in the interest of this one object. There has been no thought of personal comfort, advancement or glory—the self-abnegation, the self-sacrifice, has been absolute—they have been unparalleled. (vii)

With this kind of praise, Anthony passes into gendered legend as a woman whose every word, spoken or written, was only uttered for the sake of the cause. Harper also includes specific anecdotes of Anthony's life and press material to further reassure the public that for fifty years Anthony has only spoken out with womanly force for moral causes to which any woman would be devoted. For example, Harper includes excerpts from reviews that encourage readers to a kinder interpretation of Anthony's appearance and stress the womanliness-shines-through angle that Stanton employs so successfully to feminize Anthony's speaking persona:

> She pays no special attention to feminine graces, but is not ungraceful or unwomanly" (Hartford Post 1869); "Her face is one which would attract notice anywhere; full of energy, character and intellect, the strong lines soften on closer inspection. There is a good deal that is 'pure womanly' in the face which has been held up to the country so often as a gaunt and hungry specter's. (St. Louis *Globe Democrat,* 1879, qtd. in Harper 507)

> [T]hose who know her well and have watched her career most attentively, know her to be rich in all the best and most tender of womanly virtues, and possessed of as brave and noble a spirit and as great integrity of character as ever fell to the lot of mortal woman. (*Philadelphia Sunday Republic,* 1877, qtd. in Harper 489)

Supported by discourse like this that imitates Stanton's biographical campaign of constructing Anthony in acceptable, gendered terms, Harper weaves together a portrait of Anthony as a woman who suffered at the hands of audiences who failed to see her noble, womanly spirit but who eventually triumphed in the end over ridicule because her saintly, female spirit carried her forward. Harper creates an image of Anthony as a woman who is reluctant to step forward to the lectern but is driven to do so out of duty. This image further inscribes Anthony into the company of other noble maids like Willard who only speak out for the sake of others.

Anthony's self-sacrificing motives for taking up oratory are captured in this press summary of Anthony's response when presented flowers by delegates at a women's rights convention in St. Louis in 1879, which Harper quotes at length:

> Miss Anthony, visibly affected, responded: "Mrs. President and Friends: I am not accustomed to demonstrations of gratitude or of praise. I don't know how to behave tonight. Had you thrown stones at me, had you called me hard names, had you said I should not speak,

had you declared I had done women more harm than good and de-
served to be burned at the stake. . . . I should have known how to
answer. . . . I know nothing and have known nothing of oratory or
rhetoric. Whatever I have done has been done because I wanted to
see better conditions, better surroundings, better circumstances for
women. Now friends, don't expect me to make any proper acknowl-
edgements for such a demonstration as has been made here tonight.
I cannot; I am overwhelmed." (507)

Harper introduces this incident as "that touching scene which has been so
often described," implying that this story, which reveals an emotional
Anthony defining herself as a naive speaker who has only spoken out to right
wrongs, enjoys an emblematic status in the public's mind. In combination
with the evidence this incident presents of Anthony's conventional feminine
sentimentality ("I am overwhelmed"), this often-described scenario downplays
Anthony's oratorical power and emphasizes Anthony's womanly nature simul-
taneously in much the same way as Livermore's account of her first speech
(in which she is frightened to speak and unaware of the audience's applause)
frames her rhetorical performance in conventionally modest and naive terms.

That Harper finds it necessary as late as 1898 to reinscribe versions of
Anthony's womanliness indicates that she considers Anthony's reputation
to still be in some jeopardy. The "I know nothing of oratory" portrait of
Anthony speaks to the mixed feelings that Anthony's power as a woman
speaker could still elicit at the close of the century. Harper is concerned
enough about soothing negative response to Anthony's platform personal-
ity that she textures Anthony's biography with incidents of her life that prove
that she is a true woman among women. In a revealing recasting of the
format of "the famous write the lives of the famous" so popular in biographi-
cal collections like *Eminent Women* and *Our Famous Women,* Harper in-
cludes selections from the correspondence between Anthony and Stanton
that highlight Anthony's image as modest, dutiful, and loving. These letters
provide yet another discourse that feminizes Anthony's rhetorical personal-
ity. Quoting from a letter of Stanton to Anthony written in 1877, Harper
makes blatant use of Stanton's hierarchical status as an ideal mother to
positively implicate Anthony in a mothering role.

I send you letters from *our* children. As the environments of the
mother influence the child in prenatal life, and you were with me so
much, there is no doubt you have had a part in making them what
they are. There are a depth and earnestness in these younger ones and
a love for you that delight my heart. (489)

Remarking that "such letters as these are scattered thickly through the correspondence of fifty years" (489), Harper implies that Anthony had played a role of mother to Stanton's children throughout their lives and alerts readers to the fact that Anthony was far more conventional in the roles she played in the lives of her loved ones than her critics would suspect. In a similar move to enfranchise Anthony with as much conventional femininity as possible, Harper retells the story of Anthony's devoted nursing of her brother Daniel when he was shot and seriously wounded in 1875. Harper describes Anthony's attendance in detail, representing the nine weeks that Anthony nursed her brother and cared for his wife and her four-year-old niece and namesake, "Susie B.," as a saintly and loving act that proved beyond doubt the fundamental womanliness of Anthony's nature. Reinscribing once again an emblematic anecdote that celebrates Anthony's feminine virtues, Harper reminds her readers that at the time the "papers were filled with glowing accounts of Miss Anthony's devotion, seeming to think it wonderful that a woman whose whole life had been spent in public work should possess in so large a degree not only sisterly affection but the accomplishments of a trained nurse" (471). Harper recalls that Anthony was characterized in the press at the time as an "angel of mercy" (471). Harper concludes her account of this incident with a description of Anthony's maternal relationship with her niece and reminds readers that her journals contain "many touching entries" about "how closely the child entwined itself about her heart" (470–71).

Harper's construction of a maternal and conventionally feminine personality for Anthony takes on a more layered significance when we take into account that Anthony's input into the conception and composition of *The Life and Work of Susan B. Anthony* was considerable. Ann D. Gordon points out that in 1897, Anthony "brought Ida Husted Harper to live with her in Rochester to prepare two volumes of *The Life and Work of Susan B. Anthony* (1898) drawing on massive archives that had accumulated in the attic" (550). Compiled in collaboration with Anthony, Harper's biography has to be regarded as distinctly autobiographical in disposition. While Anthony did not directly recast her rhetorical personality as Stanton, Livermore, and Willard did, the coauthored nature of *The Life and Work of Susan B. Anthony* and that Harper drew on Anthony's materials for content imply that Anthony sanctioned and helped to shape the images that Harper inscribes of her as untutored orator and womanly woman speaking out because her feminine sensibilities are aroused. Harper's biographical construction of Anthony's life, career, and motives must be viewed as reflecting fairly closely Anthony's preferred self-representation as noble maid called reluctantly to the lectern to speak on behalf of others.

Through a series of biographical constructions during the postbellum years and the late-nineteenth century, Anthony, along with Stanton, Livermore, and Willard, was popularized in the public imagination as a good, Christian woman who applied her natural, feminine nobility to concerns that affected the whole nation. Noble maids and eloquent mothers, one and all, so the argument went, these women spoke out as mothers, daughters, and sisters who loved the country as a beloved home. One way to read this discourse that glorifies the public woman as a devoted mother doing her duty is to observe that this type of conservative appeal allowed prominent women speakers to speak and gain access to public forums and enlisted support when other types of rhetorical platforms had failed.[13] By capitalizing on rather than resisting cultural norms about women's roles, Willard, Stanton, and others shaped a subtle refutation to the cultural arguments that public rhetorical activity by women contradicted their natures as wives and mothers. By domesticating the podium, Willard, Livermore, Stanton, and Anthony did gain access to public rhetorical forums culturally marked as masculine space, and it is certainly true that playing into rather than resisting the popular tropes of the noble maid and eloquent mother allowed famous women to win the public's ear and further social reform. It is not the case, however, that the construction of these women's rhetorical careers in biographical and autobiographical literature as essentially spectacular performances of conventional femininity altered public perception in favor of viewing the public-speaking stage in the decades following the Civil War as a rhetorical space equally suited to both men and women. The biographical and autobiographical discourses that profiled women speakers as exemplary women doing their feminine duty only reinscribed more deeply the conservative notion that women could only claim public rhetorical space if they were exercising their feminine prerogative to do good works and only if they made perfectly clear to their audiences that the assembly hall was momentarily akin to that cottage fireside at which the eloquent mother and her audience of lucky children were gathered. Anthony, Livermore, Stanton, and Willard were primarily defined for the postbellum public by their supporters and by their own hand as women who mothered the nation toward a new day. As the accounts of their lives were written, they emerged as women to imitate, not because they exceeded the boundaries of the parlor or left their firesides, but because they transported their natural eloquence from those sites and extended the boundaries of their domestic worlds to include the public speaking platform.

Autobiographical and biographical constructions of the white, middle-class maids and mothers deemed famous and eminent in the postbellum

period and in the last decades of the century preserved deeply felt, cultural reservations about women's access to public rhetorical space and power. These texts, designed to defend and promote women who changed the sociological face of post–Civil War America, effectively erased the rhetorical acumen and political influence of women like Willard and Stanton in favor of praising them for performing feminine virtue so magnificently. Embedded in the pages of Stanton's *Eighty Years* and *More,* Livermore's *The Story of My Life,* Willard's *Glimpses of Fifty Years,* and Anthony's *The Life and Work of Susan B. Anthony,* the imagery of noble maids and eloquent mothers constrains more rhetorical opportunities for women than it justifies. With more in common with the smiling Dear Millie and the quiet woman than one might at first suspect, the constructed rhetorical world of Anthony, Stanton, Livermore, and Willard looks, to the nineteenth-century reader uneasy with the power of women's words, to be reassuringly parlor-like indeed.

5

NOBLE MAIDS AND ELOQUENT MOTHERS, OFF THE MAP

> It is at home that woman herself gains the power that tells most
> effectively in the outside sphere of activity. It was very largely the
> mother-love at home that inspired Frances Willard, and filled her
> delicate frame with more than magnetic power when she appeared
> in the public arena. It is at home that woman is prepared to create
> the literature that charms the world. At home she finds stimulus
> that makes her an artist. There her love is [f]ostered and all the
> noblest womanly instincts and impulses kindled and satisfied. . . .
> It is here she carries on most effectively the experiments which give
> her uttered word authority and power.
> —William C. King, ed., *Woman*

In *Woman: Her Position, Influence, and Achievement Throughout the Civilized World* (1903), a compilation of over two hundred biographical profiles of celebrated women that contains an extensive section on nineteenth-century women, Frances E. Willard is described as an influential woman who, in ideological terms, never left the hearthside. This characterization of Willard as a public figure who gained power because she was energized by mother-love and whose words were authoritative and powerful because of the central place home had in her life makes what, by 1903, is the familiar argument that the domestication of rhetorical power reveals the American woman in her best light. In the picture presented to the readers of *Woman,* Willard does not emerge as a skilled public speaker and politician who successfully claimed the male preserve of the podium as her own for twenty-five years; she is described instead as a loving woman who found in public life a wider home to oversee. This portrait, which so strikingly resembles postbellum constructions of Willard's noble-maid image, under-

cuts the legacy of the rhetorical influence of Willard and other women who reshaped the sociological landscape of post–Civil War America in favor of reasserting, yet again, the importance of conservative rhetorical behavior in the iconic structure of the ideal American woman.

Readers of *Woman* are not encouraged to minimize the facts of Willard's rhetorical career, which are fairly represented in "Frances E. Willard: The Foremost American Temperance Reformer," a profile in which Willard is lavishly praised with observations such as her "executive ability was as marvelous as her power over an audience was mighty" (414). That Willard was one of the most well-known public speakers in the country during what the authors of *Woman* call "The Golden Age of Woman's Achievement" is never disputed. What the authors of *Woman* offer instead is a re-interpretation of Willard's public rhetorical career in terms that reveal Willard to be a "golden" example of American womanhood (341). While acknowledging and praising Willard for wielding pen and voice in the service of her cause, the authors of *Woman* simultaneously reframe that achievement as the work of a devoted woman whose moral compass always pointed toward home. The authors of *Woman* go to great lengths to associate Willard's rhetorical career with the icon of the American woman who accepts that her most powerful form of rhetorical influence is domestic in origin. That effort makes clear that the cultural function of regarding rhetorical practice as a site at which gender identity and cultural power are brokered is as important to the authors of *Woman* in 1903 as it was to a legion of parlor rhetoricians, conduct authors, and popular biographers in the postbellum period.

As the twentieth century began, the cultural climate predisposing attitudes about how and where women should speak out remained saturated with ideological entanglements of women's rhetorical roles with conservative definitions of the female sphere. The ongoing prominence of these entanglements ensures that, at 1900, American women in general are awarded little more explicit social latitude to pursue rhetorical roles outside the home than they were throughout the nineteenth century. Although *Woman* was not a widely reprinted text in the early 1900s, the conservative accounts of women's rhetorical behavior promoted in this volume are representative of the degree to which a highly gendered view of rhetorical space still characterized public opinion as the new century began.[1] Reinforcement for the continued restraint of rhetorical latitude for women was amplified further by the development of histories of American oratory in which the rhetorical achievements of women are characterized in ambiguous terms at best. In the crucial decades between 1880 and 1910 when the

canon of American oratory is initially formulated, canon authors are far from agreement as to how the rhetorical contributions of nineteenth-century women should be acknowledged. Sharply different views of women's rhetorical accomplishments among canon authors mirror the cultural uneasiness with the rhetorical power of women that encouraged postbellum parlor rhetoricians and conduct authors to undermine the claims of women to public rhetorical space and motivated the authors of *Woman* to dilute Willard's stature as an influential public speaker with an overlay of domesticity. The ideological link between rhetorical performance and feminine virtue that allows the authors of *Woman* to domesticate Willard's public words preserves her public career as admirable while bracketing her rhetorical influence as the unique consequence of a good woman extending the domestic sphere (only temporarily) to include the public speaking podium. Ironically, it is the bracketing of women orators into a special rhetorical category all their own and the promotion of the idea that women co-opted the podium as feminine territory that undermines rather than ensures the inclusion of women in the history of American public speaking.

The ideological power of the special category for women speakers and the attending assumption that women feminize public rhetorical space while they occupy it is depicted clearly in the portrait of the American woman that readers of *Woman* are intended to associate with Willard:

> As for woman, wherever she goes and whatever her mission—for travel or service—her native instincts draw her homewards. She may have unusual power and be distinguished for versatility; she may have artistic ability and attain distinction on the stage or in the studio; she may make bargains behind the counter . . . or serve as shop-girl, toil as field-hand or in factory, by typewriter, ticket agent, street car conductor; she may write with the power of George Eliot and Elizabeth Barrett Browning; she may skillfully wield the pen and prove a very magician in journalism and in the nobler literatures, she may possess great persuasive power in the pulpit or on the platform. . . . but wherever a woman is, or whatever a woman does, she is at her best, her divinest best, at home! This is the center of her power. (656)

In what seems at first to be a celebratory chronicle of the widening world of women in the penultimate chapter of *Woman*, "Woman in the Home," author Bishop John H. Vincent undercuts his acknowledgment of the enlarging scope of women's lives by reasserting a familiar ideological motto: No matter where a woman goes or what she does, she succeeds best at home where her rhetorical powers and other talents are at their most divine. The

subtext of Vincent's chapter is that women without a domestic identity cannot expect their voices to count. Vincent's explicit comparison of the rhetorical power a woman might wield in the pulpit or on the platform to the far greater power she possesses in the home recalls the many arguments posed in postbellum parlor rhetorics, conduct manuals, and social commentaries that urged American women to exchange public rhetorical roles for maternal influence in the home. According to this scenario, a "divine" rhetorical calling waits for any woman who knows that her "native instincts draw her homeward" (656).

Commentaries like "Woman in the Home," which praise the advances of women in the work force, the arts, the professions, and in reform work yet ultimately encourage women readers to view the home as their greatest realm, reiterate the subtext of mixed messages characteristic of postbellum discourses that addressed the rhetorical behavior of women. In *The Golden Way to the Highest Attainments: A Complete Encyclopedia of Life* (1889), the Reverend James Henry Potts praises the woman who takes up her "God-given mission to execute as a public speaker" but also reminds his readers that no role for women exceeds the importance of "guiding . . . little footsteps" (160). In *What Can a Woman Do; or, Her Position in the Business and Literary World* (1885), M. L. Rayne devotes several chapters to a discussion of the increasing numbers of women pursuing higher education, the arts, and professional life yet concludes with the conservative cultural cliche that "the glory of woman" lies in being an inspiration to her husband's public rhetorical life rather than pursuing one of her own (485). In *The Household Encyclopedia of Business and Social Forms, Embracing the Laws of Etiquette and Good Society* (1882), James D. McCabe offers women an epistolary range that exceeded domestic correspondence yet framed that extension of rhetorical options with engravings such as "Shipwrecked Hopes" and "The Invitation" that reinscribed a epistolary world for women and centered it on conventional social life and family relationships. The parlor-speaker genre promised the golden cargo of oratorical skill to every American yet repeatedly depicted women reading poems such as "Just Two Wee Shoes" and giving readings dressed as gypsy tambourine girls instead of portraying women as public speakers.[2] Standing in a long line of texts that constrain as much as they offer, *Woman* opens with praise for extending "womanly life and grace" to "almost every phase of modern activity" but concludes with Vincent's admonishment to remember the divine realm of the home where a woman's words matter the most. Unable to deny the material changes in American life that had shifted the white, middle-class woman's world by 1903, the authors of *Woman* nonetheless strive to reas-

sure readers that although women's lives were expanding, the fortunes of mother-love had not been jeopardized as long as the authority and power of women's words remained domestic in origin.

The ultimately conservative view of the rhetorical behavior of women articulated in *Woman* enlists this text into the same ideological genre as postbellum texts that dramatized a tension between the support of a model of social progress in which women moved out of the home to speak and write in public space and the desire to check the forward momentum of changes in gender roles by constraining rhetorical opportunities for women. A focus in postbellum parlor rhetorics and conduct literature on rhetorical practice as a device in the negotiation of the proprieties of gender lends ideological force to the mother-love characterization of Willard and to other portraits of celebrated nineteenth-century women in *Woman* including descriptions of women speakers in reform movements of the 1890s such as the Alliance Movement (612–17).[3] Profiles of these women strain to contextualize the expanding involvement of women in public affairs as the natural result of a greater reach of feminine sympathy and incorporate the popular postbellum biographical trope of reconfiguring the careers of women speakers as the deployment of powerful maternal and feminine feeling. In this description, Sarah Emery, primary organizer and spokeswoman for the Alliance Movement, is celebrated for exemplary femininity in a portrait that would certainly reassure readers that although a female public speaker like "Mrs. Emery" might be persuasive, her rhetorical influence did not represent a powerful woman at work, but a loving one:

> Placid, lovable, loving mother of all the other women in this great reform is Mrs. Sarah Emery. What Elizabeth Cady Stanton is to equal suffrage and to her reverent suffrage disciples, such is Mrs. Emery to the Home Crusade and her most devoted co-crusaders. . . . Mrs. Emery makes no effort at oratory or elocutionary style. She is none the less effective and is credited with making converts wherever she speaks. . . . Her sweet spirit has shaped a face of benign loveliness. . . . She has all the wholesomeness of perfect health and the soft color of youth in her fresh, fair face. If the whole human race were to call upon her for kindly attention and for sympathy, she has enough to go around. (587)[4]

In this depiction of Mrs. Emery as a placid and loving mother, Emery's rhetorical career is expertly written into the eloquent-mother trope, complete with comparison to the extremely maternal Elizabeth Cady Stanton and a deprecating denial of rhetorical skill in favor of the naturally persua-

sive feminine qualities of sympathy, loveliness, and sweetness of spirit. Eva McDonald-Valesh, another widely traveled Alliance speaker in the 1890s, is similarly portrayed in *Woman* as both an unassuming speaker and a woman whose rhetorical effectiveness is inspired by her dedication to a cause:

> At the state convention of the People's Party of Ohio, held at Springfield in the summer of 1891, she was rapturously applauded. In the course of her remarks she referred to the opposition to woman on the rostrum, saying that she hoped to be able to speak for woman's cause as long as there were homeless, voiceless women, helpless to cope with the hard conditions of life. This she intended to do regardless of the prejudice that would relegate her to the four square walls of her home. At this point a gray-haired convert, won by the power and pathos of her plea, called out, "you are at home now; you are in the sphere for which God designed you" (591). . . . Most of these women have opened their mouths and spoke before many people. . . . All these heretical things have they done, and yet are womanliest, gentlest of women, the best of housekeepers, the loyalist of wives, the carefullest of mothers. (597)[5]

What is particularly striking in these excerpts from *Woman* is how similar these defenses of Emery's and McDonald-Valesh's choice to risk the heresy of public speaking for the sake of the voiceless are to the rationales offered by Mary A. Livermore, Willard, and others for their entrance into public rhetorical space. The interpretation in *Woman* of public-speaking roles for women as extensions of their womanly commitments to just causes mirrors Livermore's description in *My Story of the War: A Woman's Narrative of Four Years of Personal Experience as a Nurse in the Union Army, and in Relief Work at Home, in Hospitals, Camps, and at the Front, During the War of the Rebellion* (1887) of her reluctant call to the lectern as a response to the needs of those who could not speak for themselves and Willard's characterization of herself in "Safeguards for Women" (1876) as a woman who would never have "spoken" except for the sake of "heartbroken wives" and "sorrowful little children" (Morris 347). The authors of *Woman* reassure readers that although politically active, women like Emery and McDonald-Valesh retained their essential feminine natures even while trespassing on public space that continued to be defined in the early years of the twentieth century as the rhetorical territory of men. Repeated reconfigurations in *Woman* of the rhetorical careers of women speakers like Emery and McDonald-Valesh into accounts of the display of feminine virtue downplay evidence of women's rhetorical expertise and simultaneously reinforce the

distinction between the feminine rhetorical space of the parlor and the masculine rhetorical space of public life. This public rhetorical arena is generally confirmed in *Woman* as a realm women can be viewed as heretics for occupying, even while the good works that women speakers accomplish there are praised as exemplary female accomplishments.

By reinforcing the assumption that women's rhetorical influence in general was founded on the feminine virtues of maternal wisdom and loving sympathy rather than on rhetorical expertise and political acumen, texts like *Woman* illustrate the persistent influence in the early-twentieth century of a code of idealized rhetorical behavior for white, middle-class women that stressed conventional femininity and constructed the presence of women at the public-speaking podium as an unconventional phenomenon in need of explanation. Drawing upon an established, cultural suspicion of women and their rhetorical influence outside the home, this assumption enabled the reframing of women's rhetorical performances as domestic acts as the only acceptable defense of women's public rhetorical activities. When the authors of *Woman* stress the motherly nature, the untutored speaking style, and the gentle loveliness of women speakers who are, above all else, "the best of housekeepers, the loyalist of wives, the carefullest of mothers," they invoke a public regard for the words of the eloquent mother and noble maid, tropes already in place.

The gendered criteria for admirable female eloquence, defined as modesty, moral passion, and the performance of feminine virtue such as maternal or daughterly concern achieved the status of an acceptable, critical standard for judging women's rhetorical performances primarily because the constructions of the eloquent-mother and noble-maid identities for women speakers left the icon of the quiet woman ideologically undisturbed. The quiet woman is kept reassuringly in place by the eloquent-mother and noble-maid tropes that defended women's domestic credentials rather than their equal rights to public rhetorical influence. At the turn of the century, the dominant construction of public rhetorical space continues to support the view that public speaking, political oratory in particular, was a male preserve; women could enter that preserve, but they could never hope to belong there.

The ideological merger between cultural views of the ideal, American woman and attitudes toward women's rhetorical behavior exemplified by the domesticated portraits of white, middle-class female speakers in *Woman* strengthens the gendered presumptions about rhetorical behavior that influenced how the achievements of women were treated in the emerging canon of American oratory. In the late-nineteenth and early-twentieth cen-

turies, the era in which the canon of American oratory begins to develop, the cultural climate predisposing how women are represented in the canon is still a highly conservative one, thick with mistrust of women's participation in public speaking and pervaded by inducements for women to perceive their rhetorical roles as located in the home. Revealing yet one more variant of the ambivalence endemic to white, middle-class culture in the late-nineteenth century about *how* to recognize or *whether* to recognize the authority of women's words, early canon authors vacillate between recording the accomplishments of some women speakers (but certainly not all) and erasing nineteenth-century women from the historical record of American public speaking all together. Those early canon authors who recognized the achievements of women speakers, always the white, middle-class, eminent women such as Stanton, Livermore, Willard, and Anthony, built upon an existing predisposition toward reading the rhetorical performances of women as domestic acts of moral intervention and reinscribe the eloquent-mother and noble-maid tropes as the most obvious defenses for including women in the canon. These arguments, however enthusiastic, did not ultimately carry the day in the construction of canonical rationales that favor, from the outset, a hierarchical regard for the white, male statesman as the exemplary American orator. Bolstered by decades of wavering opinion as to how to evaluate the rhetorical contributions of women to American culture, canon authors who do not name women at all among the great speakers of the nation proceed with cultural impunity to erase women from the history of American oratory with the tacit permission of a public who had never been fully convinced of the rights of women to occupy those rhetorical spaces in which the politics of American life were argued.[6]

The erasure of women's speeches from the history of American public speaking is obvious as early as the 1870s in canonical treatments of American literature that valorize only the political speeches of American statesmen as having "literary" quality. Stopford Brooke's *English Literature* (1879), which includes sections on American literature, and Henry A. Beers's *An Outline Sketch of American Literature* (1887) represent texts that embody the generic tendency of early treatments of the nineteenth-century canon of American literature to name only the speeches of brilliant political orators to the canon of American oratory. Brooke argues for both the breadth and the aesthetic value of the "thrilling eloquence" of American orators by insisting that "Our literature is rich in eloquence of statesmen and orators on almost every subject capable of being elucidated by the living speaker" (180). Brooke's sweeping claims about the stature of American eloquence on "every subject and by every living speaker" are complicated by the brevity

of the canon he outlines. Brooke's canon includes many of the choices that will become standards in later canons: the speeches of Daniel Webster, Henry Clay, and John C. Calhoun are named as the "best specimens of eloquence" of the pre–Civil War period, and Edward Everett, Charles Sumner, and William H. Seward are praised as the "treasures" among the great statesmen of the antislavery era (179; 180).[7] Congratulating these statesmen for their "eloquence of thought" and "finely-spun theories," Brooke confirms for his readers the conventional image of the authoritative and skilled male orator whose "pungent addresses and writings" have the power to change the course of American history (179–80). In *An Outline Sketch of American Literature,* Beers also canonizes Webster as "the greatest of American forensic orators" whose speeches have such universal appeal that they "take their place in literature" (111). Less complimentary to Calhoun and Clay whose speeches Beers feels fall beneath the standard set by the "literary," he nonetheless mentions them in his treatment of literary developments in the "Era of National Expansion." Beers also treats Rufus Choate as the most eloquent "legal orator" of this period, reiterates the characterization of Everett as a great and elegant speaker, and confirms the rights of Webster, Clay, and Calhoun to the list of great statesmen orators (114). Beers reserves for Abraham Lincoln's "Gettysburg Address" the prestigious title of the great classic of American oratory (245–46).

Although Brooke could possibly be excused for not mentioning postbellum women orators such as Livermore, Willard, and Anthony because his treatment of American literature ends at 1879 ("American Literature, From 1647–1879"), he also fails to mention any women speakers from the "Era of National Expansion" or to record the contributions of abolitionist speakers such as Lucy Stone and Anna E. Dickinson. Similarly, Beers does not mention women speakers of either the antebellum or postbellum periods although he claims to cover the most significant works in American literature as late as 1887.

Amplifying the statesmen rubric one step further, Beers strengthens the canonical presentation of public speaking as a male preserve by categorizing great orations by rhetorical occasions that he defines along classical lines as political, legal, and occasional (ceremonial) oratory. As the canon of American oratory developed in the next two decades, the statesmen orientation of definitions of the canon of American oratory is further masculinized by the persistent categorization of great orators by their association with three traditional, male, rhetorical spheres: the political forum, the court of law, and the public-speaking-platform lecture. Occasional oratory or public address takes the place of epideictic or ceremonial rhetoric in nineteenth-

century definitions of the modes of oratory. Rather than interpreting public address as a genre that would encompass a broad range of public-speaking occasions, Beers defines public address as a subset of formal political oratory and cites only male statesmen such as Everett, Sumner, William Lloyd Garrison, and Wendell Phillips as the best examples of platform orators. At the turn of the century, the statesmen rationale and the rubric of categorizing great speeches generically as political, legal, or platform oratory comprise a well-established formula in histories of American literature that canonized the list of great American orators nearly uniformly as Webster, Clay, Choate, Calhoun, Everett, and Lincoln. This stable canon of nineteenth-century orators is reiterated by turn-of-the-century histories of American literature represented by Fred Lewis Pattee's *A History of American Literature* (1896), Alphonso G. Newcomer's *American Literature* (first published in 1901), and Julian G. Abernethy's *American Literature* (first published in 1902). All three of these texts follow what is, by the 1890s, an established pattern of regarding the period before the Civil War as the golden age of American oratory characterized by the talents of legendary statesmen like Webster and Lincoln.[8]

A particularly interesting twist in the disposition of American-literature histories written between 1880 and 1910 is that although women speakers are never included in the canon of great American orators in these texts, many women writers are accorded regular recognition either as distinguished regional authors or as notable poets, novelists, or essayists. For example, Beers discusses the work of Margaret Fuller, "the most intellectual woman of her time in America," in his treatment of "The Concord Writers" (136), and Abernethy cannot say enough in his chapter "A Group of New England Women" about the "feminine genius" of New England women writers including Harriet Beecher Stowe, Louisa May Alcott, Elizabeth Stuart Phelps, and Sarah Orne Jewett (453–54). Similarly, Pattee treats Lydia Huntley Sigourney under "The Poets" in his discussion of "The First Creative Period: 1812–1837," and Newcomer discusses Stowe's life and literary career in his chapter on "Romance" (146–48).[9] Although references to women writers are certainly sparse in comparison to discussions of male writers, it is important to observe fact that although American women writers of the nineteenth century are not given the attention that male writers receive in these histories, at least a few women are "on the map" as significant literary figures whereas nineteenth-century women orators are not once mentioned. The contrast between the recognition of women writers and the erasure of women speakers from the literary record exacerbates the degree to which the genre of American oratory emerges in postbellum

and turn-of-the-century histories of American literature as an unmitigat-
edly male genre.[10]

The statesmen approach to defining excellence in American oratory in
the developing canon of American literature is reinforced by a predisposi-
tion in the late-nineteenth century toward regarding public speaking as a
white, middle-class male preserve and by the continued prominence of
dialogues that either question women's ascent to the podium or rewrite that
accomplishment as an act of womanly devotion. Taken together, these dis-
courses provide a variety of affirmations for the authority of the statesmen
model over early published canonical texts that focus specifically on the his-
tory of American public speaking. In *The World's Famous Orations* (1906),
a multivolume canon collection that devotes three volumes to American
oratory, editor William Jennings Bryan confirms the gendered assumptions
of the statesmen model by reminding readers of Webster's popular maxim
that eloquence resides "in the man, in the subject, and in the occasion" (xi).
In the numerous canon collections published between 1900 and 1910, the
predetermined conclusion that eloquence resides "in the man" reveals its
power in the persistence with which the majority of canon authors exclude
women speakers from consideration. Titles of early canon texts are particu-
larly revealing indications of the tight, ideological grip that the statesmen
model had on developing histories of American public speaking. The col-
lection *Kings of the Platform and Pulpit* (1900) announces at the outset an
intention to omit the rhetorical achievements of women. Although not one
woman is mentioned in this compendious treatment of twenty-seven kings
of the platform and "A Hundred Anecdotes of a Hundred Men" (ix–xiv),
editor Melville D. Landon insists that *Kings of the Platform and Pulpit* con-
tains "the most comprehensive resume of the humor, wisdom, philosophy
and religion of the century" (viii). Landon could defend this claim to com-
prehensiveness despite the omission of women because they construe the
most significant rhetorical contexts in nineteenth-century American life to
be the public-speaking platform and the pulpit, public arenas that were still
defined culturally as male spheres in 1900.

Other treatments upholding the statesmen model of the canon published
at the turn of the century include Alexander Johnston's *American Orations:
Studies in American Political History* (1896); *Masterpieces of Oratory* (1900);
and editor Guy Charleton Lee's *The World's Orators* (1901). In the thou-
sands of pages of these multivolume collections, not a single acknowledg-
ment of the eloquence of American women appears. *American Orations* de-
votes an entire volume to major speeches of the anti-slavery struggle yet
restricts its coverage of orators to statesmen such as Everett, Sumner, and

Lincoln who address the topic of slavery in formal debates or before the U. S. Senate or House of Representatives. Similarly, the coverage of the "great Public Speakers of the period of the Civil War" in *The World's Orators* concentrates on the reputations of Everett, Sumner, and Phillips and venerates the "giants of the past—the Websters and the Beechers, the Calhouns and the Clays " (1–7; 15). The editors of *Masterpieces of Oratory* promise that the three-volume coverage of American orators will "take the reader through the edifice of eloquence reared by . . . peerless American orators" (1: xi). In a canon of over a hundred speeches, including speeches by Webster, Lincoln, President William McKinley with his inaugural address, and Theodore Roosevelt with his speech "Labor Day," not a single speech by an American woman is noted (2: v–vi). The absence of nineteenth-century women speakers on this list represents more than a factual omission; it represents the implied judgment that women speakers could not be included under categories such as "peerless," "giants," or "great Public speakers" (1: xi). The use of these terms to characterize an explicitly all-male canon in *Masterpieces of Oratory* implies that women orators of the masterpiece caliber simply did not exist in American history. As a conceptual move, this categorizational erasure of women speakers parallels the implicit expunging of women's oratory from the exemplary heading of "the literary" that American-literature historians such as Brooks and Beers accomplish by not including women in their analysis of American eloquence.

Functioning as an organizing point of departure for collections like *Masterpieces of Oratory* is the assumption that congressional chambers, the presidential debating platform, the pulpit, the law court, and the public lecture (when given by men) are the most significant political forums in American life and that the speeches given in these contexts comprise the only famous oratorical events in American history. By eliminating consideration of speeches delivered in the lecture halls, the churches, and community gatherings, in which nineteenth-century women speakers typically addressed their audiences and did their political work, canonical texts like *American Orations* and *Masterpieces of Oratory* effectively write women out of the history of American rhetoric by drawing canonical maps of the history of American speaking that exclude women by categorical principle. This erasure is rationalized by a generic and ideological construction of the political which restricts the field of canonical consideration to speeches given in arenas in which the presence of women was culturally suspect. Two illustrations prominently positioned in *Masterpieces of Oratory* as introductions to each of the two volumes on nineteenth-century American oratory captures the full force of this implication. A dominating white male pres-

ence is cast over this collection of masterpieces by the selection of a por-
trait of the oratorical giant Webster to introduce the volume on oratory of
the antebellum and Civil War periods (see fig. 5.1) and by a photomon-
tage entitled "The United States Senate in 1898" as a frontispiece for the
volume covering speeches from the postbellum period to 1900 (see fig. 5.2).
These two illustrations mirror the masculine construction of the orator that
the exclusively male canon of *Masterpieces of Oratory* inscribes textually. The
collage photograph of the 1898 Senate chamber seemingly filled almost to
overflowing with the images of male politicians is particularly effective in
making the point that masterful oratory takes place in a space where women
have no place.

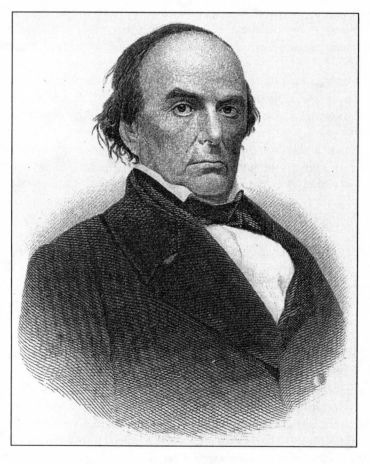

Fig. 5.1. "Daniel Webster," *Masterpieces of Oratory,* Vol. 2, 1900

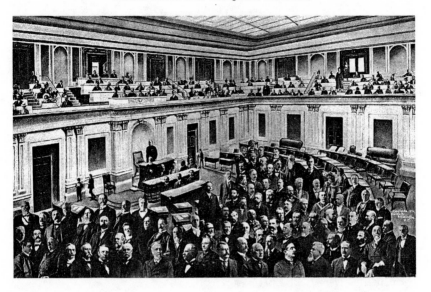

Fig. 5.2. "The United States Senate in 1898," *Masterpieces of Oratory,* Vol. 3, 1900

The authority of the statesmen model of the canon is so ideologically dominant in treatments published between 1900 and 1910 of the history of American oratory that exceptions are few and far between. Canon collections that wrote women into the spaces dominated by the gaze of Webster and the territorial claims of male politicians validate the political importance of the rhetorical settings where most nineteenth-century women gave their speeches. In the ideological foundations of these more-inclusive canons, the culturally familiar construction of women orators as good women speaking out for just causes is also promoted, and the eloquent mothers and noble maids are awarded a cultural status equivalent to male statesmen. Canons that promote women speakers as exemplars of American orators prevail upon the ideologically appealing reputations of women like Willard and Livermore to categorize the efforts of these good women speaking well as historically and politically significant in their own right. This justification for including women speakers in the canon retains the assumption that women speakers are a special case. In the minds of canon authors who value that special case, women are recognizable as great American speakers. As ample evidence indicates, however, most canon authors did not consider the special moral stature of women orators, however publicly renowned, to be a rationalization for including them in a list of statesmen, nor were they willing to support a definition of rhetorical practice sufficiently inclusive enough to recognize the lecturing career of

Livermore or the rhetorical reputations of women like Willard and Anthony who shaped the moral consciousness of the late-nineteenth century through countless speaking tours and addresses to conventions and town meetings. To do so would have been to acknowledge that the rhetorical influence of particular women speakers was equal to that of men and that women could exert statesman-like cultural power over public opinion and political events. The tension in ideological position between the canon authors who recognize women speakers as great American orators and those who categorically eliminate women from consideration for this title reveals that American culture remained sharply conflicted at the turn of the century about the public roles of women and the status of their words.

In *Famous Orators of the World and Their Best Orations* (1902), Charles Morris confirms the rhetorical stature of women by arguing "Woman as an orator has come to stay." Morris's account of the rise of women orators in America stresses that women were naturally drawn to public speaking because they were sympathetic to reform causes:

> The advent of woman into the field of oratory belongs in great mea-sure to the latter half of the nineteenth century. Kept for ages from any active participation in the political affairs of the nations, deprived of all opportunity of attaining the higher education, and confined as closely as possible to domestic duties and social interests, it is not surprising that the appearance of woman upon the rostrum in the past was almost a thing unknown. The greater freedom and broader edu-cation which came to her within the nineteenth century caused a marked change in this situation of affairs. And this was especially the case in the United States, whose republican institutions favored free thought and untrammeled action among all classes of the commu-nity. Naturally such great moral issues as those of the abolition of slavery and the development of the temperance cause came early to the front, and enlisted the active co-operation of many women of broad thought and warm sympathies. (335)

Morris identifies devotion to reform causes as the major motivation of women who sought the rostrum and acknowledges the bias that unfairly constrained rhetorical opportunities for women before the "latter half of the nineteenth century." Morris defines this bias as a hindrance that has been overcome and resolutely proclaims, "Woman . . . fairly claims a place in our record of the world's oratory" (335). Paralleling the partiality of post-bellum biographical treatments of eminent women, Morris only identifies white, middle-class women in his canon of "notable woman orators." Morris

names Willard, Livermore, Stanton, and Susan B. Anthony, along with Belva Anne Lockwood and Anna E. Dickinson, as "Notable Women Orators" of the world and introduces their speeches with descriptions of their careers and skills. In his short, biographical sketch on Livermore, Morris observes, "[L]ike most of the noted women orators, Mary A. Livermore early in life became deeply interested in the various reform movements of the time" (342). Morris also stresses Willard's reformist zeal and goes so far as to imply that Willard's devoted administrative and rhetorical labors hastened her death:

> Throughout [the organization of the National Woman's Christian Temperance Union], its energetic president aided it with voice and pen, until, worn out with her labors, death took her work from her hands, leaving it for others to carry on with resolute spirit. No woman in the nation has done more for the good of her fellows than Frances E. Willard, and her name should be honored in our memories. (346)

It is hard to imagine that Morris's readers would interpret this praise of Willard, who emerges in this portrait as a martyr, to represent anything less than the confirmation of what great women naturally do: women's "warm sympathies" motivate them to work and speak tirelessly on behalf of their "fellows" without thought of self. Morris's portrait of Willard as a woman who made the ultimate sacrifice for her fellow Americans introduces the text of Willard's speech "Safeguards for Women," in which she makes the often quoted defense of women's suffrage on the grounds that mothers should be allowed to walk beside their sons "as they go forth into life's battle" (347). Morris's praise of Willard's exemplary feminine virtue is inextricable from the motherhood appeal that infuses her speech and from how Morris rationalizes her status as a notable orator. In his awarding to Willard the title "The Woman's Crusade Orator," Morris encourages his readers to value her speeches as demonstrations of her good works.

Morris acknowledges the natural motives of Willard and Livermore who took up public speaking as the exercise of feminine sympathy in positive terms; consequently, he reasserts the ideological appeal of the eloquent-mother and noble-maid imagery that so frequently contextualizes how Willard's and Livermore's public-speaking careers had been represented to the general public in earlier decades. Morris's comments on Anthony also stress the virtue of devoted service that figures so large in his praise of Livermore and Willard: "Long derided for her opinion, in time she won the respect and admiration of those who were capable of appreciating earnest effort. . . . She continued a worker all her life" (339). Morris praises Stanton

for a "life spent in forceful displays of oratory, and in active labors for the political and legal advancement of her sex" and balances his praise of Stanton's devotion to duty with acknowledgment of her "forceful, logical, witty, sarcastic, and eloquent" oratory (336).[11]

Morris's canonical rationale credits the special moral claims of women speakers who represented themselves as mothers and daughters of the nation and affirms the eloquent-mother and noble-maid identities already closely associated with these notable women speakers. Morris's other rationale for including women speakers in the canon is the status of their speeches as "great occasions or events of history which never grow dull or stale" (v). Morris specifically argues in his introduction to *Famous Orators* that the intention is to include "the choicest orations on record in every field" chosen from several arenas: "the parliamentary chamber, the political rostrum, the bar, the pulpit, the lecture platform, and the social hall" (v). Morris shows an inclusiveness in his treatment of oratorical genres which not only reflects the range of application that oratory enjoyed in the nineteenth century but that also recognizes the importance of the rhetorical settings in which Willard, Livermore, Stanton, Lockwood, and Dickinson gave most of their addresses.[12] Although Morris recognizes that formal oratory in traditional forums constitutes a large part of the historical record of important American speeches, his identification of the platform and the social hall as equally important rhetorical occasions where, as he puts it, messages are "delivered to the world" (v) builds into his treatment of the American canon a liberality regarding oratorical genres that encourages him to acknowledge the achievements of women who forged their rhetorical careers outside the traditional male-dominated corridors of rhetorical power. Morris affirms not only the importance of the less formal rhetorical occasions in which women spoke, but also the motives of women like Willard and Livermore who claimed historic attention through the public's willingness to recognize their rhetorical performances as exemplary feminine behavior. Morris reinscribes this point of view in his praise of the martyred Willard and in his account of the feminine "warm sympathies" that generally drew women into oratorical careers (335).

Morris's canon foregrounds the importance of historically significant speeches in a generic range inclusive enough to recognize the public-speaking careers of women like Livermore, Willard, Stanton, Anthony, Dickinson, and Lockwood who built national reputations as women orators doing good works. As the canon developed in the postbellum period and early years of the twentieth century, those histories of oratory that adopt this broader generic range for defining great speeches tend to include women

speakers in the canon, albeit often minimally. When Morris compiles *Famous Orators* in 1902, the more inclusive generic definition of historic American speeches that rationalizes his inclusion of prominent women speakers is upheld by relatively few other canon authors. In other treatments that do canonize women speakers, a liberality in the definitions of oratorical genre and a willingness to acknowledge the special moral leadership that women speakers exerted are underlying factors.

In *The World's Famous Orations,* Bryan includes two speeches by women among seventy-five American speeches: Susan B. Anthony's speech, "On Woman's Right to Suffrage" (1873) and "Work Done for Humanity" by "Miss Willard" (1890). Once again, only women who are already constructed as eminent women of their times are noted. The omission of African American speakers from Bryan's canon as well indicates the extent to which the canon was already racialized at the turn of the century. What is particularly striking about Bryan's inclusion of Anthony's and Willard's speeches is the appearance of these speeches in what is otherwise a white statesmen canon through and through. Framed by his citation of Webster's "eloquence is in the man" theme, Bryan primarily identifies speeches of great American political leaders such as Calhoun, Choate, Clay, Everett, Sumner, Lincoln, and Webster as the core of the American canon. Bryan's choice to expand the boundaries of the statesmen approach to include Anthony's and Willard's speeches as historically significant speeches reveals once again that the inclusion of women speakers in the canon is influenced by how the generic boundaries of the canon are defined.

Anthony's speech "On Woman's Right to Suffrage" is one of her more strongly worded challenges to include women among voting citizens of the nation. In this address, Anthony echoes popular political themes such as "the blessings of liberty," and "the guaranteed rights" of all United States citizens. She concludes with the challenging question "Aren't women persons?" as a strategy to point out the moral necessity of extending voting rights to all people (qtd. in Bryan 10: 58). Bryan's introduction to Anthony's speech indicates that he acknowledges both the political and moral significance of her career: "Born in 1820, died in 1906; in early life a social reformer and advocate of the suffrage and other civil rights for women, with which she remained through life closely identified" (58). Bryan's representation of Willard also acknowledges the moral leadership implicit in her speeches. Bryan's bow in the direction of "Miss Willard" (Anthony does not receive the title of "Miss") and his inclusion of the speech "Work Done for Humanity" reinscribes yet again Willard's nearly legendary noble-maid image as a woman who spoke out for moral causes. In this speech, Willard

subtly redefines public life for women as a "landscape of beneficent work" and urges women to forsake private lives for humanitarian service: "Introspection, and retrospection were good for the cloister: but the up look, the outlook and the onlook are alone worthy [of] the modern Christian" (163–64). As in Morris's characterization of Willard, Bryan's selection of "Work Done for Humanity" with its theme of encouraging women to exchange the "cloistered" nature of their lives for active public service represents Willard as a devoted reformer whose rhetorical career personifies the Christian woman speaking out for just causes. Bryan's choice to include Willard's "Work Done for Humanity," which was first given in a convention hall, and Anthony's "On Woman's Right to Suffrage," which was given several times during Anthony's speaking tour of New York counties in 1873, also points out that accounting for women's contribution to the history of American public address necessarily required the recognition of a more inclusive range of oratorical genre than the traditional male domains of the Senate chamber, the law court, and the public lecture platform.[13]

Efforts like Bryan's to include women in the canon are not widespread; however, in other canon collections that include women speakers, a liberality in defining the generic boundaries of the canon is obvious. In *Modern Eloquence: A Library of After-Dinner Speeches, Lectures, and Occasional Addresses* (1900), a multivolume collection that is "devoted exclusively to occasional oratory" (v), the editors rely on a definition of the scope of "occasional oratory" as a "range from the humorous after-dinner speech to the eloquent oration and classic lecture" (v). *Modern Eloquence* claims to anthologize speeches that embody "the best spoken thought of the century" (xiii). Under this ambitious title, the editors of *Modern Eloquence* include over 3,335 speeches, including three by American women: one by Livermore and two by Julia Ward Howe. Clearly, the editors of *Modern Eloquence* overwhelmingly favor speeches by male orators including speeches by canonical favorites such as Webster, Sumner, Everett, Choate, Roosevelt, and Henry Ward Beecher as well as speeches from a large number of American literary figures such as Oliver Wendell Holmes, Mark Twain, Ralph Waldo Emerson, and William Ellery Channing. The inclusion of only three speeches by nineteenth-century women in a collection that promises to include the "best speeches" of the century points out how uncertain cultural attitudes are in the early years of the twentieth century about how to recognize the public-speaking careers of women. It is only under the broad generic categories of lectures and after-dinner speeches that women speakers are included in *Modern Eloquence* even minimally. This shows, once

again, that women are included in the early canon only when the rhetorical settings in which they typically gave their speeches are recognized as viable political forums.

Like Bryan and Morris, the editors of *Modern Eloquence* recognize the wider range of rhetorical occasions in which women orators performed, and the editors also corroborate the moral value of the eloquent-mother–noble-maid reputations associated with popular women orators by presenting women speakers (in this case Livermore and Howe) as exemplary women. Livermore's career is summarized in an introduction to her signature speech "The Battle of Life," which the editors point out "Mrs. Livermore" gave no less than "two hundred and fifty times" in her long lecturing career (5: 739–57). Just as Bryan confirms Willard's place in the noble-maid tradition in his introduction and through the selection of "Work Done for Humanity" as a representative speech, the editors of *Modern Eloquence* frame Livermore's place in the canon by recounting her reputation as a woman who came to the podium reluctantly, intending only to do good works:

> [Lecture by Mrs. Mary A. Livermore, author, editor, platform advocate of reforms (born in Boston, Mass., December 19, 1820), delivered first in the West in her husband's pulpit as a sermon, and after the war arranged for the lecture platform. The circumstance of the first delivery Mrs. Livermore thus relates: "My husband was a clergy-man, as you know, all his life, and he and I used to talk a good deal about subjects for sermons and their arrangements. I had made a draft of a sermon on the words, 'War a Good Warfare' (1 Timothy 1–18), and we had a talk about it. A little after, he sprained his ankle early one Sunday morning, when it was impossible for . . . him to get to the church, or to stand, if he got there. The leading men of the parish urged me to take his place, and my husband seconded their entreaties, and I consented. This was just at the close of the Civil War, during which I had had much experience in public speaking, without much preparation."] (739)

The choice of the editors of *Modern Eloquence* to include Livermore's characterization of herself as a reluctant and ill-prepared speaker pressed into moral service reconfirms for readers at the turn of the century Livermore's popular postbellum reputation as a good woman who did not seek the podium (or pulpit in this case) but spoke out in the service of a Christian way of life. In the text of "The Battle of Life," Livermore's virtuous motives for speaking up are reinforced by a moral tone in which she urges her

listeners to face up bravely to life's challenges and do one's best for others: "[W]e are all drafted into the battle of life, and are expected to do our duty according to the best of our ability" (739–40).

In the introduction to Howe's speech "Tribute to Oliver Wendell Holmes," the editors of *Modern Eloquence* provide background information that characterizes Howe as a highly regarded speaker who took her place among eminent men on the speaking dais:

> Tribute to Oliver Wendell Holmes. [Speech of Julia Ward Howe at the breakfast in celebration of the seventieth birthday of Oliver Wendell Holmes, given by the publishers of the Atlantic Monthly, Boston, Mass., December 3, 1879. Mrs. Howe sat at the right of Mr. Howells, then the editor of the Atlantic, who presided at one end of the tables, with Mr. Emerson on his left. Dr. Holmes sat on the right of Mr. Houghton, who presided at the other end of the table, with Mrs. Stowe on his left. Mrs. Howe was called up by the toast, "The girls we have not left behind us."] (2: 645)

The acknowledgment of Howe's stature in this introduction implies a respect for her reputation aptly summarized by James Burton Pond in his lecture "Memories of the Lyceum" also anthologized in *Modern Eloquence* (6: 893–917). In this lecture, in which Pond also notes the speaking careers of Livermore and Stanton, Howe is described as a "speaker essentially and intellectually womanly" and as "the unflinching helpmate of the brave philanthropist and scholar with whose name her own is interwoven" (905). Like Livermore, Howe's talents as a speaker are contextualized for readers of *Modern Eloquence* within a wider frame that stresses her exemplary womanliness.

It is somewhat ironic that the editors of *Modern Eloquence* acknowledge "the girls we have not left behind us" as the toast Howe responds to at the dinner celebrating Holmes when the case made for "the girls" seems a paltry one overall in *Modern Eloquence*. Although Livermore and Howe were both highly regarded public speakers, three of their speeches could hardly be considered representative of the contributions of nineteenth-century women to "the best spoken thought of the century" (1: v) However, in contrast to the majority of canon collections that do not recognize "the girls" at all, even the minimal inclusion of Howe's and Livermore's speeches in *Modern Eloquence* is significant. The inclusion of Livermore's "The Battle of Life," a standard selection throughout her lyceum career, and the inclusion of Howe's tribute to Holmes as well as "The Saloon in America," a speech that Howe delivered originally to the New England Woman's Club, makes the point that unless canon authors presume a broad generic point

of view that recognizes women's clubs, literary dinners, and lyceum lectures as significant rhetorical occasions, the achievements of women speakers like Howe and Livermore are simply not recognized.

As in the cases of Bryan's and Morris's canonical inclusion of women, a generic liberality about rhetorical occasion seems to go hand in hand in *Modern Eloquence* with a willingness to acknowledge the moral leadership of women through public speaking as a substantial cultural contribution. The subtle acknowledgment of "Mrs. Livermore" and "Mrs. Howe" as virtuous women in *Modern Eloquence,* exemplified by the characterization of Livermore as a reluctant woman called to the podium out of duty and by the presentation of Howe's literary eminence as a standard-bearer for "the girls we have not left behind us," presents Livermore and Howe to readers as accomplished speakers and also admirable, virtuous women of whom the ·country should be proud. The combination of oratorical skill and admirable feminine virtue that Livermore and Howe exemplify in *Modern Eloquence* and the generic liberality that allows their inclusion in the best speeches in the country's history is also illustrated in the canonical rationale that guides the construction of the "Gallery of Great Orators," a canon outlined in the popular parlor speaker *The American Orator* (1901). In this gallery, Howe, Willard, and Stanton are identified as impressive public-platform speakers as well as exemplary women: Howe is praised in glowing terms as a public speaker who "wielded an extensive influence" and for being "one of the best types of American womanhood" (287). Under a photograph of her looking every inch the motherly figure replete with white hair and dressed in matronly black, Stanton is credited as "a woman of remarkable oratorical gifts" (299). Willard, whose "Gallery" photograph shows her wearing her "Mother's Crusade" white ribbon, is described as a platform and pulpit speaker of much force (279). Willard is also included in the canon of famous orators in another speaker, *The New Select Speaker* (1902) by Josephine Stratton and Jeannette Stratton, in which her speech "The New Woman" is introduced in terms that call attention not only to Willard's image as noble-maid speaker but also to the ambivalent cultural context in which her reputation is acknowledged:

> Although it is not customary to include women among orators, an exception must be made in the case of Miss Willard. Few men have possessed her command over popular audiences. Her eloquence drew multitudes to listen to her burning appeals in behalf of the reforms of the day, among whom were always many who protested that they "never liked to hear a woman talk in public." Miss Willard's remarkable gifts, her zeal and earnestness, and her devotion to her cause, gave

her a world-wide reputation. This extract from one of her eloquent
public addresses is bright in thought, wholesome in sentiment, and
is a model of effective speech. (96)

In a canon that includes speeches by Clay, Everett, Phillips, and Webster,
Willard is the only woman among the famous orators represented in *The
New Select Speaker*. How arguable a move even this single inclusion of a
woman was still perceived to be is measured by the reminder to readers in
1902 of the context of opposition to Willard's public-speaking role that she
is praised for overcoming. This allusion to the bias against women speak-
ers is not characterized in *The New Select Speaker* as a thing of the past as
in Morris's more-optimistic pronouncement, but rather as an ongoing ob-
stacle that Willard's devotion and "wholesome sentiments" allowed her to
circumvent (96). This depiction in 1902 of a cultural climate in which
women speaking in public is still highly suspect points out what the small
number of inclusions of women in the developing canon of American ora-
tory corroborates: in ideological terms, public rhetorical space is a highly
disputed site, and the issue of women's rhetorical rights to public audiences
remains debatable.

As the depiction of Willard's rhetorical career in *The New Select Speaker*
makes clear, the cultural climate in which Morris, Bryan, and other more
liberal canon authors are writing remains one in which those authors who
are inclined to recognize women as great orators might do so with the ac-
knowledged proviso: "it is not customary to include women among ora-
tors." However, had even this heavily qualified rationale prevailed in the
early development of the canon, it is likely that the achievements of nine-
teenth-century women orators would have been far more widely recorded
and preserved in early histories of American public speaking than they were.
Confronting a deeply entrenched cultural opposition to "hear[ing] a woman
talk in public," the "special category" defense of women as oratorical cru-
saders and the application of a generic rubric legitimizing a range of rhe-
torical settings favored by Morris, Bryan, the editors of *Modern Eloquence,*
and a handful of others were not successful in predisposing the develop-
ment of the canon overall. During the first decade of the new century, his-
tories of American public address developed in a direction that affirmed the
culturally dominant definition of political oratory as the province of (white)
statesmen and awarded a hierarchical status to oratory produced in the tra-
ditionally male-governed forums of governmental chambers, courts of law,
and political platforms. The definitions of oratory as a rhetorical skill of
political leadership and as the molding of public opinion that underwrite
the ideology of early canonical texts construct a generic category for pub-

lic speaking that grows more exclusive of women's achievements rather than less so. In fact, the statesmen approach prevails to such an extent that by 1910 even the exceptional efforts represented by Morris, Bryan, and others to include women in the canon have disappeared from view. The public-speaking careers of women who were represented to the general public most often in positive terms as eloquent mothers and noble maids proved relatively easy to expunge from the historical record. This record very early on proved too ideologically rigid to recognize as statesmanship in action women's rhetorical achievements in a wide range of rhetorical spaces and too dismissive of domestic associations to support the arguments made by Morris and others who defended women speakers as courageous women of virtue whose speeches represented the best of American womanhood.

In *Famous American Statesmen and Orators* (1902), a title that more than captures the masculine predisposition of the evolving canon, editor Alexander K. McClure revealingly defines the "successful orator of to-day [*sic*]" to be that great "public man" who "sways public sentiment and leads the American people in ruling their own government" (17). McClure claims that his collection "intelligently covers the great American orators," yet his "intelligent" canon does not include a single speech by an American woman in a long list of over one hundred and fifty speeches (18). That the canon of great American orators had grown in *Famous American Statesmen and Orators* to include well over a hundred more statesmen than the postbellum canon that typically named no more than a dozen or so great speakers, calls attention to another subtle, categorical move in the construction of the early canon. It appears perfectly credible to editors like McClure to extend the list of speeches that exemplify American leadership to include an ever-increasing number of orations by white men. At the same time, McClure extends no recognition at all in *Famous American Statesmen and Orators* to prominent women speakers, past or present. This disregard for the historical fact of the high-profile oratorical careers of women like Willard and Anthony, with whom McClure and his readers would still be well acquainted in 1902, can only be explained by assuming that McClure takes the masculinist view of political oratory and rhetorical space so for granted that even prominent women speakers of his own era are unrecognizable under the ideological terms governing his discourse: women speakers are not famous statesmen; therefore, they are not famous orators either. Unlike Morris and Bryan who make the case that at least some women do qualify for these categories, McClure shows what is the more dominant inclination among early canon authors to presume on the ideological erasure of women from public rhetorical roles that had been explicitly asserted

as the conventional norm in America throughout the nineteenth century. McClure's position draws upon a deep layer of cultural opinion to support the default erasure of women from both the categories of statesmen and orators. In ideological terms, the permission for McClure's neglect of women who surely fulfilled any reasonable criteria for leadership and the shaping of public opinion that might have been objectively articulated is made possible by the definition of oratory as political eloquence that shapes national destiny only in the corridors of power that were still defined as the unalienable rhetorical territory of men when *Famous American Statesmen and Orators* was published in 1902.

In the foreword to the canon collection *Masterpieces of Eloquence* (1902), Chauncey M. Depew describes the American orator in the definitive masculine terms that dominate early canonical definitions of the American public speaker:[14]

> Real oratory is one of Heaven's gifts which a man may well pray for. The gift of speaking—of being able to make people listen to what you say—of inspiring men with ideals and convincing them of truth—surely than this no more superb work a man can have. The writer hides his face—though not his heart—behind his book. The orator must show his face, and if he be an orator in very deed, his will be a greater triumph than that of the writer. . . . It is easy to open the soul on paper, but to speak the truth elegantly, forcefully, convincingly before an audience of one's fellow men requires at all times ability and self-control, and, in many cases, courage of a high order. (i)

Like the illustrations "Daniel Webster" and "The United States Senate in 1898" in *Masterpieces of Oratory,* Depew's construction of the idealized male orator blanks women off the canonical map by categorically eliminating them from membership in that higher order of inspiring, triumphant, elegant, forceful, and courageous speakers whose work it is to speak the truth. Women are neither speakers nor listeners in Depew's scenario. Real oratory passes between men alone, and it is men alone who can hope to be blessed by this gift of gifts. Depew's construction of real oratory as the exclusive gift of men flies in the face of so much recorded fact about the public careers of nineteenth-century women speakers who spoke out and changed American life that one suspects that like McClure, Depew's myopic failure of conceptual imagination is predisposed by a strong heritage of cultural agitation against women assuming the high order of rhetorical work Depew depicts as the public orator's vocation.

The gendered orientation of the canon, rationalized by definitions of real oratory like Depew's, prevails without marked challenge in the twentieth century until the publication of Doris G. Yoakum's revisionist essay, "Women's Introduction to The American Platform" in William Brigance's influential canon history, *A History and Criticism of American Public Address* (1943). Yoakum restores to the historical record of American public speaking between 1820 and 1865 the names of women such as Anthony, Antoinette Brown, Lucy Brown, Angelina Grimké, Sarah Grimké, Abby Kelley, Lucretia Coffin Mott, and Stanton (153–92) and ushers in a new age in canon history.[15] In concluding her account of influential women speakers, Yoakum observes, "Only recently have those concerned with the history of oral persuasion in this country begun to ponder the possibility that women may have made some contribution to this field of speech" (188–89). Yoakum's construction of the inclusion of women in the canon as a new possibility only recently being considered indicates that the arguments made by early canon authors such as Morris and Bryan who did acknowledge the contributions of a few nineteenth-century women speakers to American culture had long been forgotten. Also forgotten along with the names of Livermore, Stanton, Willard, Anthony and many more was the insight into the range of nineteenth-century rhetorical practices that canon authors who recognized the rhetorical careers of women understood so well: the vitality and cultural influence of oratory over nineteenth-century American life was found as often in the church meeting room, the convention hall, the town square, the community gathering, and the dining hall as it was in the Senate chambers, the law court, and the political-debating platform. When early canon authors chose to privilege only the rhetorical spaces controlled by statesmen, they erased not only the voices of women who helped to shape American political culture, but also the significance of the rhetorical spaces in which most Americans heard words that changed their views and lives.

The title of the canon collection *Lords of Speech: Portraits of Fifteen American Orators* (1937) by Edgar Dewitt Jones promises a study of the "bright particular stars that bespangle the oratorical skies of one hundred and fifty years of a nation's history" (vii) yet, predictably, reinscribes only orators in the statesmen tradition. Emblematic of the constricted and gendered stance of canon collections between 1900 and 1943, *Lords of Speech* serves the same ideological function in the 1930s of reinforcing the construction of the idealized white male orator and masculine rhetorical space that *Kings of the Platform and Pulpit* achieved in 1900.[16] Between the pressure of kings on one side and lords on the other, nineteenth-century women were blotted

entirely off a canonical map already held hostage to cultural unrest and disagreement about the claims of women to public rhetorical influence.

For the nineteenth-century woman standing off stage of the public-speaking platform reserved for men alone, the historical denial of her right to that rhetorical space and to the acknowledgment that her words did change American history had been licensed by a chorus of cultural voices urging her off that platform and out of the public eye for a very long time. While she watches the ghosts of the giants of oratory called up one after another in a parade of statesmen whose words are valued far more than hers, that woman, who can look back to the turmoil her voice had caused in one century and the proof that her voice remains suspect in the next, could only wonder how long history would be willing to placate the cultural anxiety that would speed her quietly home again.

NOTES

BIBLIOGRAPHY

INDEX

NOTES

Introduction: The Feminist Analysis
of Rhetoric as a Cultural Site

1. I am using the term *rhetorical space* as a means to chart which rhetorical situations carry political power and which do not. When I refer to *public rhetorical space,* I am recognizing those rhetorical situations that potentially have impact on the shaping of cultural opinion, whether locally or globally. The argument I make throughout this book is that nineteenth-century women were encouraged to see the home as their rhetorical space and not to seek public forums to express their ideas and interests. It is important to think of rhetorical space as framing certain kinds of rhetorical opportunities that reflect the ways a culture has defined where significant cultural conversations take place. I believe that this sense of rhetorical space is articulated by Vicki Tolar Collins in her article "Women's Voices and Women's Silence in Early Methodism" (1997) in which Collins points out that developments within the culture of the eighteenth-century Methodist church "created spaces, sanctions, and support for women to speak in public and write for publication" (234). I am indebted to Collins's insight. In her recent article, "Gender and Rhetorical Space," Roxanne Mountford uses a different definition of "space" than the one I use in this project. Mountford explores "rhetorical space" as the "effect of physical spaces on a communicative event" and makes the insightful point that a material sense of rhetorical "geography" can be helpful in evaluating the nature of both historical and contemporary rhetorical performances.

2. *A History and Criticism of American Public Address,* edited by William Norwood Brigance, offers a multi-authored treatment of leaders in American public address and inscribes a canon of predominantly male speakers from the early and late national periods that include Lincoln, William Jennings Bryan, Henry Clay, John C. Calhoun, Daniel Webster, Ralph Waldo Emerson, Rufus Choate, and Wendell Phillips. In this two-volume treatment of thirty-four chapters treating single figures, Susan B. Anthony is the only woman who receives a chapter-long treatment. Only one chapter discusses an African American speaker, Booker T. Washington (Frederick Douglas receives no mention at all). The degree to which Yoakum's treatment of women speakers represents a radical departure from canon histories is discussed in chapter 5.

3. Welter and Kraditor have been cited widely in the last several years in nineteenth-century rhetoric. See A. Cheree Carlson in "Limitations on the Comic Frame: Some Witty American Women of the Nineteenth-Century" (311) and Phyllis M. Japp in "Esther or Isaiah?: The Abolitionist-Feminist Rhetoric of Angelina Grimké" (347). Even when not directly quoted or cited in footnotes, Welter in particular frequently appears in scholarly bibliographies on nineteenth-century rhetoric (see Stephen Howard Browne, *Angelina Grimké: Rhetoric, Identity, and the Radical Imagination* [196]).

4. Logan's *"We Are Coming": The Persuasive Discourse of Nineteenth-Century Women* offers an extensive revision of the canon by reinstating the names of African American women speakers who spoke widely before and after the Civil War including Maria W. Miller, Frances Ellen Watkins Harper, Mary Ann Shadd Cary (who fled to Canada to avoid the Fugitive Slave Act), Sojourner Truth, Edmonia Highgate, Ida B. Wells-Barnett, Anna Julia Cooper, Lucy Wilmot Smith, Fannie Barrier Williams, Lucy Craft Laney, and Mary Church Terrell. Logan makes the crucial point that African American women speakers considered their mission primarily to be of "uplifting" their race, a motive certainly not shared by "eminent" white women speakers such as Stanton and Willard who persistently compromised the political status of African Americans out of fear that upholding racial equality would undercut the success of their own causes of women's suffrage and temperance. In *Traces of a Stream: Literacy and Social Change among African American Women,* Royster also notes the importance of African American women speakers Mary Shadd Carey, Anna Julia Cooper, Mary Church Terrell, and Ida B. Wells-Barnett. Additionally, Royster contributes to our concept of the canon of American rhetoric an expansive definition of rhetorical genre that recognizes journalism, club work, the founding of political organizations, philanthropic agencies, educational reform, literary writing, and more as rhetorical modes put to effective use by African American women. The works of Logan and Royster are complemented by Jacqueline Bacon's work in "Do You Understand Your Own Language? Revolutionary Topoi in the Rhetoric of African-American Abolitionists" and Drema R. Lipscomb's article, "Sojourner Truth: A Practical Public Discourse."

5. Although the collection *Nineteenth-Century Women Learn to Write* (1995) edited by Catherine Hobbs focuses on the acquisition of literacy rather than rhetorical skills directly, this group of essays provides a coherent and broad contribution to remapping by exploring the many ways that nineteenth-century women acquired compositional skills. It is important to observe that mapping projects are not without their critics. Barbara Biesecker has criticized canon revisions that include forgotten women as scholarly tokenism that misses the chance to critique how canons are constituted, and Carole Spitzack and Kathryn Carter have pointed out that the tokenism of canon revisions implies that women were not as skilled as the men who were remembered. Interestingly, Campbell has dismissed these charges as nonsense in her response to both arguments in "Biesecker Cannot Speak for Her Either."

6. It is not my intention to interpret Swearingen's position of "shifting the question" to be a gesture of drawing a line in the sand between types of feminist historiography, but only to make use of the insight of her methodological distinctions to underscore the importance of a feminist analysis of how gendered cultural contexts impinge on how rhetorical theories and practices are defined and who gains access to them. I would argue that remapping and cultural field perspectives are highly compatible and that these methodological angles could profitably concur within the same study. I disagree with Xin Liu Gale who poses the questions "Who is missing from the map?" and "Why are they missing from the map?" against one another (378). I share Gale's interest in identifying the conditions under which women are lost from the historical record; however, I propose here a view of feminist historiography that envisions a profitable partnership between the mapping and cultural site approaches. (I have gone into greater detail elsewhere about general historiographic debates in the field.)

Swearingen's and Enders's works are cases in point, as is Jarratt and Ong's treatment of Aspasia. Another example is Catherine Peaden's insightful study of Jane Addams in "Jane Addams and the Social Rhetoric of Democracy" (1993) in which Peaden adopts both a mapping perspective and what I am defining as a cultural-field perspective by documenting the contributions of Addams's speeches and writings and also pointing out how constrained Addams was by heavily gendered views of women's roles in public life.

7. Although she focuses in her essay "Cultural Models of Womanhood and Female Education: Practices of Colonization and Resistance" (Catherine Hobbs 1995) on how nineteenth-century women were educated, P. Joy. Rouse points to the ideological construction of pedagogical practices in general by observing that across educational practices focusing on women, a cultural drama plays out over "a tension between beliefs of biological determinism and the social construction of identity" (231).

8. Throughout this book, I use the term *postbellum* to refer to the period between 1866 and the late 1880s. It is one of the particularly interesting aspects of the popularity of postbellum parlor rhetorics that these texts were often reprinted in the 1890s and early 1900s. The ideological agenda set in postbellum conduct manuals and letter-writing texts also extends into the late-nineteenth century because of the highly static nature of these genres. I would make the case that thinking in terms of postbellum influence in this particular historical case accurately reflects the long historical reach of conservative and gendered views of rhetorical practices.

1. Parlor Rhetoric and the Performance of Gender

1. Julia McNair Wright was a widely published author of advice literature, temperance plays, juvenile readers, short stories, and novels. *The Complete Home* was reprinted several times between 1876 and 1885. Wright was closely associated with the National Temperance Society and Publication House, publishing several plays

NOTES TO PAGES 20–21

and tracts with their sponsorship. Wright receives notice in Frances E. Willard and Mary A. Livermore's biographical volume, *American Women: Fifteen Hundred Biographies* (1893), in which Wright's literary career is described in glowing terms:

> Mrs. Wright has never had a book that was a financial failure; all have done well. *The Complete Home* sold over one-hundred-thousand copies, others have reached ten, twenty, thirty and fifty thousand. Since the organization of the National Temperance Society, she has been one of its most earnest workers and most popular authors. (804)

Such a characterization implies that Wright's name and views would have some authority with her middle-class readers who would have encountered her work in several venues. Wright's extremely successful children's reader series, *Nature Readers: Seaside and Wayside* (1887) was reprinted into 1902.

2. Robert H. Wiebe observes in *The Search for Order: 1877–1920* that at the end of the Reconstruction period, the United States was a nation without a core in which traditional values competed with the disorienting effects of increasing industrialization and urbanization. Wiebe also argues that in the extremely splintered culture of postbellum America and the later decades of the century, the construct of the nation was largely an imaginary idealization supported by Americans' attraction to the idea that the United States was a country that spanned from sea to sea and a country in which traditions, particularly Eastern values, represented an ideological center.

3. Hale's contribution to nineteenth-century conduct literature and to the support of a highly conservative definition of the American woman through her editorship of *Godey's Ladies Book* is considerable. Few women would have been better known to middle-class women readers than Hale or had more ideological power in affirming conservative gender constructions. Hale's *Manners; or, Happy Homes and Good Society All Year Around* was reprinted three times between 1868 and 1889; this text collected many of the columns and short essays Hale published regularly in *Godey's*. (For an analysis of the rhetorical influence of *Godey's*, which most nineteenth-century readers would associate with Hale's long-time editorship, see Nicole Tonkovich, "Rhetorical Power in the Victorian Parlor: *Godey's Ladies Book* and the Gendering of Nineteenth-Century Rhetoric.") Alfred Ayres was a pseudonym for Thomas Embly Osmun, conduct author and elocutionist whose widely published texts included, in addition to *The Mentor* that was reprinted into 1902, the immensely successful *The Orthoepist: A Pronouncing Manual* (1880) and *The Verbalist* (1882). These elocution texts were marketed to the home learner and went through several editions each. *The Orthoepist* went through eleven editions between 1880 and 1907, and *The Verbalist* was reprinted twenty-three times between 1882 and 1909.

4. Frank H. Fenno was a well-known name among postbellum parlor rhetoricians. In addition to his successful manual *The Science and Art of Elocution,* Fenno published a number of popular speakers and elocution anthologies between 1870

and 1900. Some of his most popular speakers, such as *The Peerless Speaker* (1900), circulated as late as 1907. An edition of Fenno's *The Science and Art of Elocution* "revised and enlarged" by his wife was published as late as 1912 with previous editions in 1880 and 1890. *Martine's Sensible Letter-Writer* is typical of letter-writing manuals circulating at midcentury in its definition of letter writing as an art and its attention to kinds of letters needed for day-to-day life such as business letters, letters of recommendation, family letters, letters of solicitation, letters of sympathy, and love letters. (For more information on nineteenth-century letter-writing literature, see chap. 3).

5. For information about the range of parlor rhetorics, see Johnson, "Popularization." In this article, I describe the historical context in which parlor rhetorics developed to such popularity, define the aims and contents of the major genres in the parlor-rhetoric movement, and discuss the theoretical relationship between parlor rhetorics and academic rhetorics. Hedrick offers a characterization of what she calls *parlor literature* that confirms the importance of the parlor as a cultural center in the antebellum home and the importance of that center for women like Stowe who developed their audiences in that domestic setting: "Parlor literature, like parlor music, was a centuries-old institution. When books were still expensive and amusements were simple, people provided their own entertainment in their homes. Typical activities included singing, playing the piano, and readings of specially produced essays and poems" (76–88).

6. Ronald F. Reid provides a close look at the kind of formal education that American men could aspire to having in antebellum America in his examination of the rhetorical education of Edward Everett (see "Edward Everett and Neoclassical Oratory"). Robert J. Connors provides a more general picture of male education in nineteenth-century America (see Connors, "Teaching and Learning as a Man").

7. Cited by Alice Stone Blackwell, *Lucy Stone: Pioneer of Women's Rights.* See O'Connor's discussion of Lucy Stone in *Pioneer Women Orators.* As O'Connor reports, Stone was one of the first women to gain a reputation as an antislavery and women's rights speaker. Stone was a key figure in the early women's suffrage movement and helped to found the American Woman Suffrage Association in 1869, for which she served as chairman of the executive committee for twenty years.

8. O'Connor characterizes Angelina Grimké as one of the "pioneer abolitionists" and makes the case that Grimké, along with Frances Maria W. Stewart, Abby Kelley, and Lucretia Coffin Mott, was one of the first women to advance to the public speaking platform to speak out against slavery. Angelina Grimké and Abby Kelley were among the first women to speak to audiences of both men and women in the 1830s and 1840s (see O'Connor 53–65). Kelley was highly regarded by her contemporaries such as Elizabeth Cady Stanton as a skilled spokeswoman for women's rights as well as abolition. In the biographical volume *Eminent Women of the Age* (1868), Stanton includes a sketch of Kelley in her treatment of prominent women in "The Woman's Rights Movement and Its Champions in the United States" (362–404). Stanton writes:

For a period of thirty years Abby Kelley has spoken on the subject of slavery. She has traveled up and down the length and breadth of this land, alike in winter's cold and summer's heat, mid scorn, ridicule, violence, and mobs, suffering all kinds of persecution,—still speaking, whenever and wherever she gained audience, in the open air, in school-house, barn, depot, church, or public hall, on weekday, or Sunday, as she found opportunity. (365)

Stanton also profiles Sarah and Angelina Grimké and Lucy Stone. Stanton calls Stone "the first speaker who really stirred the nation's heart on the subject of woman's wrongs" (392).

9. J. Agar's *The American Orator's Own Book* has a distinctly patriotic tone to its contents that focus on exemplar orations of statesmen and patriots such as "Washington's Farewell Address," "Patrick Henry before a Convention of Delegates, Virginia," and "Inaugural Message of James Madison—March, 4, 1809" (xiv–xv). Agar's *American Orator's Own Book* overlaps in contents with his other manual, *The American's Book of Oratory, or Guardian of Liberty* (1852).

10. Newman's *A Practical System of Rhetoric* was first published in 1834 and went through sixty editions in the following fifty years. One of the most popular academic texts in the period between 1830 and 1866, Newman's text was required at a number of colleges, including Amherst, Delaware, Wabash, and Michigan. Newman is theoretically influenced by Blair's *Lectures on Rhetoric and Belles Lettres* and tends to also follow Blair's example of including classic British exemplars as model speakers. Newman was professor of rhetoric and oratory at Bowdoin College from 1822 to 1839, and his textbook is assumed to be the sum of his lectures.

11. The early-nineteenth-century American prototype for elocution manuals was Ebenezer Porter's *Analysis of the Principles of Rhetorical Delivery* (1827). Porter's text was widely used at American colleges between 1827 and the 1880s. Porter's *The Rhetorical Reader* closely resembles his longer treatise on elocution in approach. Porter's texts are frequently cited by other elocutionists, particularly by homileticians.

12. In the late-postbellum period and at the turn of the century, Genung's texts *The Practical Elements of Rhetoric* (1886), *Handbook of Rhetorical Analysis* (1888), and *The Working Principles of Rhetoric* (1900) were the most widely used texts in American colleges. Quackenbos's text *Advanced Course of Composition and Rhetoric* was the most widely used and circulated American academic rhetoric manual between 1850 and 1880. Adams Sherman Hill was the author of two highly successful academic rhetoric texts in the 1890s: *The Foundations of Rhetoric* (1892) and *The Principles of Rhetoric* (1895). Like Genung's texts, Hill's texts are cited in college catalogues as late as 1915. Hill and Genung helped to popularize the definition of rhetoric as the art of adapting principles of form to particular occasions and audiences. For details on the theoretical foundations and pedagogical orientation of nineteenth-century academic rhetoric, see Nan Johnson, *Nineteenth-Century Rhetoric in North America* (1991). See in particular "The Arts of Composition and Belles Lettres" (173–225).

13. Abolitionist and feminist Lucretia Coffin Mott is described by modern biographer Nancy C. Unger as "an enormously inspirational speaker and a tireless organizer" and "one of the country's earliest and most radical, feminists and reformers" (23). Mott's high-profile speaking career spanned over fifty years, from her early involvement in speaking out against slavery along with Angelina Grimké and Sarah Grimké in the 1830s to a sustained antislavery speaking campaign in the decade before the Civil War. Mott also was a dedicated speaker for women's rights. For information on Anna E. Dickinson's fame as a public speaker before and after the Civil War, see chap. 4, n. 9. Stanton's prominence as a public speaker and reformer for women's rights was well established by the postbellum period. By 1875, Stanton had traveled and spoken extensively for the New York State Suffrage Society and the National Woman Suffrage Association, addressed the U.S. Senate as well as the New York State legislature, and established a prominent career as a lyceum speaker.

14. In the period right before the Civil War and during the war years, Brown's speech at Charlestown, West Virginia, which Brown gave to the court at his trial for treason after the Harper's Ferry raid, was cited as a model of eloquent persuasion and masterful delivery by abolitionists such as William Lloyd Garrison, who wanted to rally audiences and readers to anti-slavery issues. In *The World's Famous Orations* (1906), a canon collection of great American speeches, William Jennings Bryan includes Brown's Charlestown speech under the title "John Brown, His Speech to the Court at His Trial" (9: 186). Lincoln's "Gettysburg Address" had passed into oratorical legend by the 1870 and remained a classic model of political oratory in academic rhetoric texts as well as parlor speakers and elocution texts throughout the rest of the century. Lincoln's address at Gettysburg was canonized in nineteenth-century histories of American literature and of American address as one of the greatest orations in American history. For example, in *A History of American Literature* (1896), Fred Lewis Pattee characterizes the speech as one of the chief productions in prose inspired by the war and insists that it stands "with the great orations of the century" (347). Lincoln's "Gettysburg Address" continues to be cited in twentieth-century histories of American oratory as one of the greatest American orations ever delivered (see *A History and Criticism of American Public Address,* Ed. William Norwood Brigance 2: 828–76).

15. In the decades after the Civil War, the prominence of Mary A. Livermore, Frances E. Willard, and Susan B. Anthony as public speakers would have been difficult to ignore. Livermore was frequently described as "Queen of the Platform" and Willard as the "most famous woman in America"; Anthony was both lauded and condemned in newspaper reviews across the country (see chap. 4).

16. William Russell's other text, *American Elocutionist* (1844), was popular at midcentury but never equaled the success of *Orthophony: The Cultivation of the Voice in Elocution* (1846), which went through eighty-one editions between 1846 and 1900 and was a well-established parlor favorite for over fifty years. Russell was also the author of a textbook on the delivery of sermons, *Pulpit Elocution* (1861). Henry Mandeville's *The Elements of Reading and Oratory* was also widely reprinted be-

tween 1849 and 1880. Russell and Mandeville cover topics that are standard in nine-teenth-century elocution manuals: articulation, inflection, accent, emphasis, pause, force, pace, pitch, attitude of the body or stance, gestures of the hands, gestures of the arm, position of the feet and legs, and expressions of the face and eyes.

17. In the 1880s and 1890s, speaker manuals varied little in their contents or organization favoring these genre titles for grouping selections for study and per-formance. Rhetoric speakers were strikingly similar in content to a closely related genre of self-improvement texts that offered the reading public huge compendi-ums of literary selections under appealing titles such as *Sunbeams for the Home* (1884) and *Crown Jewels or Gems of Literature, Art, and Music* (1887). Often run-ning to over four-hundred pages in length, these literary collections typically in-cluded extensive selections under stock headings such as childhood and youth; home, friendship, and love; life and conduct; consolation and devotion; humor-ous readings; rural life; beauties of nature; and patriotism and freedom. Readers could find included under the various categories poems, essays, and fiction by well-known authors such as Charles Dickens, Washington Irving, and Harriet Beecher Stowe as well as works by ordinary authors. Characterizing reading as an activity that could "add to the staple of life," texts like *Sunbeams* and *Crown Jewels* encour-age their readers to believe that exposure to special texts yields special results: all will "be gladdened by the words of truth and light, of memory and hope, of beauty and power, within these pages" (*Sunbeams* iv). Interestingly, some literary readers were compiled by the same editors who produced texts in the speaker genre. For example, Henry Davenport Northrop is the compiler of both *The Ideal Speaker and Entertainer* (1910) and the earlier published *Crown Jewels or Gems of Litera-ture* (1887).

18. A representative example of the kind of speaker being published as late as 1910 is Henry Davenport Northrop's *The Ideal Speaker and Entertainer* (1910). This text is similar in contents to Northrop's earlier published speaker, *The Peer-less Reciter* (1894). Both texts provide a brief review of the principles of speaking followed by extensive selections for practice and performance under standard speaker headings such as "Descriptive and Dramatic Readings" (*The Peerless Reciter,* 49), Descriptive Recitations (*The Ideal Speaker,* 17), "Pathetic Recitations" (*The Ideal Speaker,* 177), and "Grave and Pathetic Readings" (*The Peerless Reciter,* 217).

19. George Melville Baker was a widely published playwright and elocutionist whose various elocution speakers were published between 1870 and 1912. Baker's most frequently reprinted texts were *The Handy Speaker* (1876), *The Premium Speaker* (1882), and *Pieces People Recommend* (1912). Baker's texts appealed to all ages and promoted the application of elocution to "all forms of public and pri-vate entertainments" (2). Emma Griffith Lumm wrote an etiquette manual, *Eti-quette at the Table* (1895) and compiled a popular turn-of-the-century speaker that appeared under two different titles: *The New American Speaker* (1910) was sim-ply a reprinting of an earlier text, *The Twentieth Century Speaker* (1899; 1900), with a different title. Lumm also compiled a children's speaker, *Young People's Star*

Speaker (1903). Lumm's texts show how little the contents of speakers had changed since 1870 as well as the fact that these parlor rhetorics were still quite popular in the first decades of the new century. *The Speaker's Garland and Literary Bouquet* was a serial publication that appeared in numerous volumes in the 1880s. Each volume offered numerous selections of poetry, drama, and prose for reading and performance. Selections were a mixture of classic texts such as "Hamlet's Ghost" and more contemporary excerpts from authors such as Charles Dickens, Washington Irving, and Alfred Lloyd Tennyson.

20. Isabelle Lehuu observes that sentimental "visual texts came to serve as medium and midwife for the dissemination of the culture of sentiment" in antebellum periodicals (91). (See Lehuu, "Sentimental Figures: Reading *Godey's Ladies Book* in Antebellum America.")

21. Titles like these appear regularly under the "pathetic" category. Often certain poems were anthologized in several manuals creating a kind of "domestic canon" of literature for women performers. See, for example, the inclusion of Dickens's "The Death of Little Nell" in both Northrop's *The Ideal Speaker and Entertainer* (194) and *The Complete Speaker Reciter* (174).

22. "Mrs. Sigourney" quoted here is Lydia Huntley Sigourney, widely known nineteenth-century poet and literary figure as well as essayist on women's conduct and the virtues of the home. Sigourney was one of the editors of *Godey's Ladies Book* between 1837 and 1850 and the author of the widely reprinted conduct manual *Letters to Young Ladies* (1833). Confirming Sigourney's stature in the reading public's mind, Frank Luther Mott observes in *A History of American Magazines 1741–1850* that Sigourney was the

> most popular poetess who ever wrote in America. . . . Her popularity was
> equaled only by her industry; her posthumous memoirs record over two
> thousand contributions to more than three hundred periodicals, and she
> published forty-six volumes of all sorts—poetry, essays, travel, fiction, historical sketches, and cookbooks, etc. She is omnipresent in the magazines
> of the period and she had editorial connections with several. (585)

Although Sigourney died in 1865, her poems are frequently anthologized in postbellum literary collections and speakers intended for the home reader. For example, Sigourney is highlighted as a major author of religious "gems" by the editor of *Crown Jewels* (1887) [3]. Most speakers include at least one of Sigourney's poems and usually more. By all accounts, the opinion of Sigourney would have been influential on the middle-class readers who would have regarded her as one of the eminent women of her time. Poems in these anthologies appear to have been mainly drawn from Sigourney's more popular volumes of poetry, which are identified in the biographical sketch of Sigourney in Willard and Livermore's *American Women* (1893) as "Pocahontas and Other Poems" (1841), "Voice of Flowers" (1845), "Weeping Willow" (1846), and "Water Drops" (1847) (657). For a recent analysis of Sigourney's contribution to rhetoric see Jane Donawerth's "Hannah More."

2. Reigning in the Court of Silence: Women and Rhetorical Space

1. The many pages awarded to the woman question and to discussions of feminine speech and behavior in popular postbellum periodicals and the popular press tell us quite clearly that the debate about whether or not women should be controlling rhetorics of power in traditionally male preserves is an intense one well into the twentieth century. Nineteenth-century periodicals that followed this debate particularly closely before and after the Civil War included *Ladies Repository* and *Ladies Companion,* widely circulating ladies magazines that, along with *Godey's Magazine and Ladies Book,* dominated the market in the decades before the Civil War. Other periodicals that followed the woman question included the *Atlantic Monthly, The Knickerbocker, Scribners Monthly,* and *Arena.* Although the *Ladies Repository* ended its publication reign of nearly fifty years in 1873, this magazine enjoyed a wide circulation during its time, sharing readers with other popular "ladies magazines" such as *Godey's Ladies Book* and *Peterson's Magazine* in the decade after the Civil War (see Mott 57; 306–7). Mott observes that *Punchinello* and *Puck* were both magazines that tended to satirize the "suffragists" in cartoons and "indelicate" lampoons (3: 91). Karen Halttunen analyzes the role of *Godey's Lady's Book* in the "Sentimental Culture and the Problem of Fashion" in *Confidence Men and Painted Women: A Study of Middle-Class Culture in America, 1830–1870* (1982): 56–91.

2. In her chapter on antebellum etiquette literature, "Sentimental Culture and the Problem of Etiquette," (92–123) Halttunen argues that the parlor is the center stage for the performance of antebellum etiquette:

> The many ceremonial rules governing parlor entrances and exits were designed to reinforce the crucial social distinction between that region of the house—the parlor and its environs—where the laws of gentility were in force, and those regions—the hall, the stairway, and the dressing rooms— where those laws were relaxed. (104)

Halttunen argues that following the rules of etiquette was a way for "socially ambitious middle-class men and women to demonstrate the sincerity of their gentility" (118). Jane E. Rose argues a slightly different thesis in "Conduct Books for Women, 1830–1860: A Rationale for Women's Conduct and Domestic Role in America" (Catherine Hobbs 37–58). Rose stresses that antebellum conduct books were among many cultural discourses that "reinforced a doctrine of separate spheres" (37) and upheld the icon of the ideal wife and mother as a stable and unifying icon in the Jacksonian Age when "a number of factors threatened the social cohesion" of the nation (44). While I agree with Rose, I believe that evidence indicates that the need to sustain the icon of the ideal American woman is equally intense in the postbellum period.

3. Taken collectively, the parlor-rhetoric curriculum was made up of various types of instructional materials: elocution manuals and speakers (see chap. 1),

conduct manuals, parlor encyclopedias, and letter-writing literature (see chaps. 2 and 3). Each genre contributed to a conservative cultural definition of rhetorical options for women.

4. Mott observes that the lecturing careers of Stanton, Livermore, and Anthony, along with that of Anna Dickinson, were followed closely by major magazines including the *Nation* and *Punchinello*. This kind of coverage, in combination with newspaper reviews of their lectures, would have kept these prominent women speakers in the public eye (3: 93). (For further discussion of the prominence of Stanton, Livermore, and Anthony and of the career of Frances E. Willard, see chap. 4.)

5. These headings from *The Imperial Highway: Essays on Business and Home Life with Biographies of Self-Made Men* (1888) are representative of the chapter headings that treat the conduct of women (455, 472, 502). Hilkey refers to books like *The Imperial Highway* as success manuals. However, in this chapter, I use the category "advice manual" for texts like *The Imperial Highway* and Potts's *The Golden Way* that offer instruction on family life, courtship, raising children, the right kind of education, and other topics that are typically discussed in advice manuals as moral issues rather than matters of success alone. Differing from advice manuals in their range of contents, etiquette manuals deal mostly with manners, appropriate dress, and often, as I discuss in chapter 3, correct letter writing.

6. What Cowen offers postbellum female readers is continued dominion over a mother's empire that, as Mary P. Ryan points out in *Empire of the Mother: American Writing about Domesticity 1830–1860,* had been conflated ideologically with the icon of the morally superior woman and mother in antebellum domestic literature and deeply inscribed upon the general public consciousness by the 1850s (112). Ryan remarks on the unacknowledged irony in this fusion of the fact that although the imperial mother may have ruled absolutely in her domestic sphere, she did so in the isolation of having to keep to the fireside (113). Kerber shows the early foundations of the mother's-empire ideology in the construction of the ideal Republican Mother:

> In the years of the early Republic a consensus developed around the idea that a mother committed to the service of her family and to the state, might serve a political purpose. Those who opposed women in politics had to meet the proposal that women could—and should—play a political role through the raising of a patriotic child. The Republican Mother was to encourage in her sons civic interest and participation. She was to educate her children and guide them in the paths of morality and virtue. (283)

The ideological parallels between Kerber's definition of the Republican Mother and its later incarnation in icons such as the eloquent mother are striking.

7. Popular conduct manuals often sold thousands and thousands of copies. Hilkey reports that Bates's *The Imperial Highway* went through multiple editions between 1888 and 1912.

8. The prominence of Hugh Blair in the nineteenth-century American public

mind did not rest solely on the over fifty American editions of his text, *Lectures on Rhetoric and Belles Lettres.* Blair's name as a cleric and critic of stature in Britain was also associated with moral advice on the Christian life through the popularity of collections of his sermons that were reprinted in American editions before the Civil War. The American edition of *Sermons by Hugh Blair: To Which Is Prefixed, the Life and Character of the Author* (1844) was printed verbatim from the last London edition (1840) and was a particular favorite from which Blair was often quoted.

9. The attention that the woman's kingdom receives in this except from the chapter "Women's Work" in *Our Beacon Light,* that echoes the conservatism of Potts's *The Golden Way,* reveals just how extensively postbellum conduct literature aligns women with the domestic sphere and preserves "the empire of the mother." Within volumes that devote several chapters to young men such as "Where to Secure an Education," "The Dignity of Labor," "Learning a Trade," "Choosing an Occupation," "Practice of Law," "The Practice of Medicine," "Room in the Ministry," "Pleasures of Mercantile Life," "How to Succeed," and "Where to Succeed" (12–17), topics addressed to women readers are few. Only a handful of chapters on women including standards such as "Women's Work," "Girls at Home," and "Home Entertainment," stands in rather sharp contrast in content and number with the dozens of chapters in these manuals typically devoted to explaining to young men how to "aspire to visions of greatness" (see *Our Beacon Light* 12–17; *The Golden Way* 158). Conduct manuals like *Our Beacon Light* and *The Golden Way* are written from a overtly religious point of view, and authors like Potts inevitably treat conduct as Christian behavior. The title to one of Potts's other popular volumes makes his Christian point of view extremely clear: *The Golden Dawn: Or Light on the Great Future; in This Life, Through the Dark Valley, and in the Life Eternal* (1884).

10. Hilkey speculates that the preservation of the woman's-sphere viewpoint by success writers such as Conwell may have been motivated partly by the fear that the movement of women outside the home could threaten employment for men and by a general anxiety about shifting gender roles: "Success writers' admonitions against women in the professions may have expressed an underlying anxiety about the advent of the 'New Woman' who pursued higher education, professional employment, and public careers, often eschewing the traditional domesticity of marriage, home and family" (161).

11. Hartley's *The Ladies Book of Etiquette and Manual of Politeness* was first published in 1856 and was reprinted twelve times through 1882. Hartley's and Sarah Hale's popular guides bridge the antebellum and postbellum eras, and their prominent articulation of a conservative view of women's rhetorical behavior and defense of the domestic-sphere ideal influence women's conduct literature throughout the remainder of the century. Ryan describes Hale's editorship of *Godey's Ladies Book* as making a major contribution to molding "a new ideal of home life, placing a uniquely feminine sensibility at the center. . . . The magazine elevated the ordinary homemaker to an ethereal sphere of female power" (34).

12. Adam Craig's *Room at the Top* was reprinted four times between 1880 and

1884. Craig was also the compiler of a modestly successful literary reader, *The Casket of Literary Gems* (1879).

13. Richard Alfred Wells's *Manners: Culture and Dress of the Best American Society* was originally published in 1860. The 1890 edition was reprinted seven times and as late as 1894, a publishing record that indicates how little etiquette advice had changed between the antebellum and postbellum periods.

14. Postbellum encyclopedias covered a range of topics that was not always uniform. The inclusion of the etiquette of conversation was standard, however, until the turn of the century. Starting roughly at 1900, American encyclopedias begin to move away from a conduct orientation toward strictly expository information about topics such as history, grammar, writing, letter writing, literature, geography, natural history, government and politics, industry, agriculture, science, and education. *The Standard Dictionary of Facts: A Practical Handbook of Ready Reference Based upon Everyday Needs* (1908) represents the evolving genre of encyclopedia that covers the latter topics but does not include etiquette of conduct topics such as marriage and the raising of children. The generic shift in direction in the evolution of the American encyclopedia can also be noted by the change from stressing the term "forms" to an emphasis on "facts" in the title of volumes, a change that implies that the scope of the encyclopedia tradition has moved away from behavior (forms) in the direction of reference materials (facts).

15. Etiquette manuals in both the antebellum and postbellum periods are rarely original in their offerings, and it is not uncommon to see, as this example illustrates, maxims about conversation and other issues repeated verbatim from manual to manual. It is interesting to consider that although the woman question was hotly contested in the popular press and in conduct literature after the Civil War, this turbulence does not shift the ideological hegemony of etiquette advice to any observable degree. On the pages of etiquette manuals spanning over fifty years, from the antebellum period to the turn of the century, the quiet lady of parlor conversation continues to be reinscribed in exactly the same terms.

16. George Auther Gaskell, author of *Gaskell's Compendium of Forms* (twenty-six editions between 1880 and 1894) and Thomas Edie Hill, author of *Hill's Manual of Social and Business Forms* (approximately fifty editions between 1883 and 1911) were immensely successful authors whose treatments of the rhetorical arts of writing and speaking dominated the market among parlor encyclopedias.

17. *The Glory of Woman* was reprinted under two new titles subsequent to its original publication in 1896: *A Ladies Guide to Health and Beauty* (1902) and *Girlhood to Motherhood* (1907). Both titles belie the strong etiquette orientation of these manuals.

18. Mrs. M. L. Rayne is Martha Louise Rayne, postbellum conduct author and minor novelist. *What Can a Woman Do* was reprinted four times between 1883 and 1893. Rayne's other conduct books for women were *Written for You; or the Art of Beautiful Living* (1882) and *Gems of Deportment and Hints of Etiquette* (1881). Rayne draws on the contents of both these works for the material in *What Can a Woman Do.*

3. "Dear Millie": Letter Writing and Gender in Postbellum America

1. Nineteenth-century letter-writing manuals and guides included in conduct literature and encyclopedias to the general reader typically devote sections to the use of proper salutations and stress the need for appropriate formality in correspondence between men and women unless a couple is engaged or married. For example, see the discussion of address in the chapter on "Love, Courtship, Marriage, etc." in the extremely popular antebellum manual, *Chesterfield's Letter Writer and Complete Book of Etiquette* (1857), 53–58. In her general treatment of American courtship, Ellen Rothman discusses the love letter (*Hand and Hearts: The History of Courtship in America,* New York: Basic, 1994).

2. A few treatments of the nineteenth-century epistle as a rhetorical art are available although they are examinations of the letter in the work and lives of nineteenth-century literary figures such Dickinson, Melville, and Hawthorne (see Elizabeth Hewitt, "Dickinson's Lyrical Letters and the Poetics of Correspondence," *Arizona Quarterly* 52.1 [1996]: 27–58; and "Scarlet Letters, Dead Letters: Correspondence and the Poetics of Democracy in Melville and Hawthorne," *Yale Journal of Criticism* [1999], Forthcoming; also Linda S. Kauffman, *Special Delivery: Epistolary Modes in Modern Fiction* [Chicago: University of Chicago Press, 1992] and *Discourses of Desire: Gender, Genre, and Epistolary Fictions* [Ithaca, N.Y.: Cornell University Press, 1986]). For general discussions of the rhetorical practices of American letter writing, see "I Have Taken This Opportunity of Writing You a Few Lines: A Genre Popularly Practiced" in William Merrill Decker, *Epistolary Practices: Letter Writing in American Before Telecommunications* (Chapel Hill: The University of Carolina Press, 1998) 57–103; and Nan Johnson, "Composition and Belles Lettres," *Nineteenth-Century Rhetoric in North America* (Carbondale: Southern Illinois University Press, 1991) 210–13. For general discussions of epistolarity, see also Janet Gurkin Altman, *Epistolarity: Approaches to a Form* (Columbus: Ohio State University Press, 1982). For a different reading of the rhetorical uses of the epistolary form by nineteenth-century women, see Lisa M. Gring-Premble, "Writing Themselves into Consciousness: Creating a Rhetorical Bridge Between the Public and Private Spheres," *Quarterly Journal of Speech* 84 (1998): 41–61. Gring-Premble argues that one of the ways that nineteenth-century women developed a shared feminist consciousness was through correspondence (42).

3. Albert Cogswell's *The Gentleman's Perfect Letter Writer,* first published in 1877, is dependent for content on an earlier text by Cogswell writing under the name James Kernan, *Perfect Etiquette; or How to Behave in Society* (1872). James Lawrence Nichols published several business manuals and letter-writing manuals for the parlor reader and the business man. Nichols's texts were popular in the 1890s and reprinted into the first decade of the twentieth century. An example of the latter is *The Busy Man's Friend: A Guide to Success by Facts and Figures* (1902).

4. *The Home Cyclopedia of Necessary Knowledge: Embracing Five Books in One Volume* (1902), which includes "books" on general information, business, history,

cooking and housekeeping, and health and medicine, represents the wide range that the parlor encyclopedia embraced at the turn of the century. In the chapter "The Language We Speak," the reader is offered the kind of advice on composition and letter writing that most parlor encyclopedias typically offer between 1880 and 1910: a review of grammar, punctuation, sentence structure, "helps in spelling," clarity in sentence structure, how to write with force, and the use of the figures of speech (2: 19–33). Parlor encyclopedias typically offer this kind of instruction in the basics of composition in addition to sections on letter writing and oratory.

5. The most successful American letter-writing manual for over half a century, *The Fashionable [American] Letter Writer,* first published in 1818, went through twenty-seven editions into 1860. Latter versions of the manual were published under the title *American Fashionable Letter Writer* (1845). A modestly successful manual at midcentury, *Chesterfield's Letter Writer and Complete Book of Etiquette* went through three editions between 1857 and 1860. The format conflation between treatments of letter writing and etiquette in this manual indicates the degree to which the two subjects are associated with one another just before the Civil War. In its treatment of standard letter-writing topics such as the importance of a tactful style, correct grammar and punctuation, paragraph structure, and the overall organization of an effective letter, *Chesterfield's* is typical of most nineteenth-century letter-writing manuals. *Chesterfield's* also treats the major genres of letter writing: business letters, letters of friendship, family correspondence, letters of condolence, and courtship and marriage letters (8–58).

6. Blair's treatise was reprinted widely in America between 1800 and 1875 in full or abridged editions to which American authors often added annotations. Blair rightfully claims the reputation as the most influential of eighteenth-century British rhetorical theorists and critics on the development of the belletristic tradition in nineteenth-century rhetoric. That tradition stressed the critical analysis of literary works and the relationship between criticism and the development of intellectual character and taste.

7. Mrs. L. G. Abell was also the author of another self-help manual for women, *The Skillful Housewife's Book,* first published in 1846 and reprinted under that title in 1852 and 1858. *Woman in Her Various Relations* (1850) is dependent on the content of Abell's earlier text.

8. Newcomb's *How to Be a Lady* was a rewrite of his previously published manual, *A Practical Directory for Young Christian Females* (1850), a popular antebellum conduct manual published by the Massachusetts Sabbath School Society and reprinted ten times between 1833 and 1851. Newcomb was also the author of *How to Be a Man* (first published in 1846), also a very successful antebellum manual that was reprinted fifteen times between 1846 and 1860.

9. Sarah J. Hale's *Manners; or, Happy Homes and Good Society All Year Around* (New York: Arno, 1972 [1868]) went through three editions between 1868 and 1889. Between 1828, when Hale assumed the editorship of the influential *Ladies Magazine,* and her death in 1877, Hale was rarely out of the public eye, publishing thirty-six volumes of prose and poetry as well as numerous editorials and ar-

ticles on women's interests and conduct. Halttunen associates Hale with an advocacy of proper social forms associated with "the middle-class home and, more specifically, within the social sphere defined as the parlor" (187). These forms were viewed as more reliable in the eyes of the middle class at midcentury than Christian principles in maintaining social order. In antebellum and postbellum letter-writing literature as well as in advice manuals like Hale's *Manners; or, Happy Homes and Good Society All Year Around,* letter writing is defined as one of these forms.

10. In the introduction to *The Ladies Book of Etiquette and Manual of Politeness,* Hartley equates politeness with the expression of grace and sincerity. The sincere person is always a polite person. This idea that behaving well implied purity of heart predisposes nineteenth-century etiquette discussions both before and after the Civil War. As Hartley explains, the good person is always attentive to the "spirit of politeness":

> The spirit of politeness consists in a certain attention to forms and ceremonies, which are meant both to please others and ourselves, and to make others pleased with us; a still clearer definition may be given by saying that politeness is goodness of heart put into daily practice; there can be no true politeness without kindness, purity, singleness of heart, and sensibility. (3)

For Hartley, proper letter writing is an act of the pure heart.

11. William Brisbane Dick edited and published several volumes for parlor readers in the postbellum period and toward the turn of the century, including *One Hundred Amusements for Evening Parties, Picnics and Social Gatherings* (1873), a compendium of games and songs, and the juvenile parlor speaker, *Dick's Speeches for Tiny Tots* (1895).

12. John Burton Duryea was a prolific parlor writer who produced numerous volumes on business writing and business matters in general toward the end of the century and into the 1920s. *The Art of Writing Letters: A Manual of Correct Correspondence,* first published in 1891, went through three editions. Duryea's numerous books on correspondence and business communication, including *How to Solicit: A Man to Man Talk* (1924) and *When to Stop Talking* (1926), were reprinted as late as 1955. The extensive circulation of Duryea's books in the last decades of the nineteenth century and into the twentieth indicates that his promotion of a domestic sphere for female correspondence would have reached a wide readership.

13. In what seems a revealing resonance of mixed feelings regarding women and their rhetorical roles, the illustrations "The Invitation," and "Yes or No?" also appear in *Gaskell's Compendium of Forms,* similarly placed in the chapter on letter writing (220–26). This use of the same illustrations is particularly significant when we recall just how widely circulated volumes like *Gaskell's* and *The Household Encyclopedia* were. James Dabney McCabe, author of *The Household Encyclopedia,* published several volumes on American history and was well known to the reading public in the last decades of the century. *The Household Encyclopedia* went through three editions between 1881 and 1884. Other well-known publications by McCabe include *Great Fortunes and How They Were Made; or the Struggles and*

Triumphs of Our Self-Made Men (1871) and *Heroes and Statesmen of America, Being a Popular Book of American Biography, Embracing the Lives of the Representative Great Men of the Nation* (1878). When we note how much of McCabe's career is devoted to the documenting of the lives and accomplishments of great men, his uneasiness with the status of women revealed in his contradictory characterization of the woman writer in *The Household Encyclopedia* seems predictable. The appearance of both "The Invitation" and "Yes or No?" in *Gaskell's* as well as McCabe's *The Household Encyclopedia* would have given these images of women writing in only domestic scenes a wide circulation for over two decades.

4. Noble Maids Have Come to Town

1. Frances E. Willard was founder of the Woman's Christian Temperance Union in 1874 and president of that organization in 1874 until her death in 1898. In the decades after the Civil War, the WCTU was the largest women's organization in the United States. Willard was without doubt a national figure who, by the time of her death, had earned the reputation as the most famous American woman in the world. Early biographies of Willard are notoriously unreliable, influenced unduly by Willard's autobiography *Glimpses of Fifty Years*. Modern research on Willard's life has been compromised by the destruction by Anna Gordon, Willard's long-time companion, of the substance of Willard's personal papers after Willard's death. Although a promoter of the Willard legend against her own better judgment, Mary Earhart provides in her biography of Willard, *Frances Willard: From Prayers to Politics* (1944), sound documentation of Willard's political career and of the nation's high regard for her that prompted the state of Illinois (at Gordon's promotion) to lobby for the placement of a statue of Willard in Statuary Hall in the Capitol at Washington where it remains today (3). Recent works on Willard include Carol Mattingly's analysis of Willard's leadership in the WCTU in *Well-Tempered Women: Nineteenth-Century Temperance Rhetoric* (1998); James Kimble's examination of why Willard wrote *Glimpses of Fifty Years* in "Frances Willard as Protector of the Home" (1999); and Carolyn DeSwarte Gifford's analysis of Willard's success in melding the suffrage agenda into the goals of the WCTU in "Frances Willard and the Woman's Christian Temperance Union's Conversion to Woman Suffrage" (1995).

2. The *Dictionary of American Biography* (1902) describes Sanborn as "delightfully humorous" (327). Sanborn is also included in *The National Cyclopedia of American Biography* (1899), which promises to describe "the lives of the founders, builders, and defenders of the Republic, and of the men and women who are doing the work and molding the thought of the present time" (title page), as well as two other turn-of-the-century American biography volumes: Mary S. Logan's *The Part Taken by Women in American History* (1902) and Oscar Fay Adams's *A Dictionary of American Authors* (1904).

3. It is common wisdom in modern scholarship on the nineteenth-century suffrage and temperance movements to observe that the leaders of these move-

ments, such Stanton and Willard, made political and rhetorical use of the public's reverence for the ideal American woman to plead for equal rights for women and the sanctity of the home. Stanton goes so far in the support of this ideal as to endanger the movement by expressing shock during the reconstruction years that white men would consider giving the vote to black men before their virtuous white mothers, wives, and daughters, a racial slur that made Stanton far more controversial politically than her grandmotherly public image would imply. Generally defined as a shrewd strategy that advanced both causes, the theme of the noble American woman forms a crucial component of scholarly analysis of the political successes of Willard as well as Stanton and Anthony. (See, for example, Elizabeth Griffith, *In Her Own Right: The Life of Elizabeth Cady Stanton* (1984) and Lois W. Banner, *Elizabeth Cady Stanton: A Radical for Women's Rights* (1980) for their analyses of Stanton's speeches and writings.) Although widely acknowledged as a stock feature of the political platforms of the woman's rights and temperance movements, there is little evidence to suggest that leaders like Stanton and Willard did not indeed believe their claims that feminine moral instinct should prevail. Just how strategic a move it actually was to argue for reforms as "noble women watching over the nation as they would their homes" has to be evaluated against some kind of evidence that Willard, Stanton, and others recognized this kind of rhetoric as a choice among other rhetorical platforms rather than simply regarding it as the most earnest articulation of a view of women that they themselves actually believed.

4. Shirley Wilson Logan's detailed exploration of Frances Ellen Watkins Harper's speaking career and influence in both the African American and white communities contributes further evidence that omitting Harper from the eminent women speakers of the nineteenth century was a factual as well as moral oversight. See "'We are Bound Up Together': Frances Harper's Converging Communities of Interest" in *"We Are Coming": The Persuasive Discourse of Nineteenth-Century Black Women* (1999), 44–69. It is also important to observe that the omission of African American women from the canon of eminent nineteenth-century women and the subsequent erasure of their contributions from the canon of American rhetoricians to which it is surely linked could be read as evidence of another kind of cultural fiction about gender altogether, as an effort to sustain for the American public the superiority of the white man and white statesman-orator who was superior not only to women of both races but African American men as well. In *Manliness and Civilization: A Cultural History of Gender and Race in the United States, 1880–1917,* Gail Bederman advances the theory that parallel to the ideology of the true womanhood (but with far greater cultural power) was the fiction of white American manhood. This fiction required the support of a number of other fictions including the idealization of the white American woman as the angel of the hearth and the equally fictional demonization of African American men. Bederman's insight that gender fictions are interrelated with fictions about race is a significant one and a reading that bears more scrutiny by historians of rhetoric as it implies that gendered theories of rhetorical performance conceal idealization of whiteness.

5. Phelps herself is characterized in much the same terms by Elizabeth T. Spring, who likens Phelps to an Easter lily and stresses the admirable femininity of her writing:

> In her, and in her writing, force and sweetness so blend that we cannot tell whether it is the beautiful that draws us or the good and the true that stimulate and content us. If the flower is a lily, it is an Easter lily, with comfort and ministry in its grace, and ethereal and immortal meaning folded in its rare, white petals. (580)

Phelps was a widely known author of fiction, magazine articles, and poems whose publishing career spanned 1864–1902. She was a persistent advocate of women's equality although her reform interests shifted more toward temperance and Christianity in her published work in the 1880 and 1890s (Radinovsky 428). Phelps's life and career have been the subject of a range of scholarly accounts including, most recently, chapters in Susan K. Harris's *Nineteenth-Century American Women's Novels: Interpretative Strategies* (1990).

6. Laura Curtis Bullard was a minor fiction writer and close associate of Stanton who helped Stanton edit *The Revolution,* the major periodical of the suffrage movement in the 1870s.

7. Barnes's argument that the eloquent woman rules absolutely within her domestic sphere echoes similar arguments constraining women's rhetorical activities made in postbellum conduct literature and letter-writing manuals that characterize the wise mother as "dropping tiny seeds" on the "good soil of receptive minds" of her family (see chaps. 1 and 3.)

8. The "English divine" that Mrs. O. W. Scott refers to here as a moral authority is most likely Charles Haddon Spurgeon (1834–1892), British preacher and essayist, whose collections of sermons and conservative Christian conduct advice such as *Twelve Sermons on Vital Questions* and *Words of Wisdom for Daily life* were widely reprinted and anthologized in America between 1870 and the 1890s.

9. Among the most-established facts of Dickinson's professional career as a public speaker is that her remarkable success as a popular abolition speaker was initially promoted by William Lloyd Garrison. Dickinson's outspoken support of women's rights attracted the attention of influential supporters like Lucretia Coffin Mott, who arranged for Dickinson's first address on women's rights to a large audience. "Young, striking in appearance, sarcastic, possessing a strong contralto voice and complete confidence in her emotional biases, she profited by the increasing disposition toward Abolition tenets in the North and become a national sensation" (Dickinson 245). "At the height of her career (1863–1875), Dickinson could command a thousand dollars a lecture; by 1872, she was earning more than $20,000 per year and was more popular on the national lyceum circuit than any other speaker except Henry Ward Beecher" (Berkeley 558). All of Dickinson's modern biographers observe that by 1880, Dickinson's career had waned as American audiences seemed unmoved by Dickinson's political opinions on women's rights and education and her criticism of reconstruction. Dickinson's speeches and her

remarkable career have received less scholarly attention than they deserve from historians of rhetoric. A fairly recent exception is George Philip Prindle, "An Analysis of the Rhetoric in Selected Representative Speeches of Anna Elizabeth Dickinson" (Diss., Stanford Univ., 1972).

10. Bickerdyke was canonized in collections published after the Civil War honoring women whose "shining deeds" relieved untold suffering (see, for example, the chapter "Mother Bickerdyke" in Frank Moore, *Women of the War: Their Heroism and Self-Sacrifice* [1866], 465–72). Interestingly, the particular speech of Bickerdyke that Livermore recounts for her readers in *The Story of My Life* is anthologized in Sylvia G. L. Dannett, *Noble Women of the North* (1959). Dannett characterizes Bickerdyke's speech as "one of the most eloquent, direct speeches delivered to the folks at home by a woman who had been living and working at the battlefront from the very beginning of the war" (231–32). Dannett refers to Livermore's account of the event and seems clearly indebted to her summary of the speech and to her praise for Bickerdyke's maternal eloquence.

11. Theodore Tilton was one of the leading abolitionists and radical Republicans in the North before and just after the Civil War with close connections to William Lloyd Garrison, Wendell Phillips, Charles Sumner, and Henry Ward Beecher. A scandal in which Tilton publicly accused Beecher of seducing his wife, a charge that Beecher denied but that Tilton's wife later acknowledged as true, ruined Tilton's career. He was forced by strong public support of Beecher to flee the country. Stanton's reference to him in her memoir possibly can be interpreted as a gesture intended, among other things, to restore in part Tilton's credibility.

12. In her memoir, *A Ragged Register (of People, Places and Opinions),* published in 1879 and which reflects over nearly twenty years of professional traveling, Dickinson reveals herself to be a provocative speaker and a wit who suffered no fools. As frequently hissed out as praised and accosted in trains and waiting rooms by citizen critics and well-wishers alike, Dickinson is far more candid about the "louts" she often found in her audiences than Livermore or Stanton are ever willing to be.

13. For a defense of this view, see Carol Mattingly's discussion of "Woman-Tempered Rhetoric: Public Presentation and the WCTU," in *Well-Tempered Women: Nineteenth-Century Temperance Rhetoric* and Bonnie J. Dow's defense of Willard's use of the womanhood trope in "The 'Womanhood' Rationale in the Woman Suffrage Rhetoric of Frances E. Willard." Campbell's view of "feminine feminists" and their discourses of accommodation is mixed. Campbell both praises the inventiveness of women like Willard who managed to gain the podium by projecting femininity and recognizes that such a rhetorical approach only inscribed conventional views of women even further (121–45). However, Campbell does believe that the unique rhetorical strategies of nineteenth-century women reformers need to be evaluated in and of themselves and not in comparison with masculine styles of nineteenth-century oratory. Campbell summarizes these strategies as the use of biblical authority, personal experience, vivid metaphors, and the power of a moral ethos. A. Cheree Carlson also takes the stance that the use of moral force

of conventional womanhood was a valuable strategy for nineteenth-century reformers. Carlson argues that "the moral reform movement used skillful casuistic stretching of the feminine ideal to justify taking nontraditional action in the name of traditional values. In so doing, the movement also began to create a new consciousness in its members" (17). (See Carlson, "Creative Casuistry and Feminist Consciousness: The Rhetoric of Moral Reform.")

5. Noble Maids and Eloquent Mothers, Off the Map

1. Parlor speakers, conduct literature, and various parlor-rhetoric manuals continued to articulate a conservative view of public rhetorical options for women and to reinforce the home as the center of women's discursive worlds in the early-twentieth century (for example, see Francis P. Hoyle, *The Complete Speaker and Reciter* [1905] and *The Ladies Guide to Health and Beauty* [1902]).

2. Chapters 1, 2, and 3 treat the doublespeak of parlor rhetorics, conduct literature, and letter-writing guides that contributes to the late-nineteenth-century cultural climate that never encouraged women to move into rhetorical roles outside the home without serious objections.

3. The Alliance Movement is defined in *Woman* as "the great farmer manifesto" brought on by "The Grange . . . a most noble order, of untold service and solace to erstwhile cheerless lives." Speakers like Sarah Emery, primary organizer and spokeswoman for the movement, and McDonald-Valesh are interpreted in *Woman* as affiliated with the Alliance Movement out of concern for their homes: "So now Alliance women look at politics and trace the swift relation to the home—their special sphere" (583–84).

4. Sarah Emery was a Greenback and Populist leader who was extremely active in the 1880s as a speaker for the Farmer's Alliance, the Union Labor party, the Woman Suffrage Association, and the Woman's Christian Temperance Union. Emery was also an outspoken supporter of the Grange movement that promoted legislative protection of farmers and also promoted educational and social opportunities in farming communities. Little to no scholarship exists that explores women's wide participation as speakers in the Populist movement. Michael Kazin does give Willard's role as a populist speaker attention in his section "The Womanly Voice" in *The Populist Persuasion: An American History* (1995). Kazin's description of Willard as a speaker, confirms, once again, Willard's legendary noble-maid image:

> Members who did not share her radical views were still devoted to this slender beauty whose clear, blue eyes and ethereal composure—shining from thousands of drawings and photographs—made her seem blessed. Whether in print, in small meetings, or before audiences of several thousand people, Willard assumed the same gentle, emphatic tone. (84)

5. Eva McDonald-Valesh's public-speaking persona is characterized in much the same way that Willard was so often viewed—earnest, soft spoken, and feminine. The attention to the performance of conventional femininity in women

speakers of the 1890s admits little deviation from the ideal of the reformist woman speaker whom McDonald-Valesh is made to represent here.

6. In *Canons and Contexts* (1991), Paul Lauter observes in his discussion of the canon of American literature in the 1920s, "No conclave of cultural cardinals establishes a literary canon, but for all that it exercises substantial influence. For it encodes a set of social norms and values; and these, by virtue of its cultural standing, it helps to endow with force and continuity" (23). Adopting Lauter's insight, the development of the canon of American public speaking can be regarded as both a cultural product and a cultural force. The pressure of the woman question was not the only issue exerting influence on the development of the canon of American oratory. Threatened by the pervasive influence of newspapers, authors at the turn of the century typically frame their accounts of great American public speaking with the polemic that oratory is a political necessity in a democracy and, therefore, cannot ever die. A preservationist's zeal clearly motivates several canon authors who construct the statesmen canon as proof against the disaster of assuming that oratory might not remain politically powerful an art of rhetoric as it had been in earlier eras in American history.

7. Brooke's list of statesmen-orators is similar to the great men canon of orators that postbellum rhetoricians and elocutionists such as Agar, Genung, and Adams Sherman Hill affirm in their citations as examples of model speeches for study. This similarity implies that rhetoricians who wrote popular theoretical treatises also contributed to the statesmen orientation of the canon of American public speaking by identifying the speeches of only male orators such as Webster and Lincoln as models of rhetorical skill to be studied and imitated (see chap. 1).

8. Henry Augustin Beers was a literature professor at Yale from 1871 to 1926. His text *An Outline Sketch of American Literature* was first published in 1878, with a subsequent seven editions under that title through 1896. Another version was published under the title *Initial Studies in American Letters* (1895), which was republished in 1906. Beers was also the author of another widely used literature text, *A History of English Romanticism in the Eighteenth Century* (1899), which went through thirteen editions into 1929. The wide circulation of Beers's texts was exceeded by the twenty editions of Brooke's *English Literature with an Appendix on American Literature* between 1879 and 1916. Versions of Pattee's *A History of American Literature* went through fifteen editions between 1896 and 1937. Newcomer's *American Literature,* first published in 1898, went through several editions through 1913. Abernethy's *American Literature* was also republished several times, going through eight editions between 1902 and 1913. The wide circulation of these histories of American literature from the postbellum period through the 1930s collectively popularized in the academy a statesmen canon of American public speaking for over fifty years. The promotion of the statesmen canon of American orators during this period is particularly important for, as Elizabeth Renker has pointed out, the first four decades of the twentieth century represent a crucial era in the development of the field of American literature in the academy.

9. The generic habit of treating women literary figures but never considering women orators in the history of American literature of the postbellum period endures into the twentieth century with the wide circulation of academic histories such as the texts of Beers and Pattee, authors who are recognized as having had a significant hand in shaping the early canon of American literature. For example, Nina Baym recognizes both Beers and Pattee as major authors of the narrative of the history of American literature between 1882 and 1912. (See Baym, "Early Histories of American Literature: A Chapter in the Institution of New England.") The standard omission in the academic canon of American literature of women speakers is also reflected in histories written for the general reader rather than for the academic audience or classroom use such as Van Wyck Brooks, *The Flowering of New England: 1815–1865* (1946) in which Brooks treats women writers such as Cambridge poets Sigourney and Maria Gowan Brooks yet omits women abolition speakers from a treatment of prewar eloquence that highlights "the voices of Charles Sumner and Wendell Phillips" (155–57; 393).

10. Nina Baym observes in *American Women Writers and the Work of History, 1790–1860* (1995) that "the literary profession, which opened to women early in the nation's history—indeed, it might be more accurate to say that the profession was opened *by* them—supported a very wide range of female endeavor" (3). The position of women speakers in the nineteenth century, however, was quite different as women were perceived to be attempting to assail a sphere of rhetorical activity dominated by men. There was no open ground here for women orators. Baym has convincingly argued that women literary writers actually enjoyed a tremendous amount of cultural space for their work. The problem, Baym's implies, is that when the canon of American literature becomes stabilized in the early twentieth century, the value of women's writing in the nineteenth century is devalued aesthetically because of its association with the domestic sphere in subject or point of view. This judgment, cautions Baym, should not be confused with the fact that in the antebellum period in particular, American women flooded the printways with all matter of genres including fiction, poetry, drama, travel books, advice books, editorials, histories, biographies, and memoirs and were not constrained by their domestic identities in the promotion of that work. That women of the antebellum period are recognized in early canons of American literature would seem to support Baym's argument that the cultural position of women writers before the Civil War was actually a strong one. The problem with the status of women in the canon of American oratory is not, however, parallel. Throughout the nineteenth century and into the twentieth, cultural prohibitions against women trespassing into the sphere of political oratory and public rhetorical spaces in general remain so constant that the very presence of women on the speaking platform is considered an aberration even as the twentieth century begins. Public address is not a rhetorical space that is retrospectively co-opted by canon writers as masculine territory: It was always masculine territory.

11. In his analyses of both Lockwood and Dickinson, Morris praises their excellent speaking skills. He remarks that for "unflinching perseverance, intellectual

power, logic, and eloquence, few women have surpassed Belva Anne Lockwood" (348). Morris describes Dickinson as a speaker of intelligence, excellent judgment, wit, pathos, and claims for her a "dramatic fervor of eloquence" unequaled among women speakers in general (353).

12. Morris includes Lockwood's speech, "The Political Rights of Women," which Morris describes as one of many that Lockwood gave "before Congressional Committees in the cause of women" (348). Lockwood's speech is the only speech by a woman that Morris includes given in what other canon authors of the same period would no doubt construe as the legitimate political forum of the Congressional chamber. Morris's chapter "Notable Women Orators" is part of the section "American Oratory" and is organized around time periods in the chapters such as "Revolutionary Orators of the United States," "The Golden Age of American Oratory," "Orators of the Civil War Period," and rhetorical genres including "Recent Political Orators," "Famous Pulpit Orators," and "Speakers on Festive Occasions." Falling between "Leaders in the Lecture Field" and "Speakers on Festive Occasions," the section on "Notable Women Orators" takes on a kind of generic status as if one could reasonably treat orations by women as a particular kind of oratory distinguishable from more traditional types such as political or pulpit oratory.

13. Harper characterizes this particular speech of Anthony's as "a masterpiece of clear, strong, logical argument in defense of woman's right to the ballot which never has been equaled. Her audiences were large and attentive and public sentiment was thoroughly aroused" (1: 435). From press reviews from New York papers that Harper cites to document Anthony's movements in 1872 and 1873, it seems clear that Anthony's speaking tour in 1873, when "On Woman's Right to Suffrage" was her lead speech, was centralized in New York (438–48).

14. New York Sen. Chauncey M. Depew is described in "The Gallery of Great Orators" in *The American Orator* (1901) as "the happiest after-dinner and extemporaneous orator in the country" (189). Depew's speeches are often anthologized in canon collections of the early 1900s. As a politician and a well-known public speaker, Depew's pronouncements on the nature of oratory as the gift of men would have carried weight with readers well aware of his reputation as an orator.

15. It is possible that the neglect of the contributions of women to the nineteenth-century rhetorical history that Yoakum attempts to remedy was and continues to be encouraged by a fundamental misconception of the range of rhetorical activities and sources of rhetorical education that were typical of nineteenth-century American life. This inaccurate view has been expressed most recently by Hayden White who articulates the historically indefensible view that rhetoric was, in general, suppressed in the nineteenth century and did not play a central role in the curriculum of public schools and colleges.

16. Other widely cited canon collections published after 1910 that reinscribe a statesmen canon before and after the 1943 publication of Yoakum's essay include Warren Choate Shaw, *History of American Oratory* (1928), A. Craig Baird, *American Public Addresses: 1740–1952* (1956); and Robert T. Oliver, *History of Public*

Speaking in America (1965). Up to the present time, no scholarly critique has focused in detail on how the canon of American public address developed after 1910. Karlyn Kohrs Campbell has sharply criticized the omission of women in current public address anthologies and has observed that this omission distorts the history of American public speaking in "The Communication Classroom: A Chilly Climate for Women?" Campbell is accurate in her estimation of current anthologies, and her criticism should be viewed as an encouragement to feminist historians to mount a thorough critique of twentieth-century rhetoric. An exception to the trend Campbell laments (which antedates her remarks in 1985) is Patricia Bizzell and Bruce Herzberg, *The Rhetorical Tradition: Readings from Classical Times to the Present.*

BIBLIOGRAPHY

Abell, Mrs. L. G. *The Skillful Housewife's Book*. New York: Newell, 1846.

———. *Woman in Her Various Relations: Containing Practical Rules for American Females*. New York: Holdredge, 1850.

Abernethy, Julian G. *American Literature*. New York: Merrill, 1908.

Adams, Oscar Fay. *A Dictionary of American Authors*. Boston: Houghton, 1904.

Agar, J. *The American Orator's Own Book*. New York: Saxton, 1859.

Allen, Montfort B., and Amelia C. McGregor. *The Glory of Woman: Or Love, Marriage and Maternity: Containing Full Information on All the Marvelous and Complex Matters Pertaining to Women*. Philadelphia: National, 1896.

Altman, Janet Gurkin. *Epistolarity: Approaches to a Form*. Columbus: Ohio State UP, 1982.

The American Orator. Chicago: Kuhlman, 1901.

Ayres, Alfred [Thomas Embley Osmun]. *The Mentor: A Little Book for the Guidance of Such Men and Boys as Would Appear to Advantage in the Society of Persons of the Better Sort*. New York: Funk, 1884.

———. *The Orthoepist: A Pronouncing Manual*. New York: Appleton, 1880.

———. *The Verbalist*. New York: Appleton, 1882.

Bacon, Jacqueline. "Do You Understand Your Own Language? Revolutionary *Topoi* in the Rhetoric of African-American Abolitionists." *Rhetoric Society Quarterly* 28.2 (1998): 55–76.

Baird, A. Craig. *American Public Addresses: 1740–1952*. New York: McGraw, 1956.

Baker, George M. *The Handy Speaker: Comprising Fresh Selections in Poetry and Prose, Humorous, Pathetic, Patriotic, for Reading Clubs, School Declamations, Home and Public Entertainments*. Boston: Lee, 1876.

———. *Pieces People Recommend*. Boston: Baker, 1912.

Banner, Lois W. *Elizabeth Cady Stanton: A Radical for Women's Rights*. Boston: Little, 1980.

Barnes, William H. "The Eloquence of Woman." *Ladies Repository: A Monthly Periodical Devoted to Literature, Art, and Religion* 14 (1854): 174.

Bates, Jerome Paine. *The Imperial Highway, Essays on Business and Home Life with Biographies of Self-Made Men*. Chicago: Natl. Lib. Assn., 1888.

Baym, Nina. *American Women Writers and the Work of History, 1790–1860*. New Brunswick: Rutgers UP, 1995.

———. "Early Histories of American Literature: A Chapter in the Institution of New England." *American Literary History* 1.3 (1989): 459–88.

Bederman, Gail. *Manliness and Civilization: A Cultural History of Gender and Race in the United States, 1880–1917.* Chicago: U of Chicago P, 1995.

Beers, Henry A. *An Outline Sketch of American Literature.* New York: Chautauqua Press, 1887. Urbana: U of Illinois P, 1978.

Berg, Albert Ellery, ed. *The Universal Self Instructor: An Epitome of Forms and General Reference Manual.* New York: Thomas Kelly, 1882.

Berkeley, Kathleen. "Anna Elizabeth Dickinson." Garraty and Carnes 6: 557–59.

Biesecker, Barbara. "Coming to Terms with Recent Attempts to Write Women into the History of Rhetoric." *Philosophy and Rhetoric* 25.2 (1992): 120–61.

Bizzell, Patricia, and Bruce Herzberg. *The Rhetorical Tradition: Readings from Classical Times to the Present.* Boston: Bedford, 2001.

Blackwell, Alice Stone. *Lucy Stone: Pioneer of Women's Rights.* Boston: Little, 1930.

Blair, Hugh. *Lectures on Rhetoric and Belles Lettres.* New York: Carvill, 1829.

———. *Sermons by Hugh Blair; To Which Is Prefixed, the Life and Character of the Author.* New York: Taylor, 1844.

———. "Woman." *Ladies Companion* 12 (1839): 62.

Brigance, William Norwood, ed. *A History and Criticism of American Public Address.* 2 vols. New York: McGraw, 1943.

Brooke, Stopford. *English Literature with an Appendix on American Literature.* New York: Appleton, 1879.

Brooks, Van Wyck. *The Flowering of New England: 1815–1865.* Cleveland: World, 1946.

Brown, Charles Walter. *The American Star Speaker and Model Elocutionist.* Chicago: Donohue, 1902.

Browne, Stephen Howard. *Angelina Grimké: Rhetoric, Identity, and the Radical Imagination.* East Lansing: Michigan State UP, 1999.

Bryan, William Jennings, ed. *The World's Famous Orations.* 10 vols. New York: Funk, 1906.

Bullard, Laura Curtis. "Elizabeth Cady Stanton." *Our Famous Women* 602–23.

Campbell, Karlyn Kohrs. "Biesecker Cannot Speak For Her Either." *Philosophy and Rhetoric* 26.2 (1993): 153–59.

———. "The Communication Classroom: A Chilly Climate for Women?" *American Communication Association Bulletin* 51 (1985): 68–72.

———. *Man Cannot Speak for Her: A Critical Study of Early Feminist Rhetoric.* New York: Greenwood, 1989.

———. "The Sound of Women's Voices." *Quarterly Journal of Speech* 75 (1989): 212–58.

Carlson, A. Cheree. "Creative Casuistry and Feminist Consciousness: The Rhetoric of Moral Reform." *Quarterly Journal of Speech* 78 (1992): 16–32.

———. "Limitations on the Comic Frame: Some Witty American Women of the Nineteenth Century." *Quarterly Journal of Speech* 74 (1988): 310–22.

Chesterfield's Letter Writer and Complete Book of Etiquette. New York: Dick, 1857.

Clark, Gregory, and S. Michael Halloran, eds. *Oratorical Culture in Nineteenth-Century America*. Carbondale: Southern Illinois UP, 1993.

Cmiel, Kenneth. *Democratic Eloquence: The Fight over Popular Speech in Nineteenth-Century America*. New York: Morrow, 1990.

Cogswell, Albert [James Kernan]. *The Gentlemen's Perfect Letter Writer*. New York: Cogswell, 1877.

———. *Perfect Etiquette; or, How to Behave in Society*. New York: Hurst, 1872.

Collier's Cyclopedia of Commercial and Social Information and Treasury of Useful and Entertaining Knowledge on Art, Science, Pasttimes, Belles-Lettres, and Many Other Subjects of Interest in the American Home Circle. Comp. Nugent Robinson. New York: Collier, 1882.

Collins, Vicki Tolar. "Women's Voices and Women's Silence in the Tradition of Early Methodism." Wertheimer 233–54.

Connors, Robert J. "Frances Wright: First Female Civic Rhetor in America." *College English* 62.1 (1999): 30–57.

———. "Teaching and Learning as a Man." *College English* 58.2 (1996): 137–57.

"Conversation as a Fine Art." *Ladies Repository: A Monthly Periodical Devoted to Literature, Art, and Religion* 28.1 (1868): 10–13.

Conway, Jill. "Woman Reformers and American Culture, 1870–1930." *Journal of Social History* 5 (1971–1972): 164–77.

Conway, Kathryn M. "Woman Suffrage and the History of Rhetoric at the Seven Sisters Colleges, 1865–1919." Lunsford 203–26.

Conwell, Russell H., comp. *Social Abominations, or the Follies of Modern Society Portrayed by Many Eminent Writers*. Chicago: The National Book Concern, 1892.

Cooke, Rose Terry. "Real Rights of Women." Conwell 433–44.

Cott, Nancy F. *The Bonds of Womanhood: "Woman's Sphere" in New England, 1780–1835*. New Haven: Yale UP, 1977.

Cowen, B. R. *Our Beacon Light, Devoted to Employment, Education, and Society*. Columbus, Ohio: Patrick, 1889.

Craig. Alan. *The Casket of Literary Gems*. Chicago: Homes, 1879.

———. *Room at the Top or How to Reach Success, Happiness, Fame, and Fortune*. Chicago: Sumner, 1883.

Dannett, Sylvia G. L. *Noble Women of the North*. New York: Yoseloff, 1959.

Decker, William Merrill. *Epistolary Practices: Letter Writing in America Before Telecommunications*. Chapel Hill: U of North Carolina P, 1998.

Depew, Chauncey M. Foreword. "The Art of Oratory." *Masterpieces of Eloquence*. Ed. Rossiter Johnson. New York: Nelson, 1902. i–iv.

Dick, William Brisbane, ed. *Dick's Society Letter-Writer for Ladies*. New York: Dick, 1884.

———. *Dick's Speeches for Tiny Tots*. New York: Dick, 1895.

———. *One Hundred Amusements for Evening Parties, Picnics and Social Gatherings*. New York: Dick, 1873.

Dickinson, Anna E. *A Ragged Register (of People, Places, and Opinions)*. New York: Harper, 1879.

Donawerth, Jane. "Hannah More, Lydia Sigourney, and the Creation of Woman's Tradition of Rhetoric." In *Rhetoric, the Polis, and the Global Village.* Ed. C. Jan Swearingen and Dave Pruett. Mahwah: Erlbaum, 1999. 155–61.

———. "Textbooks for New Audiences: Women's Revisions of Rhetorical Theory at the Turn of The Century." Wertheimer 337–56.

Dow, Bonnie J. "The 'Womanhood' Rationale in the Woman Suffrage Rhetoric of Frances E. Willard." *Southern Communication Journal* 56.4 (1991): 298–307.

Duryea, J. B. *The Art of Writing Letters: A Manual of Correct Correspondence.* Des Moines: Duryea, 1894.

Earhart, Mary. *Frances Willard: From Prayers to Politics.* Chicago: U of Chicago P, 1944.

Eminent Women of the Age: Being Narratives of the Lives and Deeds of the Most Prominent Women of This Generation. Hartford: Betts, 1868.

Enders, Jody. "Cutting Off the Memory of Women." Sutherland and Sutcliffe 47–58.

The Fashionable American Letter Writer: Or the Art of Polite Correspondence. Brookfield: Merriam, 1837.

Fenno, Frank H. *The Science and Art of Elocution; or How to Read and Speak.* Philadelphia: Potter, 1878.

"Frances E. Willard: The Foremost American Temperance Reformer." King 413–14.

Frink, Henry Allyn. *The New Century Speaker.* 1898. New York: Books for Libraries, 1971.

Gale, Xin Liu. "Historical Studies and Postmodernism: Rereading Aspasia of Miletus." *College English* 62.3 (2000): 361–86.

Garraty, John A., and Mark C. Carnes, eds. *American National Biography.* 24 vols. New York: Oxford UP, 1999.

Gaskell, G. A. *Gaskell's Compendium of Forms, Educational, Social, Legal, and Commercial.* Boston: Garrison, 1881.

Genung, John Franklin. *Handbook of Rhetorical Analysis.* Boston: Ginn, 1888.

———. *The Practical Elements of Rhetoric.* Boston: Ginn, 1886.

———. *The Working Principles of Rhetoric.* Boston: Ginn, 1900.

Gere, Anne Ruggles. *Intimate Practices: Literacy and Cultural Work in U. S. Women's Clubs, 1880–1920.* Urbana: U of Illinois P, 1997.

Gifford, Carolyn DeSwarte. "Frances Willard and the Woman's Christian Temperance Union's Conversion to Woman Suffrage." *One Woman, One Vote: Rediscovering the Woman's Suffrage Movement.* Ed. Marjorie Spruill Wheeler. Troutdale: OrL New Sage, 1995. 117–33.

Gilmore, Leigh. *Autobiographics: A Feminist Theory of Women's Self-Representation.* Ithaca: Cornell UP, 1994.

Ginzberg, Lori D. *Women and the Work of Benevolence: Morality, Politics, and Class in the Nineteenth-Century United States.* New Haven: Yale UP, 1990.

Glenn, Cheryl. *Rhetoric Retold: Regendering the Tradition from Antiquity Through the Renaissance.* Carbondale: Southern Illinois UP, 1997.

Gordon, Ann D. "Anthony, Susan B." Garraty and Carnes 1: 547–50.

Griffith, Elizabeth. *In Her Own Right: The Life of Elizabeth Cady Stanton.* New York: Oxford UP, 1984.

Gring-Premble, Lisa M. "Writing Themselves into Consciousness: Creating a Rhetorical Bridge Between the Public and Private Spheres." *Quarterly Journal of Speech* 84 (1998): 41–61.

Hale, Sarah J. *Manners; or, Happy Homes and Good Society All Year Around.* 1868. New York: Arno, 1972.

Halttunen, Karen. *Confidence Men and Painted Women: A Study of Middle-Class Culture in America, 1830–1870.* New Haven: Yale UP, 1982.

Harper, Ida Husted. *The Life and Work of Susan B. Anthony.* 2 vols. Indianapolis: Hollenbeck, 1898.

Harris, Susan K. *Nineteenth-Century American Women's Novels: Interpretative Strategies.* New York: Cambridge UP, 1990.

Hartley, Florence. *The Ladies Book of Etiquette, and Manual of Politeness.* Boston: Lee, 1882.

Hedrick, Joan. *Harriet Beecher Stowe: A Life.* New York: Oxford UP, 1994.

Hewitt, Elizabeth. "Dickinson's Lyrical Letters and the Poetics of Correspondence." *Arizona Quarterly* 52.1 (1996): 27–58.

Hilkey, Judy. *Character Is Capital: Success Manuals and Manhood in Gilded Age America.* Chapel Hill: U of North Carolina P, 1997.

Hill, Adams Sherman. *The Foundations of Rhetoric.* New York: American, 1892.

———. *The Principles of Rhetoric.* New York: American, 1895.

Hill, Thomas Edie. *Hill's Manual of Social and Business Forms: Guide to Correct Writing.* Chicago: Hill, 1883.

Hobbs, Catherine, ed. *Nineteenth-Century Women Learn to Write.* Charlottesville: UP of Virginia, 1995.

Hobbs, June Hadden. "I Sing for I Cannot Be Silent": *The Feminization of American Hymnody, 1870–1920.* Pittsburgh: U of Pittsburgh P, 1997.

The Home Cyclopedia of Necessary Knowledge. N.p., 1902.

How to Write: A Pocket Manual of Composition and Letter-Writing. New York: Fowler, 1857.

Hoyle, Francis P. *The Complete Speaker and Reciter.* New York: Parker, 1905.

———. *The World's Speaker, Reciter, and Entertainer.* Philadelphia: World Bible, 1905.

The International Speaker and Popular Elocutionist. Chicago: Internatl., 1895.

Jarratt, Susan, and Rory Ong. "Aspasia: Rhetoric, Gender, and Colonial Ideology." Lunsford 9–24.

Johnson, Nan. *Nineteenth-Century Rhetoric in North America.* Carbondale: Southern Illinois UP, 1991.

———. "The Popularization of Nineteenth-Century Rhetoric: Elocution and the Private Learner." Clark and Halloran 139–57.

Johnston, Alexander, ed. *American Orations: Studies in American Political History.* New York: Putnam's, 1896.

Jones, Edgar Dewitt. *Lords of Speech: Portraits of Fifteen American Orators.* Chicago: Willett, 1937.

Kates, Susan. "The Embodied Rhetoric of Hallie Quinn Brown." *College English* 59.1 (1997): 59–71.

———. "Subversive Feminism: The Politics of Correctness in Mary Augusta Jordan's *Correct Writing and Speaking (1904)*." *College Composition and Communication* 48.4 (1997): 501–17.

Kauffman, Linda S. *Discourses of Desire: Gender, Genre, and Epistolary Fictions.* Ithaca: Cornell UP, 1986.

———. *Special Delivery: Epistolary Modes in Modern Fiction.* Chicago: U of Chicago P, 1992.

Kazin, Michael. *The Populist Persuasion: An American History.* Ithaca: Cornell UP, 1995.

Kerber, Linda K. *Women of the Republic: Intellect and Ideology in Revolutionary America.* Chapel Hill: U of North Carolina P, 1980.

Kimble, James. "Frances Willard as Protector of the Home: The Progressive, Divinely Inspired Woman." Watson 47–62.

King, William C., ed. *Woman: Her Position, Influence, and Achievement Throughout the Civilized World.* Springfield, MA: King, 1903.

Kraditor, Aileen S. *Means and Ends in American Abolitionism: Garrison and His Critics on Strategy and Tactics, 1834–1850.* New York: Pantheon, 1967.

———. *Up from the Pedestal: Selected Writings in the History of American Feminism.* Chicago: Quadrangle, 1968.

Landon, Melville D., ed. *Kings of the Platform and Pulpit.* Akron: Saalfield, 1900.

Lauter, Paul. *Canons and Contexts.* New York: Oxford UP, 1991.

Lee, Guy Charleton, ed. *The World's Orators: Orators of America.* New York: Putnam, 1901.

Lehuu, Isabelle. "Sentimental Figures: Reading *Godey's Lady's Book* in Antebellum America." *The Culture of Sentiment: Race, Gender, and Sentimentality in Nineteenth-Century America.* Ed. Shirley Samuels. New York: Oxford UP, 1992. 73–91.

Lindsay, Mrs. Samuel. "What is Worth While." *Three Minute Readings for College Girls.* Ed. Harry Davis. New York: Hinds, 1897. 239–41.

Lipscomb, Drema R. "Sojourner Truth: A Practical Public Discourse." Lunsford 227–46.

Livermore, Mary A. *My Story of the War: A Woman's Narrative of Four Years of Personal Experience as a Nurse in the Union Army, and in Relief Work at Home, in Hospitals, Camps, and at the Front, During the War of the Rebellion.* Hartford: Worthington, 1887.

———. *The Story of My Life, or the Sunshine and Shadow of Seventy Years.* Hartford: Worthington, 1897.

———. "Twenty-five Years on the Lecture Platform." *Arena* 23 (1892): 261–71.

Logan, Mary S. *The Part Taken by Women in American History.* 1902. New York: Arno, 1972.

Logan, Shirley Wilson. *"We Are Coming": The Persuasive Discourse of Nineteenth-Century Black Women.* Carbondale: Southern Illinois UP, 1999.

Lumm, Emma Griffith, ed. *Etiquette at the Table.* Chicago: n. p. 1895.

———. *The Home School Speaker and Elocutionist.* New York: Boland, 1899.

———. *The New American Speaker.* Chicago: Walter, 1910.

———. *The Twentieth Century Speaker.* New York: Boland, 1899.

———. *Young People's Star Speaker.* Chicago: Thompson, 1903.

Lunsford, Andrea. "On Reclaiming Rhetorica." Lunsford 3–8.

———, ed. *Reclaiming Rhetorica: Women in the Rhetorical Tradition.* Pittsburgh: Pittsburgh UP, 1995.

Malone, Dumas, ed. *Dictionary of American Biography.* Vol. 15. New York: Scribner's, 1946.

Mandeville, Henry. *The Elements of Reading and Oratory.* New York: Appleton, 1880.

Martine's Sensible Letter-Writer. New York: Dick, 1866.

Masterpieces of Oratory: Orations of American Orators. 3 vols. New York: Fifth Avenue, 1900.

Matthews, Glenna. *The Rise of the Public Woman: Woman's Power and Woman's Place in the United States, 1630–1970.* New York: Oxford UP, 1992.

Mattingly, Carol. *Well-Tempered Women: Nineteenth-Century Temperance Rhetoric.* Carbondale: Southern Illinois UP, 1998.

McCabe, James D. *Great Fortunes, and How They Were Made; or the Struggles and Triumphs of Our Self-Made Men.* Philadelphia: Maclean, 1871.

———. *Heroes and Statesmen of America, Being a Popular Book of American Biography, Embracing the Lives of the Representative Great Men of the Nation.* Philadelphia: Ziegler, 1878.

———. *The Household Encyclopedia of Business and Social Forms, Embracing the Laws of Etiquette and Good Society.* N.p.: n.p., 1882.

McClure, Alexander K. *Famous American Statesmen and Orators.* New York: Lovell, 1902.

McNair Wright, Julia. *The Complete Home: An Encyclopedia of Domestic Life and Affairs.* Philadelphia: McCurdy, 1879.

Melosh, Barbara. *Gender and American History since 1890.* London: Routledge, 1993.

Miller, Diane H., Cal M. Logue, and Cindy Jeneky. "Civil Liberties: The Expansion of White Women's Communicative Activities from the Antebellum South Through the Civil War." *Southern Communication Journal* 61.4 (1996): 289–301.

Miller, Susan. *Assuming the Positions: Cultural Pedagogy and the Politics of Commonplace Writing.* Pittsburgh: U of Pittsburgh P, 1998.

Moore, Frank. *Women of the War: Their Heroism and Self-Sacrifice.* Hartford: Scranton, 1866.

Morris, Charles. *Famous Orators of the World and Their Best Orations.* N.p.: n.p., 1902.

Mott, Frank Luther. *A History of American Magazines, 1741–1850.* 3 vols. Cambridge: Harvard UP, 1939.

Mountford, Roxanne. "Gender and Rhetorical Space." *Rhetoric Society Quarterly* 31.1 (2001): 41–71.

The National Cyclopaedia of American Biography. Vol. 9. New York: White, 1899.

Newcomb, Harvey. *How to Be a Lady: A Book for Girls.* Boston: Gould, 1846.

———. *How to Be a Man.* Boston: Gould, 1846.

———. *A Practical Directory for Young Christian Females.* Boston: Massachusetts Sabbath School Soc., 1833.

Newcomer, Alphonso G. *American Literature.* Chicago: Scott, 1908.

Newman, Samuel P. *A Practical System of Rhetoric.* New York: Dayton, 1842.

Nichols, J. L. *The Business Guide; or, Safe Methods of Business.* Naperville: Nichols, 1886.

———. *The Busy Man's Friend, A Guide to Success by Facts and Figures.* Atlanta: Nichols, 1902.

Northrop, Henry Davenport, ed. *Crown Jewels or Gems of Literature, Art, and Music.* Chicago: Miller, 1887.

———. *The Ideal Speaker and Entertainer.* New York: Bertron, 1890.

———. *The Peerless Reciter or Popular Program.* Chicago: Monarch, 1894.

O'Connor, Lillian. *Pioneer Women Orators: Rhetoric in the Antebellum Reform Movement.* New York: Columbia UP, 1954.

Oliver, Robert T. *History of Public Speaking in America.* Boston: Allyn, 1965.

Our Famous Women: An Authorized Record of the Lives and Deeds of Distinguished American Women of Our Times. Hartford: Worthington, 1884.

Pattee, Fred Lewis. *A History of American Literature.* New York: Silver, 1896.

Peaden, Catherine. "Jane Addams and the Social Rhetoric of Democracy." Clark and Halloran 184–207.

The Perfect Gentleman; or Etiquette and Eloquence. New York: Dick, 1860.

Phelps, Elizabeth Stuart. "Mary A. Livermore." *Our Famous Women* 386–414.

Pinneo, T. S. *The Hemans Reader for Female Schools.* New York: Clark, 1847.

Pond, James Burton. "Memories of the Lyceum." Reed 6: 893–917.

Porter, Ebenezer. *Analysis of the Principles of Rhetorical Delivery.* Andover: Newman, 1827.

———. *The Rhetorical Reader.* New York: Newman, 1848.

Potts, James Henry. *The Golden Dawn; or, Light on the Great Future in This Life, Through the Dark Valley, and in the Life Eternal.* Philadelphia: Ziegler, 1884.

———. *The Golden Way to the Highest Attainments: A Complete Encyclopedia of Life.* Philadelphia: Ziegler, 1889.

Prindle, George Philip. "An Analysis of the Rhetoric of Selected Speeches of Anna Elizabeth Dickinson. Diss. Stanford U, 1972.

Quackenbos, G. P. *Advanced Course of Composition and Rhetoric.* New York: Appleton, 1879.

"Quiet Woman." *Ladies Repository: A Monthly Periodical Devoted to Literature, Art, and Religion* 2 (1868): 461.

Radinovsky, Lisa. "Elizabeth Stuart Phelps." Garraty and Carnes 17: 427–28.

Rayne, Mrs. M. L. *Gems of Deportment and Hints of Etiquette.* Chicago: Tyler, 1881.

————. *What Can a Woman Do; or, Her Position in the Business and Literary World.* Detroit: Dickerson, 1885.

————. *Written for You; or, the Art of Beautiful Living.* Detroit: Tyler, 1882.

Reed, Thomas B., et al., eds. *Modern Eloquence: A Library of After-Dinner Speeches, Lectures, and Occasional Addresses.* 10 vols. Philadelphia: Morris, 1900.

Reid, Ronald F. "Edward Everett and Neoclassical Oratory in Genteel America." Clark and Halloran 29–56.

Renker, Elizabeth. "Resistance and Change: The Rise of American Literature Studies." *American Literature* 64.2 (1992): 345–65.

Rose, Jane E. "Conduct Books for Women, 1830–1860: A Rationale for Women's Conduct and Domestic Role in America." Catherine Hobbs 37–58.

Rosenberg, Carroll Smith. "Beauty, the Beast, and the Militant Woman: A Case Study in Sex Roles and Social Stress in Jacksonian America." *American Quarterly* 23 (1971): 563–84.

Rothman, Ellen. *Hand and Hearts: The History of Courtship in America.* New York: Basic, 1994.

Rouse, P. Joy. "Cultural Models of Womanhood and Female Education: Practices of Colonization and Resistance." Catherine Hobbs 230–47.

Royster, Jacqueline Jones. *Traces of a Stream: Literacy and Social Change among African American Women.* Pittsburgh: U of Pittsburgh P, 2000.

Russell, William. *American Elocutionist.* Boston: Jenks, 1844.

————. *Orthophony: Or the Cultivation of the Voice in Elocution.* Boston: Ticknor, 1846.

————. *Pulpit Elocution.* New York: Wiley, 1861.

Ryan, Mary P. *The Empire of the Mother: American Writing about Domesticity 1830–1860.* New York: Harrington, 1985.

Sanborn, Kate. "Frances E. Willard." *Our Famous Women* 691–715.

Scott, Joan Wallach. *Gender and the Politics of History.* New York: Columbia UP, 1988.

Scott, Mrs. O. W. "The Model Woman." *Ladies Repository: A Monthly Periodical Devoted to Literature, Art, and Religion* 34 (1874): 432–34.

Shaw, William Choate. *History of American Oratory.* Indianapolis: Bobbs Merrill, 1928.

The Shelby Dry Goods Herald. Advertisement. Knisely. Fall and winter 1883.

Simmons, Sue Carter. "Radcliffe Responses to Harvard Rhetoric: "An Absurdly Stiff Way of Thinking." Catherine Hobbs 264–92.

The Speaker's Garland and Literary Bouquet. Vol. 2. Philadelphia: Garrett, 1884.

Spitzack, Carole, and Kathryn Carter. "Women in Communication Studies: A Typology for Revision." *Quarterly Journal of Speech* 73 (1987): 401–23.

Spoel, Phillippa M. Rev. of "Molly Meijer Wertheimer, ed., Listening to Their Voices: The Rhetorical Activities of Historical Women." Ed. Molly Meijer Wertheimer. *Rhetorica* 17.1 (1999): 91–95.

Spurgeon, Charles Haddon. *Twelve Sermons on Vital Questions.* New York: Revell, 1870.

————. *Words of Wisdom for Daily Life.* Baltimore: Woodward, 1894.

The Standard Dictionary of Facts: A Practical Handbook of Ready Reference Based upon Everyday Needs. Buffalo: Frontier, 1908.

Stanton, Elizabeth Cady. *Eighty Years and More (1815–1897).* London: Unwin, 1898.

Stratton, Josephine W., and Jeannette M. Stratton, eds. *The New Select Speaker.* New York: Howell, 1902.

Sutherland, Christine Mason. "Mary Astell: Reclaiming Rhetorica in the Seventeenth Century." Lunsford 93–116.

Sutherland, Christine Mason, and Rebecca Sutcliffe, eds. *The Changing Tradition: Women in the History of Rhetoric.* Calgary: U of Calgary P, 1999.

Swearingen, C. Jan. "A Lover's Discourse: Diotima, Logos, and Desire." Lunsford 25–52.

————. "Plato's Women: Alternative Embodiments of Rhetoric." Sutherland and Sutcliffe 35–46.

Tilton, Theodore. "Mrs. Elizabeth Cady Stanton." *Eminent Women* 332–61.

Tonkovich, Nicole. "Rhetorical Power in the Victorian Parlor: *Godey's Ladies Book* and the Gendering of Nineteenth-Century Rhetoric." Clark and Halloran 158–83.

————. "Writing in Circles: Harriet Beecher Stowe, the Semi-Colon Club, and the Construction of Women's Authorship." Catherine Hobbs 145–75.

Treasures of Use and Beauty: An Epitome of the Choicest Gems of Wisdom, History, Reference and Recreation. Detroit: Dickerson, 1883.

Unger, Nancy C. "Lucretia Coffin Mott." Garraty and Carnes 16: 21–23.

Vail, Walter Scott. *Sunbeams for the Home: To Illuminate the Pathway of Life.* Boston: Guernsey, 1884.

Vincent, John H. "Woman in the Home." King 656–64.

Wagner, Joanne. "Intelligent Members or Restless Disturbers: Women's Rhetorical Styles, 1880–1920." Lunsford 185–202.

Watson, Martha, ed. *Lives of Their Own: Rhetorical Dimensions in Autobiographies of Women Activists.* Columbia: U of South Carolina P, 1999.

Wells, Richard A. *Manners, or Culture and Dress of the Best American Society Including Social, Commercial and Legal Forms.* Cincinnati: Clark, 1892.

Wells, Susan. "Women Write Science: The Case of Hannah Longshore." *College English* 58.2 (1996): 176–91.

Welter, Barbara. *Dimity Convictions: The American Woman in the Nineteenth Century.* Athens: Ohio UP, 1976.

Wertheimer, Molly Meijer, ed. *Listening to Their Voices: The Rhetorical Activities of Historical Women.* Columbia: U of South Carolina P, 1997.

White, Hayden. "The Suppression of Rhetoric in the Nineteenth Century." *The Rhetoric Canon.* Ed. Brenda Deen Schildgen. Detroit: Wayne State UP, 1997. 21–32.

Whiting, Samuel. *Elegant Lessons for the Young Lady.* New Haven: Converse, 1824.

Wiebe, Robert H. *The Search for Order: 1877–1920.* New York: Hill, 1967.

Willard, Frances E. *Glimpses of Fifty Years: The Autobiography of an American Woman*. Chicago: Smith, 1889.

Willard, Frances E., and Mary A. Livermore, eds. *American Women: Women of the Century: Fifteen Hundred Biographies*. New York: Mast, 1893.

Yoakum, Doris G. "Women's Introduction to the American Platform." Vol. 1. *A History and Criticism of American Public Address*. Ed. William Norwood Brigance. New York: McGraw, 1943. 2 vols. 153–92.

Young, James Harvey. "Dickinson, Anna Elizabeth." *Dictionary of American Biography*. Ed. Harris E. Starr. New York: Scribner's, 1944. 244–45.

Zaeske, Susan. "'The Promiscuous Audience' Controversy and the Emergence of the Early Woman's Rights Movement." *Quarterly Journal of Speech* 81 (1995): 191–207.

INDEX

Abell, Mrs. L. G., 89–91, 189n. 7
Abernethy, Julian G., 155, 196n. 8
Adams, Oscar Fay, 191n. 2
Addams, Jane, 177n. 6
African American women, 114; and
 cult of true womanhood, 5; in nine-
 teenth century, 6–7; as orators, 115,
 163, 176n. 4; as reformers, 115; rhet-
 oric of, 7, 9. *See also* biographical lit-
 erature; history; Stanton, Elizabeth
 Cady; Willard, Frances E.
Agar, J., 25–26, 30, 180n. 9
Alcott, Louisa May, 114, 155
Alliance Movement, 150, 195n. 3
Altman, Janet Gurkin, 188n. 2
Anthony, Susan B., 114–15; biography
 of, by Stanton, 136, 138–39; career
 of, 185n. 4; as exception, 31, 49,
 175n. 2; fame as lecturer, 112; friend-
 ship with Stanton, 116, 134; as icon,
 16, 122; influence of, 160; as model,
 113; as noble maid and surrogate
 mother, 140–44; oratorical skill of,
 140, 161; as public speaker, 153–54,
 181n. 15; rewritten history of, 141–
 42, 169, 171; roles of, 143; rhetori-
 cal world of, 145; speeches of, 163–
 64, 198n. 13
argumentation, art of: for home learner,
 21; and power, 22. *See also* manuals;
 performance
Aspasia, 8, 11
Astell, Mary, 8

audience: popular, 2; promiscuous, 5
Ayres, Alfred, 67–68, 178n. 3

Bacon, Jacqueline, 176n. 4
Baker, George M., 33, 182n. 19
Banner, Lois W., 192n. 3
Barnes, William H., 118–19, 121
Barton, Clara, 113
Bates, Jerome Paine, 53–54, 66, 185n. 7
Baym, Nina, 197nn. 9, 10
Bederman, Gail, 192n. 4
Beecher, Catherine E., 114
Beecher, Henry Ward, 194n. 11; as ex-
 emplary speaker, 29–30; and popu-
 larity as speaker, 193n. 9; speeches of,
 164; veneration of, 157
Beers, Henry A., 153–55, 196n. 8,
 197n. 9
behavior: code of rhetorical, 2; and cor-
 rect manners, 94; domestic rhetor-
 ical, 74–75; feminine rhetorical,
 51–52; popular constructions of, 2;
 rhetorical reserve and, 66–67. *See also*
 femininity; gender; parlor rhetorics;
 space; women
Bickerdyke, Mary A. *See* Mother Bick-
 erdyke
Biesecker, Barbara, 176n. 5
biographical literature, 112–13, 121–
 22; African American women's exclu-
 sion from, 114–15
Bizzell, Patricia, 199n. 16
Blackwell, Alice Stone, 179n. 7

213

historiography: feminist, 8, 177n. 6;
questions in, 9, 11
history: presumptions of remapping, 9;
remapping of, 7–8, 176n. 5, 177n. 6;
and remapping gender, 11; revision-
ist construction of, 139, 145. *See also*
African American women; *individual
names of women speakers;* women
Hobbs, Catherine, 13, 176n. 5
Holmes, Oliver Wendell, 164, 166
Hortensia, 8
Howe, Julia Ward, 113–14, 116; as ac-
complished speaker, 167; eminence
of, 136, 164–65; stature of, 166
Howe, Maud, 116
hymnody: as rhetorical practice, 12–13

Japp, Phyllis M., 176n. 3
Jarratt, Susan, 8, 177n. 6
Jewett, Sarah Orne, 155
Johnston, Alexander, 156
Jones, Edgar Dewitt, 171
Jones, Mary Harris. *See* "Mother" Jones
Julian of Norwich, 8

Kates, Susan, 7
Kauffman, Linda S., 188n. 2
Kelley, Abby, 115, 136, 171; eminence
of, 179n. 8; negative influence of, 23
Kempe, Margery, 8
Kerber, Linda K., 4
Kimble, James, 126–27, 191n. 1
Kozin, Michael, 195n. 4
Kraditor, Aileen S., 4, 175n. 3

Laney, Lucy Croft, 176n. 4
Lauter, Paul, 196n. 6
Lee, Guy Charleton, 156
Lehuu, Isabelle, 183n. 20
letters: business, 96–97; familiar, 96–
97; family, 92–93; as rhetorical art,
188n. 2. *See also* letter writing
letter writing, 20, 70; and character,
89–91; and conduct, 94, 98–99; and

domestic sphere, 79–80; and ency-
clopedias, 102–3; and etiquette, 93,
190n. 10; form and style in, 80–81,
86–87; and gender, 88–89, 94–96,
99–100; handbooks and manuals, 2,
85–87, 178n. 4, 188nn. 1, 6; and
home learner, 20–21; illustrations of,
discussed, 81–84, 104–6; impor-
tance of, 77, 90, 106–7; and men,
96; models of, 96–100; rhetorical
power of, 79; as rhetorical skill, 86–
88, 102; and women, 89–90, 92, 96–
97, 106–8. *See also* behavior; manuals
Lincoln, Abraham, 157, 175n. 2; in
canon, 163; as exemplary speaker,
29–30, 196n. 7; and "Gettysburg
Address," 154–55, 181n. 14
Lindsay, Mrs. Samuel, 51, 54, 64, 66
Lipscomb, Drema R., 176n. 4
Livermore, Mary A., 16, 111, 112,
114, 121, 154, 162; autobiography
of, 128–33, 151; on Bickerdyke,
194n. 10; career of, 116–17, 159–
60, 185n. 4; characterization of, 123;
and Chautauqua circuit, 116; as elo-
quent mother, 113, 140, 141–45;
eminence of, 153; as exception, 31,
49; and first public speech, 142; for-
gotten in canon, 171; as icon, 122;
moral tone of, 165–66; and Soldier's
Aid Societies, 129; as speaker, 161,
181n. 15; and United States Sanitary
Commission, leadership of, 116, 129;
on Wright, 178n. 1
Lockwood, Belva Anne, 162, 197n. 11; as
notable orator, 161; speech of, 198n. 12
Logan, Mary S., 111, 191n. 2
Logan, Shirley Wilson, 6, 176n. 4,
192n. 4
London, Melville D., 156
Ludlow, Henry C., 23
Lumm, Emma Griffith, 33–34, 41;
writings of 182n. 19
Lunsford, Andrea A., 8

Sentin, Amasia, 8

Seward, William H., 154

Sigourney, Lydia Huntley, 4, 155, 183n. 22

Simmons, Sue Carter, 7

Smith, Lucy Wilmot, 176n. 4

space: defined, 175n. 1; domestic, 52; postbellum rhetorical, 120; public rhetorical, 2, 3, 50, 52, 112, 114; rhetorical, 43, 49, 70, 75, 144, 169; and rhetorical opportunities, 47, 145; and rhetorical setting, 164–65; women's price for, 63; women's rhetorical, 31, 148, 168, 197n. 10. *See also* gender; public speaking

speaker tradition, 33, 43, 45

Spitzack, Carole, 176n. 5

Spoel, Phillippa M., 8–9

Spring, Elizabeth T., 193n. 5

Spurgeon, Charles Haddon, 120, 193n. 8

Stanton, Elizabeth Cady, 3, 30, 114, 121; and African Americans, 176n. 4; on Anthony, 116, 141; autobiography of, 123, 128, 134–37; as biographer, 136, 138, 140; career of, 162, 166, 185n. 4; compared to Emery, 150; correspondence with Anthony, 142; as editor, 193n. 6; as eloquent mother, 144; eminence of, 153; essays of, 115; as exception, 31, 49; fame of, 112–13; forgotten in canon, 171; and friendship with Anthony, 134; as icon, 122; on ideal American woman, 192n. 3; and influence as rhetorician, 16; on Kelley, 179n. 8; and National Woman Suffrage Association, 181n. 13; and New York State Suffrage Society, 181n. 13; as orator, 161, 167, 181n. 13; rhetorical acumen of, 145; and views on women in public life, 136–37

Stanton, Henry, 117

Stewart, Frances Maria W., 179n. 8

Stone, Lucy, 22, 136; as abolitionist speaker, 154, 179n. 7; eminence of, 115; at Oberlin College, 22

Stowe, Harriet Beecher, 116; fame of, 113–14; literary reputation of, 13, 155; and parlor literature, 179n. 5

Stratton, Jeannette M., 34, 167

suffrage: American Women Suffrage Association, 179n. 7; as righteous issue, 20; women's movement for, 115, 117–18, 191n. 3; Woman's Suffrage Convention, 116

Sumner, Charles, 154–57, 163–64, 197n. 9

Sutherland, Christine Mason, 8

Swearingen, C. Jan, 8, 11–13, 177n. 6

tableaux, 43; themes of, 44–45. *See also* performance

temperance movement, 191n. 3; as issue, 30

Terrell, Mary Church, 176n. 4

Tilton, Theodore, 134–35, 194n. 11

Tonkovitch, Nicole, 13, 178n. 3

Tonn, Mari Boor, 7

Truth, Sojourner, 3, 115, 176n. 4

Twain, Mark, 164

Unger, Nancy C., 181n. 13

Vincent, Bishop John H., 148–49

Wagner, Joanne, 7

Washington, Booker T., 175n. 2

Washington, George, 25,

WCTU. *See* Woman's Christian Temperance Union

Webster, Daniel, 157, 159, 168; in canon, 163–64, 175n. 2; on eloquence, 156; as exemplary speaker, 25, 30, 196n. 7; influence of, 154–55

Wells, Richard A., 68, 187n. 13

Wells, Susan, 4

Nan Johnson is a professor in the Department of English at The Ohio State University, where she teaches the history of rhetoric, feminist rhetorical theory, rhetorical criticism, theories of composition, and writing. She is the author of *Nineteenth-Century Rhetoric in North America* (1991) and numerous articles and book chapters on nineteenth-century American rhetoric, rhetorical theory, composition theory, historiography, and the state of the discipline of rhetoric studies. Her work has appeared in *College English, Philosophy and Rhetoric, Rhetorica, Rhetoric Review, Rhetoric Society Quarterly, Journal of Advanced Composition, Quarterly Journal of Speech,* and *Nineteenth-Century Prose.*

Studies in Rhetorics and Feminisms

Studies in Rhetorics and Feminisms seeks to address the interdisciplinarity that rhetorics and feminisms represent. Rhetorical and feminist scholars want to connect rhetorical inquiry with contemporary academic and social concerns, exploring rhetoric's relevance to current issues of opportunity and diversity. This interdisciplinarity has already begun to transform the rhetorical tradition as we have known it (upper-class, agonistic, public, and male) into regendered, inclusionary rhetorics (democratic, dialogic, collaborative, cultural, and private). Our intellectual advancements depend on such ongoing transformation.

Rhetoric, whether ancient, contemporary, or futuristic, always inscribes the relation of language and power at a particular moment, indicating who may speak, who may listen, and what can be said. The only way we can displace the traditional rhetoric of masculine-only, public performance is to replace it with rhetorics that are recognized as being better suited to our present needs. We must understand more fully the rhetorics of the non-Western tradition, of women, of a variety of cultural and ethnic groups. Therefore, Studies in Rhetorics and Feminisms espouses a theoretical position of openness and expansion, a place for rhetorics to grow and thrive in a symbiotic relationship with all that feminisms have to offer, particularly when these two fields intersect with philosophical, sociological, religious, psychological, pedagogical, and literary issues.

The series seeks scholarly works that both examine and extend rhetoric, works that span the sexes, disciplines, cultures, ethnicities, and sociocultural practices as they intersect with the rhetorical tradition. After all, the recent resurgence of rhetorical studies has not so much been a discovery of new rhetorics; it has been more a recognition of existing rhetorical activities and practices, of our newfound ability and willingness to listen to previously untold stories.

The series editors seek both high-quality traditional and cutting-edge scholarly work that extends the significant relationship between rhetoric and feminism within various genres, cultural contexts, historical periods, methodologies, theoretical positions, and methods of delivery (e.g., film and hypertext to elocution and preaching).

Queries and submissions:
Professor Cheryl Glenn, Editor
 E-mail: cjg6@psu.edu
Professor Shirley Wilson Logan, Editor
 E-mail: Shirley_W_Logan@umail.umd.edu
Studies in Rhetorics and Feminisms
 Department of English
 142 South Burrowes Bldg
 Penn State University
 University Park, PA 16802-6200